Unser Kaiser und unser Kronprinz in Posen.

DICTATED BY LIFE

MARSDEN HARTLEY'S
GERMAN PAINTINGS
AND ROBERT INDIANA'S
HARTLEY ELEGIES

EXHIBITION ITINERARY:

FREDERICK R. WEISMAN ART MUSEUM
University of Minnesota, Minneapolis, Minnesota
April 14–June 18, 1995

TERRA MUSEUM OF AMERICAN ART
Chicago, Illinois
July 11–September 17, 1995

THE ART MUSEUM AT FLORIDA INTERNATIONAL UNIVERSITY
Miami, Florida
October 13–November 22, 1995

DICTATED BY LIFE

MARSDEN HARTLEY'S
GERMAN PAINTINGS
AND ROBERT INDIANA'S
HARTLEY ELEGIES

PATRICIA MCDONNELL
WITH ESSAY BY MICHAEL PLANTE

FREDERICK R. WEISMAN ART MUSEUM
UNIVERSITY OF MINNESOTA

DISTRIBUTED BY D.A.P./DISTRIBUTED ART PUBLISHERS, INC., NEW YORK

LENDERS TO THE EXHIBITION

Albright-Knox Art Gallery, Buffalo, New York
The Brooklyn Museum, Brooklyn, New York
Chicago Historical Society, Chicago, Illinois
The Cleveland Museum of Art, Cleveland, Ohio
Columbus Museum of Art, Columbus, Ohio
Hirshhorn Museum and Sculpture Garden, Smithsonian Institution,
 Washington, D.C.
The Metropolitan Museum of Art, New York, New York
Minnesota Historical Society, St. Paul, Minnesota
The University of Iowa Museum of Art, Iowa City, Iowa
National Gallery of Art, Washington, D.C.
The Regis Collection, Minneapolis, Minnesota
Robert Indiana, Vinalhaven, Maine
The Toledo Museum of Art, Toledo, Ohio
Washington University Gallery of Art, St. Louis, Missouri
West Point Museum, U.S. Military Academy, West Point, New York
Whitney Museum of American Art, New York, New York

REPRODUCTION CREDITS

Published by
Frederick R. Weisman Art Museum, University of Minnesota,
333 East River Road, Minneapolis, Minnesota 55455

© 1995 Frederick R. Weisman Art Museum. All rights reserved.
ISBN: 1–885116–01–2
Library of Congress Catalogue Card number: 95–060335

Designer: Kristen McDougall, Minneapolis
Editor: Phil Freshman, Minneapolis
Production: Stanton Publication Services, St. Paul
Printing: Friesen Printers, Altona, Manitoba
Distributor: D.A.P./Distributed Art Publishers, Inc.,
636 Broadway, New York, New York, 10021

This catalogue and the exhibition it accompanies are made possible by generous support from the B.J.O. Nordfeldt Fund for American Art.

Cover: Marsden Hartley, *Portrait*, circa 1914–1915 (detail), cat. no. 12.
Front endpaper: *Unser Kaiser und unser Kronprinz in Posen*, 1913. Postcard from Marsden Hartley, postmarked August 30, 1913, to Gertrude Stein, Yale Collection of American Literature, Beinecke Rare Book and Manuscript Library, Yale University. **Back endpaper:** *Parade, Fahnenkompagnie*, 1913. Postcard from Marsden Hartley, postmarked September 5, 1913, to Gertrude Stein, Yale Collection of American Literature, Beinecke Rare Book and Manuscript Library, Yale University.

Printed in Canada

[CONTENTS]

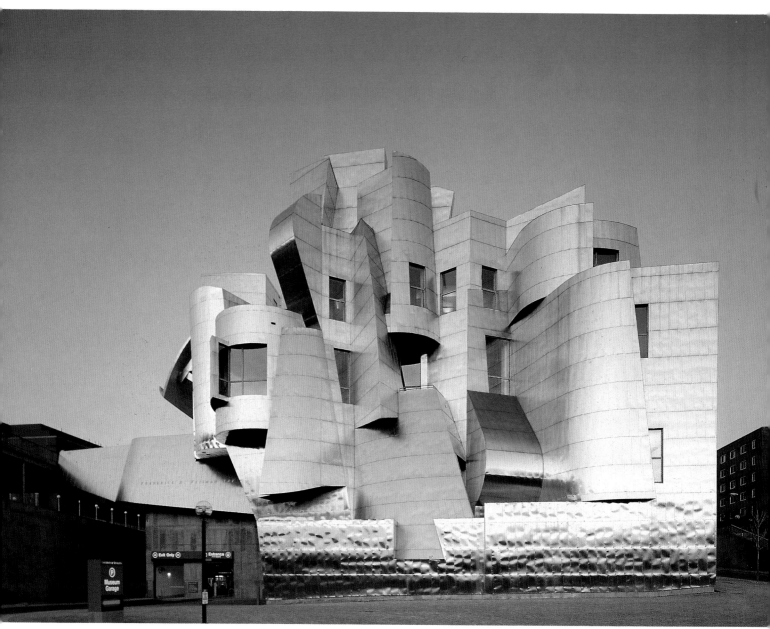

FREDERICK R. WEISMAN ART MUSEUM, UNIVERSITY OF MINNESOTA, MINNEAPOLIS.

[DIRECTOR'S FOREWORD]

The exhibition *Dictated by Life: Marsden Hartley's German Paintings and Robert Indiana's Hartley Elegies* represents a true milestone for the Frederick R. Weisman Art Museum. Founded in 1934 as the Little Gallery, the museum was subsequently known over the next six decades as the University Gallery and the University of Minnesota Art Museum. In 1993 it moved into permanent quarters in a remarkable new building, designed by Frank O. Gehry, and took on its present name. Born in Minneapolis and a resident of Los Angeles until his death in 1994, Frederick R. Weisman was a major collector of twentieth-century art whose generosity was essential in creating the structure that bears his name.

In 1976 the museum received a substantial bequest from its first director, Hudson D. Walker, of the collection of early twentieth-century American art that he had built with his wife, Ione. Among the many significant works included were a large number by the painter Marsden Hartley. Walker, who had been Hartley's patron, dealer, and friend, believed passionately in his importance. After Hartley's death, he tirelessly promoted his art to museums and collectors. Walker's bequest made the museum the largest Hartley repository in the country. Through his gift, he hoped that the museum would serve as a resource for scholars who would recognize what he saw as Hartley's true place in American art history.

In 1984 the museum organized a major Hartley retrospective, made up of works from the collection, that toured nationally. Nonetheless, the space restrictions of our former facility kept the collection from being fully shown or utilized. Finally, with the new building and the present major research exhibition, the museum is able to help fulfill the dream implicit in Hudson Walker's bequest—of making a significant contribution to Hartley

scholarship while also bringing the artist to the attention of a broad audience.

Dictated by Life had its genesis even before construction of the new museum began. Kimberly Mock, a University of Minnesota art department alumna, alerted me to a set of new works by the painter Robert Indiana. She called these his "homage to Marsden Hartley" and suggested that we might be interested in showing them. Since 1978 a resident of Vinalhaven—the small island off the coast of Maine where Hartley spent the summer of 1938—Indiana in 1989 began a series of paintings based on ones Hartley had produced in Germany in 1914 and 1915. Known as the War Motif series, these "abstract portraits" are seen by some scholars as the artist's highest achievement and have established Hartley as a pioneering figure in American modernism. Given the Weisman Art Museum's Hartley holdings, which include one of the War Motif paintings, we quickly came to the idea of mounting an exhibition that would combine the Indiana paintings with the Hartley originals that had inspired them. While Indiana's suite of prints related to his Hartley Elegies has been exhibited—at the Bates College Museum of Art in Lewiston, Maine (Hartley's birthplace)—the paintings themselves have not been shown publicly until now. *Dictated by Life* also brings together works Hartley made in Berlin that have not been exhibited as a group since a 1915 show there and a 1916 show in New York.

Patricia McDonnell wishes to thank the following people, who gave invaluable help at various stages of this lengthy project: Christopher Campbell, Kermit S. Champa, Wanda M. Corn, Charles C. Eldredge, Thomas W. Gaehtgens, Stephen Jones, Nancy Locke, Townsend Ludington, Garnett McCoy, Lori Misura, Herbert Scherer, Gail R. Scott, Robert Silberman, James D. Steakley,

Timothy R. Rodgers, Patricia Willis, and Judith Zilczer.

Michael Plante, as an essayist for this book, earned our respect and thanks through his intelligence and humor. We also would like to extend our gratitude to all of the lenders to the exhibition, who are listed at the front of this book.

Museum colleagues around the country also aided this project. We would like to thank: Kathleen Flynn, Barbara Dayer Gallati, and Guillermo Ovale of the Brooklyn Museum; Walter Keener of the Chicago Historical Society; Delbert Gutridge and William Robinson of the Cleveland Museum of Art; Ray Bouc of the Columbus Museum of Art; Phyllis Rosenzweig and Stephen E. Weil of the Hirshhorn Museum and Sculpture Garden; Alleyne Miller of the Metropolitan Museum of Art; Vicki Gilmer and Myron Kunin of the Regis Collection; Robert F. Phillips and Pat Whitesides of the Toledo Museum of Art; Pamela Curran of the University of Iowa Museum of Art; Pat Dursi and Michael J. McAfee of the West Point Museum; Ellin Burke and Barbi Schecter Spieler of the Whitney Museum of American Art; and Patricia Willis of the Yale Collection of American Literature, Beinecke Rare Book and Manuscript Library.

In the museum, many individuals were part of the project represented by this exhibition and catalogue. Robert Bitzan, Rose Blixt, Karen Duncan, Kathleen Fluegel, Mary Kalish-Johnson, John LeMoine, Colleen Sheehy, and Sara Wilson should be especially recognized for their skillful help at every turn.

Thanks also are due to research assistant Laura Muessig, editor Phil Freshman, designer Kristen McDougall, and publication manager Don Leeper, who kept attentive eyes on every detail involved in this book.

I would like to acknowledge not only the intelligence and dedication of our curator, Patricia McDonnell, in organizing this exhibition and catalogue but also the entire Weisman Art Museum staff for the care they devoted to each aspect of this project.

Finally, I must recognize the generosity of Robert Indiana, who opened his Vinalhaven home to Patricia and me, and who, through his deep connection to Marsden Hartley, gave us fresh insights into both Hartley and himself.

LYNDEL KING

TOP RIGHT: MARSDEN HARTLEY, *PORTRAIT*, CIRCA 1914–1915. OIL ON CANVAS, FREDERICK R. WEISMAN ART MUSEUM, BEQUEST OF HUDSON WALKER FROM THE IONE AND HUDSON WALKER COLLECTION. PLATES, P. 46.

BOTTOM RIGHT: ROBERT INDIANA, *KVF VIII*, 1989–1994. OIL ON CANVAS, COLLECTION OF THE ARTIST. PLATES, P. 96.

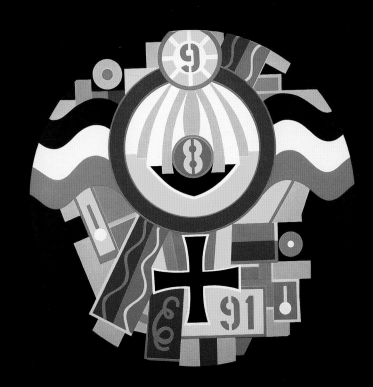

[INTRODUCTION]

PATRICIA MCDONNELL

Dictated by Life: Marsden Hartley's German Paintings and Robert Indiana's Hartley Elegies draws together the work of two major artists from opposite periods of the twentieth century. The exhibition that this book accompanies operates as a kind of prism through which one can take in a long view of American art in our century. Naturally, differences between the work of these two artists abound, but intriguing similarities that reflect a continuum of interests are also present. Viewed together, the two sets of formally and iconographically related paintings, one by the early American modernist Marsden Hartley and the other by the pop artist Robert Indiana, produce a visual and intellectual texture that puts each project in sharper focus.

The exhibition title is taken from a letter Hartley wrote in 1913 in which he explained that "everything I do is attached at once + directly to personal experiences — It is dictated by life itself—."[1] The statement touches the pulse of Hartley's aesthetic enterprise during his years abroad, 1912 to 1915. While he painted abstractions in these years, he maintained that his pictorial experiments depended on the daily traffic of life experiences. The same principle holds for the art of Robert Indiana, especially in his recent homage, the Hartley Elegies. Indiana found inspiration to begin the series in the fact that his and Hartley's identities were both attached strongly to Maine and that Hartley had lived in a house near his on Vinalhaven island. Indiana combines references to his life history with Hartley's in canvases that paraphrase Hartley's German paintings. In works dictated by life experiences both artists strove, among other things, to express their identity as homosexual men. The various ways in which the two divulge that intimate side of themselves, Hartley in his time and Indiana in ours, is one of the focal points of this exhibition and book.

One of the most interesting artists of the early modern period, Hartley (1877–1943) was part of the heady group orbiting Alfred Stieglitz and his New York galleries early in this century. Arthur Dove, John Marin, Georgia O'Keeffe, Paul Strand, and other core artists of the Stieglitz circle were his colleagues. While those affiliations and New York constituted a base of support for Hartley, the city was not his permanent home. He led a peripatetic existence, residing abroad several times and in various places around the country during his life. He first set foot in Europe in 1912. Aged thirty-five and bearing the status of an emerging artist, he longed for the "artist's education" that he felt the Continent offered.[2] Initially, he went to Paris, there joining the international mix of artists, writers, and intellectuals who surrounded the American writer Gertrude Stein. After a year he moved to Berlin, where he stayed for roughly two and a half years.

Hartley was deeply in love with the imperial capital. He left it only in December 1915, when wartime conditions impeded money transfers from the United States and his cash reserve had dwindled. It is not far-fetched to say that Berlin loved Hartley back, because it provided the environment in which he produced some of the most vital and influential paintings of his career. His German paintings take the spectacle of Wilhelmine Berlin, sift it through the artist's experience, and play it back for viewers in the vocabulary of the most progressive painting of the day.

Pre-World War I Berlin was a city of stark contrasts. One of the world's major industrial and cultural centers, it served as a theater for the formation of modernity. But fast-paced, gritty, metropolitan Berlin also was the capital of Germany's Second Reich, hosting the imperial court of Kaiser Wilhelm II. Wilhelm was a con-

servative, arrogant ruler with an immense appetite for pomp and circumstance. Consequently, the elaborate trappings of the court were everywhere visible in this ultramodern city. Hartley benefited from both. In his paintings, images of military parades and majestic imperial guards are set to the jarringly syncopated rhythms of hectic metropolitan life.

With the coming of war, Hartley's art changed — but only by degrees. A cherished friend died in battle on the Western Front, and Hartley's paintings of military paraphernalia now focused on this German officer. Hartley had met Karl von Freyburg, a fair-haired young army lieutenant, in Paris in 1912. It was a visit early the next year to von Freyburg and his cousin, Hartley's friend the sculptor Arnold Rönnebeck, that prompted the artist to move to Berlin three months later. Once relocated, Hartley became immersed in the city's significant gay subculture, a community then unique in its size and force. Many have assumed that Hartley and von Freyburg were lovers because of his paintings memorializing the German's death. Whether the two in fact had such a relationship will likely never be known. What is known is that Hartley grieved terribly over the loss of his friend and incorporated cryptic references to him in evocative tributes such as *Portrait of a German Officer* (p. 29) and *Portrait* (p. 9, cat. 12).

Hartley's War Motif series, the twelve known paintings prompted by von Freyburg's death, are today icons in American art history. Initially, they were lauded for their formal accomplishment, for they represent one of the first fully resolved contributions by an American to the international current of abstraction. In them, Hartley embraces elements from French cubism and German expressionism and marries them to American transcendentalist ideologies. More recently, scholars have been attentive to the ways that these paintings record Hartley's homosexuality. Sexual identity was also expressed, however, in his portrayals of imperial Berlin with its ever-present military in the prewar years. A scandal that unfolded in Berlin a few years before Hartley's arrival, one that captured global attention, disclosed a significant incidence of homosexuality in Germany's military. Therefore, when Hartley — a gay man in Berlin who counted German officers among his friends — began adopting military imagery in 1913 and 1914, he was building coded references to his sexual identity into his work.

Marsden Hartley and the art of the code have been important sources for Robert Indiana (b. 1928). Unlike Hartley, who never achieved the widespread recognition he desired during his lifetime, Indiana was in his early thirties when he found fame and critical recognition. In 1962, when he was thirty-four, his work and that of his closest friends — Ellsworth Kelly, Agnes Martin, James Rosenquist — were already in the collection of the Museum of Modern Art in New York.[3] His recognition came amid the noisy revolution that displaced the then dominant style — abstract expressionism — by the pop artists, an assortment of individuals that included Indiana, Roy Lichtenstein, Claes Oldenburg, James Rosenquist, Andy Warhol, and Tom Wesselmann.

The words *noisy* and *revolution* aptly characterize the emergence of pop because most critics' initial response to this work, which is rooted in the mass-media vernacular, was plainly antagonistic. One critic, Max Kozloff, first termed this cadre of new artists "vulgarians." Another, Irving Sandler, later reflected that pop art initially "disturbed American intellectuals as a whole."[4] Pop art emerged through a series of gallery exhibitions in the first three years of the 1960s. By the fall of 1962, when the Sidney Janis Gallery in New York mounted its exhibition *The New Realists*, the *New York Times* critic Brian O'Doherty announced that "pop art is officially here."[5] Indiana called 1963 "the year of the pop explosion."[6] But absolute certainty about the arrival of pop came in 1964, when the architect Philip Johnson commissioned ten pop artists to create immense murals for the New York State pavilion, which he designed, for the 1964 World's Fair in Flushing Meadows, New York.[7] The murals extended the reach of pop artists well beyond the elite art world to the many thousands of visitors to the fair.

Indiana was an agent of this radical change. He was born Robert Clark in New Castle, Indiana. When he moved to New York City in 1953 after a stint in the U.S. Army and art schooling in Chicago and Maine, he changed his last name to that of his home state. The fresh start in a new place and the hope of making himself anew spurred this rechristening. In New York, he became a resident of Coenties Slip, in an aging maritime district of lower Manhattan. Rent was cheap, and the affordable studio space in older warehouses attracted such artists as Kelly, Martin, Rosenquist, Cy Twombly, and Jack Youngerman.

Indiana's work, from these early years on through the present, weds a hard-edged abstraction with the flashy imagery and terse verbiage of American advertising. He points to the early part of his life and its connection to the American roadways as sources for his work and style. He had a rootless childhood in the Midwest. By the time he was seventeen, he and his family had lived in twenty-one houses. Roadside diners with beckoning monosyllabic signs, such as EAT, and road markers for U.S. routes 29, 37, 40, and 66 haunted his memory. Indiana reshaped these punchy commonplace symbols into his art. This translation of the vernacular into pictorial heraldry is double-edged, however, for Indiana both celebrates this animated, visual language of the streets and critiques its seductive power. Indiana's art is one of signs—about signs, symbolism, and semiotics.

Several primary characteristics of Indiana's work intersect with Hartley's War Motif series and make for a natural connection between the two artists. The hieratic organization of bold design elements—brilliantly colored and tightly woven into a flat, frontal pattern—is an aesthetic both painters share. Indiana also appreciates Hartley's embrace of everyday life, his infusion of the electrified pageantry of imperial Berlin into a reconstituted and radical painting vocabulary. Indiana has been practicing a similar maneuver in his own art for decades. Finally, Indiana understands and admires Hartley's use of superficially neutral pictorial symbols in his German paintings, symbols that both reveal and conceal his identity as a homosexual. This kind of nimble footwork—pointing to and yet dodging an open disclosure of his sexual side—has likewise been a part of Indiana's art from the start.

Hartley became a focus for Indiana with his move to Maine. Hartley was born in Lewiston, Maine, and though he traveled incessantly, he always returned to and is identified with his home state. Indiana had attended the Maine Skowhegan School of Painting and Sculpture on a scholarship in 1953. He began a pattern of summering in Maine in 1969. In 1978 he purchased and moved permanently into a former Odd Fellows hall, the Star of Hope, on Vinalhaven. It is a monstrous Victorian edifice that Indiana considers "Charles Addamsesque."[8] Indiana soon discovered that Hartley had occupied the house near his sculpture studio on Vinalhaven during the summer of 1938. The serendipity set Indiana to work.

Begun in 1989 and completed in 1994, his Hartley Elegies series numbers eighteen paintings.

The Elegies are Indiana's third set of paintings that recast an American artistic landmark. He devoted a series to Charles Demuth's 1928 painting The Figure Five in Gold (p. 78). And he set Joseph Stella's 1920–1922 canvas The Voice of the City of New York Interpreted: The Bridge (p. 77), which Hart Crane celebrated in his famous 1930 poem The Bridge, to the savvy of his pop style (p. 76). Now he has completed the series on Hartley. As Michael Plante demonstrates in his essay for this book, this chain—Demuth, Crane, Hartley—fabricates a genealogy placing Indiana in direct line with significant gay artists of the past who were themselves by turns secretive and open about their sexuality in their work.

Indiana is at his most specific and least guarded in the Hartley Elegies. As always, he writes himself and his personal history into his painting. With the Elegies, this personalizing opens associations between Hartley and von Freyburg to Indiana and his own relationships. The name Ellsworth, for example, seen both in KvF IV (p. 92, cat. 25) and KvF XI (p. 99, cat. 30), alludes to the town in Maine where Hartley died and to Indiana's affectionate involvement with the artist Ellsworth Kelly during his years on Coenties Slip. The initials TvB, which also appear in KvF IV, are a Germanized reference to Indiana's Vinalhaven friend Tad Beck. With the puzzle of such symbols illuminated, the meaning is plain to see. Indiana, like Hartley, identifies himself in his work.

This introduction teases to the surface several links between these two artists and their projects. Both of them respond to their environments and do so through an impulse to personalize. Hartley embraces the chaotic spectacle of prewar Berlin and identifies his place in it through his art. Indiana embraces Hartley, the artist of Maine, in his move to Maine. He injects his work about Hartley with snippets of his own life story. Both men adopt preexisting formal vocabularies—Hartley, French cubism and German expressionism and Indiana, hard-edge abstraction and mass-media graphics. They then rework those vocabularies with skilled sophistication and yield a new and radical aesthetic. Finally, both artists infuse their work with the subject of their sexuality.

The Brazilian educator Paulo Freire argues in The Pedagogy of the Oppressed (1970) that we begin defining who we are with our learning and use of language.

He believes that we start understanding our relation to the dominant culture, and truly taking part in it, once our individual identity has been clearly established. Hartley and Indiana play out this process in the paintings included in this exhibition. In these works, they invent a refined language that articulates who they are. Until very recently, homosexual men and women have been impeded by proscriptive social modes of conduct (as well as by fear of imprisonment) from openly expressing themselves. The weight of such repression has often led homosexual artists and writers to devise coded languages by which to express that side of themselves. Hartley and Indiana are two such artists. Their imagery at once announces the fact of their homosexuality to knowing viewers and veils it from the average passerby. While the homosexual current that runs through both groups of works is important, the final power of these paintings lies in a kind of artistic integrity they possess that resists the critic's scalpel. Their meanings exist on multiple levels, and the viewer's engagement with them can yield a complex set of rewards. The scrutiny offered by this exhibition and book is therefore presented as a contribution to a larger discussion, and not the final word.

NOTES

1 Marsden Hartley to Alfred Stieglitz, August 1913, Yale Collection of American Literature, Beinecke Rare Book and Manuscript Library, Yale University. Hereafter cited as YCAL.

2 Marsden Hartley, "Somehow a Past," unpublished autobiography, n.d., unpaginated, YCAL.

3 For coverage of Indiana's early years in New York City, see Michael Plante's essay in this book.

4 Max Kozloff, "'Pop' Culture, Metaphysical Disgust, and the New Vulgarians," *Art International* 6, no. 2 (March 1962): 34–36; and Irving Sandler, *American Art in the 1960s* (New York: Harper and Row, 1988), 7.

5 Brian O'Doherty, "Art: Avant-Garde Revolt," *New York Times* (October 31, 1962): 41.

6 Robert Indiana, "Autochronology," *Robert Indiana* (Philadelphia: Institute of Contemporary Art, 1968), 54.

7 Helen Harrison, "Art for the Millions, or Art for the Market?," *Remembering the Future: The New York State World's Fair from 1939 to 1964* (New York: Queens Museum and Rizzoli International Publications,1989), 137–165.

8 Quoted in Carl J. Weinhardt, Jr., *Robert Indiana* (New York: Harry N. Abrams, 1990), 208.

EL DORADO

[MARSDEN HARTLEY IN IMPERIAL BERLIN]

PATRICIA MCDONNELL

On November 3, 1914, Marsden Hartley wrote his friend and gallery dealer, Alfred Stieglitz, from Berlin, "I am working out some war motives which people praise highly."[1] From this casual reference arises the title for a group of works that are often regarded as Hartley's highest achievement and now have a distinguished place in the annals of American art history. From roughly October 1914 through November 1915, he produced his War Motif series of paintings, twelve of which are known today. They represent a powerful finale to his three and a half years abroad, much of which he spent in Berlin.

Hartley first ventured to the imperial capital in early 1913 in the company of German friends he had met in Paris. His response to the city's charms was immediate

LEFT: ALFRED STIEGLITZ, *MARSDEN HARTLEY*, 1911. PHOTOGRAPH, YALE
COLLECTION OF AMERICAN LITERATURE, BEINECKE RARE BOOK AND MANUSCRIPT
LIBRARY, YALE UNIVERSITY, GERTRUDE STEIN COLLECTION.

and strong. Once back in Paris, he quickly plotted a return to Berlin, which was for him "without question the finest modern city in Europe."[2] He moved there in April 1913 and stayed until December 1915. Arnold Rönnebeck, a sculptor, and Karl von Freyburg, Rönnebeck's cousin and a lieutenant in the German army, showed Hartley about town and entertained him while he lived there. Von Freyburg died on October 7, 1914, an early casualty of the Great War. Hartley had been deeply attached to him and began the War Motif series to reconcile himself to this loss. Even at the time, Hartley sensed that these paintings were important and explained that they "achieved a nearness to the primal intention of things never before accomplished by me."[3]

Most art historians have agreed with Hartley, for in these canvases he was able to distill the syntax that was imperial Berlin — the spectacle of its vital urban pace, raucous nightlife, and courtly trappings — fuse it, and invent a pictorial language that matched its disjointed frenzy. A familiar motif in the language describing imperial Berlin is its electricity, an apt symbol for a brash modernity at a time when not all sectors of the city had electrical power and lighting. "The nerve and soul of the city was electrified," the German Leonhard Frank reported

about Berlin in the 1910s. "Life was electrified."[4] Hartley found it "packed with that live-wire feeling" and "fairly bursting with organized energy."[5]

The whir of this agitated metropolitan experience greets the viewer of Hartley's German paintings and the works of the War Motif series particularly. Bold primary colors blare noisily from the canvases. Colors are mostly flat and unmodulated, a choice that amplifies the paintings' dizzying, kaleidoscopic quality. Black often serves as a background color and single tonal reference point for this interplay. A tumble of parts—here a recognizable motif, there an abstract shape—move in syncopated rhythm across the painted surface. The airtight knit of motifs and emblems, similar to cubist collage, jams elements together to produce a frontal, two-dimensional effect. Planes of single, bold colors press against each other and the canvas surface. The high drama of this mixture pointedly mimics the gritty exuberance that was metropolitan Berlin during Hartley's stay.

This radical pictorial language is all Hartley's devising. Yet, his language builds on the strengths of other recent art, from which he has selected to forge his contribution to the avant-garde. In the years 1912 to 1915 Hartley moved quickly between New York, Paris, London, and Berlin, feasting on art as he went and teaching himself about his own. The War Motif paintings vividly demonstrate his assimilation of the orphism of Robert Delaunay and the synthetic cubism of Pablo Picasso in France as well as strains of expressionism from Wassily Kandinsky, Franz Marc, and *Die Brücke* artists in Germany.[6]

A panoply of medallions, plumes, helmets, insignia, emblems, flags, and banners is on parade in Hartley's radical canvases. These echo the pageantry of imperial Berlin and record Hartley's steps there. His friendship with von Freyburg, whom Hartley idealized as "a true representative of all that is lovely and splendid in the German soul and character," provides a central fact in Hartley's expression of his homosexuality in these memorial paintings.[7] But he had introduced the subject of homosexuality into his art before the War Motif paintings when he adopted the vestments of the military in Berlin. His move to clothe an expression of his sexual identity in the dress of avant-garde pictorialism and German military regalia successfully disguised this content for all but the initiated few.

Masterful works of art in any discipline are reflections of the gifts and identities of their makers and of the particular social, cultural, and historical conditions in which they are made. An appreciation of Hartley's achievement in the War Motif paintings depends on an understanding of his gifts, identity, and life circumstances in 1914 and 1915. These paintings represent one of the first forays by an American artist into abstraction. Hartley nimbly combined traces of French cubism, German expressionism, and early American modernism to arrive at works that join and yet transcend these sources. The series also shows Hartley confidently advancing the American transcendentalist principles that had occupied him for well over a decade. He had adopted Ralph Waldo Emerson, William James, Gertrude Stein, and Walt Whitman as his artistic models and intellectual mentors, all authors who either founded or were deeply indebted to transcendentalism. Hartley wrestled with their legacy to create on canvas an aggressively modern yet fundamentally transcendentalist idiom. Finally, the works collectively announce Hartley's identity as a homosexual man to the viewer able to decode the references. It is relevant that the modern history of homosexual emancipation began in Berlin, a city that sustained a large and active gay subculture beginning in the late nineteenth century. Hartley participated in this subculture, and many of the paintings he did in Germany reflect his involvement in it. These divergent threads fuse into a seamless whole in the War Motif paintings—each layered upon the other to yield a sophistication greater than a sum of the parts.

Marsden Hartley exhibited his recent work from Germany in the fashionable Haas-Heye Galerie of the Münchener Graphik Verlag in October 1915.[8] While reviews were generally favorable, sales evidently did not materialize.[9] His finances running thin, he needed to return to New York City, where his work had an established market. Alfred Stieglitz quickly arranged an exhibition of Hartley's German paintings, which took place at his 291 gallery in April 1916. Reviews were mixed, and several critics, seeing the "enemy" insignia and emblems that ran through the paintings, hinted that the artist was expressing pro-German sentiment. Hartley may have guessed in advance that these images would meet with criticism. In a brief artist's statement accompanying the show, he wrote:

THE FORMS ARE ONLY THOSE WHICH I HAVE OBSERVED CASUALLY FROM DAY TO DAY. THERE IS NO HIDDEN SYMBOLISM WHATSOEVER IN THEM; THERE IS NO SLIGHT INTENTION OF THAT ANYWHERE. THINGS UNDER OBSERVATION, JUST PICTURES OF ANY DAY, ANY HOUR. I HAVE EXPRESSED ONLY WHAT I HAVE SEEN.[10]

Had Hartley been counseled that these paintings would read as treasonous avowals of support for Germany? Or was he attempting to conceal the language of homosexuality embedded in them? From the time of the 1916 exhibition, critics and scholars focused on the strictly military aspects of the German paintings. More recently, they have paid attention to the subtext of homosexuality in the works.[11] However, an additional interpretation is possible, one suggested by a reading of Hartley's statement as an expression of the transcendentalist inter-

ests that he had been pursuing—and that had helped give him a sharper sense of his artistic goals—in the years just prior to his stay in Berlin.

Hartley's firm embrace of transcendentalism, the early nineteenth-century literary and philosophical movement associated with Bronson Alcott, William Ellery Channing, Ralph Waldo Emerson, Margaret Fuller, Henry David Thoreau, and Walt Whitman, courses through the German paintings.[12] His beginnings as an artist found Hartley reading Emerson's two-part collection, *Essays* (1841, 1844), which he likened to the Bible.[13] He frequently acknowledged his debt to the transcendentalists. His most intense dedication to their complex of ideas took place roughly from 1905 to 1907, when he befriended disciples of Walt Whitman, worked for the summer of 1907 at the

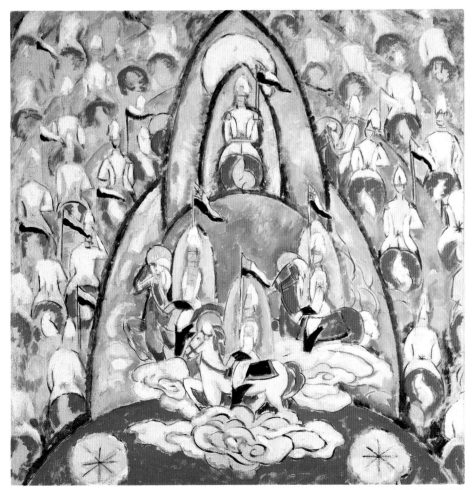

MARSDEN HARTLEY, *THE WARRIORS,* 1913. OIL ON CANVAS, THE REGIS COLLECTION, MINNEAPOLIS, MINNESOTA.

Bahá'í colony Green Acres in Eliot, Maine, and even contemplated a life in the ministry.[14] This early experience shaped Hartley profoundly, and he carried it with him for virtually the whole of his career.[15] "I belong naturally to the Emerson-Thoreau tradition," he wrote in 1933, "and I know that too well. It is my native substance."[16]

Through journals, essays, and poetry, transcendentalists articulated their belief that an ideal spiritual reality exists behind empirical appearances. Emerson once defined transcendentalism as "the feeling of the Infinite" and saw in nature the force of an immanent life spirit, a force he alternately called the Aboriginal Power and the Over-Soul.[17] Perception of this creative force, for Emerson and other transcendentalists, was wholly intuitive and subjective. Yet, this philosophy remained bound to the earth through the corollary belief that the sublime spirit manifests itself through the external forms of nature—a Walden Pond or the Concord woods. To denote the presence of an elemental force, Emerson often capitalized the noun: Nature. He understood the spirit coursing through nature to be infinite, intemporal, radiant, primal, and resolutely spiritual—but, again, a spirit contained within the objects and phenomena of the material, physical world. "Nature" for him was "the symbol for spirit."[18]

Perception of the Over-Soul comes rarely, comes as divine insight, and comes solely through one's subjective unconscious. Emerson described these experiences as rapturous, consuming, even mystical. His most powerful characterization of one such moment appears in his 1836 essay "Nature":

> THERE [IN THE WOODS] I FEEL NOTHING CAN BEFALL ME IN LIFE,—
> . . . STANDING ON THE BARE GROUND,—MY HEAD BATHED BY THE
> BLITHE AIR AND UPLIFTED INTO INFINITE SPACE,—ALL MEAN EGO-
> TISM VANISHES. I BECOME A TRANSPARENT EYEBALL; I AM NOTH-
> ING; I SEE ALL; THE CURRENTS OF THE UNIVERSAL BEING CIRCU-
> LATE THROUGH ME; I AM PART OR PARCEL OF GOD."[19]

One consequence of this emphasis on the subjective side of experience is the raised value given the individual. In transcendentalist thought the individual is seen as supreme. The early historian of transcendentalism, William Henry Channing (William Ellery Channing's nephew and biographer), made this premise clear when he argued that the new school of thought constituted "an assertion of the inalienable integrity of man and of the immanence of divinity in instinct."[20] Since it is the subjective, *felt* experiences that inform any understanding of

reality, all knowledge—about ourselves, the world, and basic existential truth—depends on the individual and his or her unique perceptions. Thus the individual's intuitive and primal experiences supersede any knowledge that can be gained through empirical study or rational, discursive explanation.

This emphasis upon the individual created a severe antagonism toward discursive intellect among transcendentalists and many of their adherents. According to Emerson, "all just persons . . . refuse to explain themselves, . . . [they] communicate without speech, and above speech."[21] Hartley followed suit, adding that "true art cannot explain itself."[22] It is in the inexplicable unconscious that internal and external, spirit and matter, sublime radiance and sensuous touch conjoin.

Hartley's greatest power as an artist lies in the ways he translated an essentially transcendentalist philosophy onto canvas.[23] He updated the tradition while fitting squarely within it. Writing in 1944, the year after Hartley's death, the critic Clement Greenberg saw that he "was preeminently a man of emotion and started from emotion. He succeeded only when his applied aesthetic broke down and his emotion broke through."[24] This primacy given to direct experience, as we shall see, governs his success with the German paintings.

Hartley garnered his first notable attention as an artist for his paintings of the mountains in Maine, done from roughly 1907 to 1909. These works won the enthusiasm of Alfred Stieglitz (1864–1946), the man who pioneered a course for avant-garde artistic expression in the United States in the early years of this century. Through his activities as photographer, publisher, editor, and dealer—in a word, as provocateur—Stieglitz stirred interest in a radical vanguard on American shores. Hartley brought him paintings to see in the spring of 1909. Although Stieglitz had recently turned away another artist, Max Weber, with the claim that the season at his gallery at 291 Fifth Avenue was fully subscribed, he found a way to fit in a Hartley show.[25] With this show, which opened that May, Hartley began breathing the rare air of the Stieglitz coterie and became one of the five core artists—the others were Arthur Dove, John Marin, Georgia O'Keeffe, and Paul Strand—whom Stieglitz promoted, supported, and, when necessary, prodded.

Maine Snowstorm (1908) (p. 19), with its late-impressionist style, is an exemplary work from this period. Hartley expressively depicts the whirling force of a

MARSDEN HARTLEY, *MAINE SNOWSTORM*, 1908. OIL ON CANVAS, FREDERICK R. WEISMAN ART MUSEUM, GIFT OF IONE AND HUDSON WALKER.

mountain storm through a heated passion of accumulated paint strokes. He presents a quintessentially transcendentalist moment, a vision of the world in which time and rational consciousness are momentarily suspended and all is unified by the power of nature. Hartley explained that, in these paintings, he was "rendering the God-spirit in the mountains."[26] Following Emerson's dictum to artists, he aimed less "to recite correctly the order and superposition of the strata [in landscape], than to know why all thought of multitude is lost in a tranquil sea of unity." His inventive stitch stroke underscores this symbolic content. A veritable tapestry of agitated paint-handling and tonal color creates a unifying surface effect, a pictorial form that expresses his belief in a pantheist spirit. Hartley asserted that these early mountain paintings spoke "of [the] supremacy of mighty things — things that . . . are conscious only of the great energy in them over which they have no control."[27]

By 1904 or 1905 at the latest, Hartley had also discovered the writing of Walt Whitman. For that was the time he began associating with a circle of Whitman loyalists led by Horace Traubel, the poet's self-appointed biographer and propagandist.[28] Like others of his generation, Hartley appreciated the ways in which Whitman elaborated upon Emerson's premises. Whitman's metaphorical embrace and celebration of all aspects and objects of contemporary experience, exemplified in the epic poem *Song of Myself* (1855), met Emerson's charge "to convey a larger sense by simpler symbols" and to express "that Unity . . . within which every man's particular being is contained and made one with all other."[29] Whitman's project to communicate the vernacular of American experience and thereby to establish and enrich a distinctly American contribution to world literature followed Emerson's call in his 1837 address "The American Scholar." As Whitman himself acknowledged in 1860, "I was simmering, simmering, simmering; Emerson brought me to a boil."[30]

Beyond the philosophical center shared with Emerson, Whitman's work had two other critical attractions for Hartley. First, Whitman was an iconoclast who forged an unconventional literary style. The slap at orthodox narratives and language inevitably made him outstrip Emerson in importance among progressive American artists at the turn of the century.[31] For them, Whitman's work stood as an inspiring monolith. His second attraction for Hartley was that he was a homosexual

who wove thinly veiled homoeroticism into his verse. Whitman's celebrations of the body put him in the vanguard of a sexual revolution that began in the nineteenth century and has yet to see an end. Decades before D. H. Lawrence, Henry Miller, or even Marcel Proust, he modeled sexual expressiveness in his work. His sense of freedom in such matters won him a significant following abroad, especially in England and Germany and especially among gay readers in those countries who could decipher the homoerotic elements of his work.[32]

Later, during 1912 to 1914, Hartley liked to paraphrase a verse from Whitman's *Leaves of Grass* (1855) — to Arnold Rönnebeck, to Franz Marc, and to Alfred Stieglitz. "'I do not doubt that exteriors have their exteriors — interiors have their interiors — and that the eyesight has another eyesight,'" he wrote Marc, hailing Whitman as "our greatest American poet." Hartley believed that Whitman expressed "the keynote of what real modern art is to be. The seeing into new depths of ourselves — and the universe."[33] And, as he explained elsewhere, this was his project, too.

Hartley's early Maine canvases show that Hartley had internalized American transcendentalist values and used them as grist for his painter's mill before 1912, the year he first set foot in Europe. By the time he arrived there, however, he had lost confidence. From 1910 to 1912 he jumped from style to style, lacking either a focused vision or a direction toward one. This aimlessness shows in the initial still lifes and mystical abstractions he painted in Paris, where he settled initially.

There he fell in with the expatriate crowd that frequented the salon of Gertrude Stein and Alice B. Toklas. His association with Stein (1874–1946) was propitious, for she unwittingly helped him to redirect his work toward major accomplishment. She aided him most by the model of her example but also by her enthusiastic response to his work at a critical moment.

By 1912, Stein had reached a crucial turning point in her own career. She had recently finished *The Making of Americans* (1903–1911, published 1925), a lengthy volume of torrential prose and complex character analyses. Her experiments in this book led her in 1908 to begin producing literary portraits, which she intended to help her "understand the meaning of being" of her subjects.[34] The literary scholar Wendy Steiner traces Stein's theoretical roots for this new genre of portraiture to William James (1842–1911), under whom Stein had studied psychology at

Radcliffe and with whom she remained in contact.[35] James had initiated the study of psychology at Harvard, and his influential book *The Principles of Psychology* (1890) was in circulation a decade before Freud began publishing. Today, however, he is best remembered for his later contributions to philosophy in such books as *The Varieties of Religious Experience* (1902), *Pragmatism* (1907), and *Essays in Radical Empiricism* (1912).

Wendy Steiner proposes that Stein resumed an interest in the typology of character, a subject she first came in contact with through James, when she began her word-portrait experiments. Creating comparative character types enabled Stein to arrive at the "bottom nature," as she called it, of her subjects. *A Long Gay Book*, written from 1909 to 1912, was pivotal to this development. In it Stein's descriptions become decreasingly comparative and increasingly focused on language for its own sake. Conventional description finally dissolves altogether, and a concrete poetry emerges. Steiner explains this evolution:

TO CHARACTERIZE THE DEVELOPMENT OF STEIN'S CONCEPTION OF THE INDIVIDUAL, WE MIGHT SAY THAT IT IS A SHIFT FROM A HIGHLY ELABORATED TYPOLOGIZING IN WHICH CHARACTERISTICS OR REPEATED ACTS—THINKING, LOVING, RESISTING—DEFINE AN INDIVIDUAL BY PLACING HIM IN RELATION TO OTHERS COMPARABLY DEFINED, TO A POSITION IN WHICH CHARACTER IMPLICATES SIMPLY DO NOT FUNCTION. IN THIS LATTER PHASE, ANYTHING THAT FUNCTIONS AS 'EVIDENCE' OF CHARACTER IS DISREGARDED, BECAUSE IT IS MEDIATE. . . . THE IMMEDIATE EXPERIENCE WITHIN THE MOVING SUBJECT IS ALL THAT STEIN IS INTERESTED IN. . . . WHAT WE HAVE NOW, IN EFFECT, IS A PROGRAM FOR A TEXT-OBJECT—A PIECE OF WRITING THAT IS TO HAVE THE VERY DEGREE AND INTENSITY OF MOVEMENT THAT ITS SUBJECT HAS, THAT BECOMES INDEPENDENT AND UNIQUE IN ORDER TO RENDER WITH IMMEDIACY THE INDEPENDENCE AND UNIQUENESS, THE ESSENCE, OF THIS SUBJECT.[36]

Stein's portraits of Picasso and Hartley—both published in *Camera Work*, the journal Stieglitz edited from 1903 to 1917—illustrate this development. The Picasso portrait was written in 1909 soon after Stein had begun experimenting.

THIS ONE WAS ONE WHO WAS WORKING. THIS ONE WAS ONE BEING ONE HAVING SOMETHING BEING COMING OUT OF HIM. THIS ONE WAS ONE GOING ON HAVING SOMETHING COME OUT OF HIM. THIS ONE WAS ONE GOING ON WORKING. THIS ONE WAS ONE WHOM SOME WERE FOLLOWING. THIS ONE WAS ONE WHO WAS WORKING.[37]

This excerpt shows Stein still producing literal description, conveying the salient features she perceived in Picasso's personality. By the time of the Hartley portrait in 1913, however, she was fully engaged in a more evocative kind of writing.

M—N H—
A COOK. A COOK CAN SEE. POINTEDLY IN UNIFORM,
EXERTION IN A MEDIUM. A COOK CAN SEE.
CLARK WHICH IS AWFUL, CLARK WHICH IS SHAMEFUL,
CLARK AND ORDER.
A PIN IS A PLUMP POINT AND PECKING AND COMBINED AND
MORE MUCH MORE IS IN FINE.
RATS IS, RATS IS OAKEN. ROBBER. HEIGHT, AGE, MILES,
PLASTER, PEDAL, MORE ORDER.[38]

Stein has selected words here for their apparent onomatopoeic suggestiveness. Cadence and pace, too, are evocative but hardly descriptive. The text is meant to embody Hartley's "meaning of being," not to specify his qualities.[39] By not presenting an aspect of the man we might recognize and by disrupting her syntax, Stein establishes what she called the "continuous present," a state in which one is caught up in the raw perceptions of the moment.[40] Here, she believed, lay the potential for a true expression of individual essence.

Stein's writing evolved into abstraction, and one might assume that a natural consequence of this would be a disassociation between the subject and the description of it. But she was persistently devoted to conveying a direct, unmediated perception of her given subject's inner core in language that approximated that perception as closely as possible. As she later explained:

I HAD TO FIND OUT INSIDE EVERY ONE WHAT WAS IN THEM THAT WAS INTRINSICALLY EXCITING AND I HAD TO FIND OUT NOT BY WHAT THEY SAID NOT BY WHAT THEY DID NOT BY HOW MUCH OR HOW LITTLE THEY RESEMBLED ANY OTHER ONE BUT I HAD TO FIND IT OUT BY THE INTENSITY OF MOVEMENT THAT THERE WAS INSIDE ANY ONE OF THEM.[41]

This concentration upon insight born of intuitive apprehension of her subjects points again to Stein's reliance on William James' ideas. He asserted that perceptual experience is the "only one primal stuff or material in the world, a stuff of which everything is made."[42] Stein drew upon Jamesian principles when she invested such value in the immediate, preconscious experiences of her subjects.

Stein and Hartley began discussing James' work not long after they met. Hartley later marked the start of their closer, lasting relationship by her loan to him of James' *The* *Varieties of Religious Experience*, a book that, Hartley wrote in 1913, strongly influenced him.[43] This work outlines the central principles of James' larger body of thought—his concepts of a pluralistic universe, pragmatism, and radical empiricism. Through this book and his talks with Stein, then, Hartley became familiar with James' fundamental concepts. In discovering James through her, he also renewed his already deep appreciation of Emerson and Whitman, for Jamesian philosophy advances numerous tenets basic to transcendentalism.

James concurred with Emerson in his general approach to questions regarding existence and our experience of it.[44] Both argued that all knowledge of reality is personal by its very nature, since we experience or come to know the world individually, uniquely. Building upon Emerson's precedent, James argued that individual and intuitive perceptions, and not mental concepts, inform and order our knowledge of reality.

Early in his career, James wrote that "introspective observation is what we have to rely on first and foremost and always."[45] This premise matured and deepened but changed little in James' mind. He expressed the point in *The Varieties of Religious Experience* best when he wrote, "so long as we deal with the cosmic and the general, we deal only with the symbols of reality, but as soon as we deal with private and personal phenomena as such, we deal with realities in the completest sense of the term."[46] Hence, personal experience, for James, was the locus for insight into and knowledge about reality—indeed, the only reliable source.

Both Emerson and James believed further that the nature of reality itself transcends subject-object distinctions. "Experience," James proposed, "has no such inner duplicity. . . . We have every right to speak of it as subjective and objective both at once."[47] Accordingly, material objects fuse with our perceptions of them, and these terms are considered inseparable. James wrote:

THE PAPER SEEN AND THE SEEING OF IT ARE ONLY TWO NAMES FOR ONE INDIVISIBLE FACT. . . . THE PAPER IS IN THE MIND AND THE MIND IS AROUND THE PAPER, BECAUSE THE PAPER AND MIND ARE ONLY TWO NAMES THAT ARE GIVEN LATER TO THE ONE

ALFRED STIEGLITZ, *PORTRAIT OF MARSDEN HARTLEY*, 1915. GELATIN PLATINUM PRINT, FREDERICK R. WEISMAN ART MUSEUM, GIFT OF IONE AND HUDSON WALKER.

TOP RIGHT: *PARADE, FAHNENKOMPAGNIE*, 1913. POSTCARD FROM MARSDEN HARTLEY, POSTMARKED SEPTEMBER 5, 1913, TO GERTRUDE STEIN, YALE COLLECTION OF AMERICAN LITERATURE, BEINECKE RARE BOOK AND MANUSCRIPT LIBRARY, YALE UNIVERSITY.

EXPERIENCE. . . . TO KNOW IMMEDIATELY, THEN, OR INTUITIVELY, IS FOR MENTAL CONTENT AND OBJECT TO BE IDENTICAL.[48]

Our understanding of reality, therefore, while founded upon an unmediated, necessarily individual experience, relies on the seamless relation or rapport between fixed objects and our perception of them. For James, "knowledge of sensible realities thus comes to life inside the tissue of experience. It is *made*."[49]

Hartley's encounter with these concepts proved profoundly liberating. However, it was timing and concurrence that made James' impact on him so important. Timing, because Hartley used the lessons of James' philosophy to redirect his art productively at a moment when he needed very much to do so. Concurrence, because, as noted, the philosopher's ideas resonate with those of Emerson and Whitman, and because Gertrude Stein was also then beneficially appropriating these concepts for her work. Discovering in James and Stein formulas already deeply ingrained in himself, Hartley gained a new confidence. He began understanding what he was about as a painter and where he wanted his work to go. He said as much, acknowledging nine months after his arrival abroad, "this is what my European experience is doing for me, actually creating me."[50]

Stein contributed to Hartley's new self-assurance in yet another way—she enthusiastically enjoyed his art. Through her friendships, colorful parties, and art collecting, she lived at the international nexus of the artistic avant-garde. The ambitious Hartley understood clearly what Stein's interest in him could mean, and he reveled in her flattery.[51] She visited his Paris studio, and his paintings struck a nerve. He bubbled on about her visits in letters to Stieglitz, boasting, "She says I have done in a picture what neither Matisse or Picasso have done—to make every part of a picture life—[.]"[52] Stein later made her own report to Stieglitz. "Hartley has really done it," she assured. "Each canvas is a thing in itself and contained within itself and the accomplishment of it is quite xtraordinarily [sic] complete. . . . He has managed to keep your attention freshened and as you look you keep on being freshened."[53] When Hartley loaned several drawings to Stein, she took down other works to hang them next to a Cézanne, a Manet, and a Renoir in her apartment.[54] Stein paid Hartley the greatest homage, perhaps, by writing the word-portrait of him quoted above.[55] Quite simply, it helped him that she believed him to be "one of the important people."[56]

While Hartley found a renewed confidence and a revitalized sense of his artistic bearings in Stein's Paris, it was in Berlin that he found his place. Arnold Rönnebeck invited him to the German capital. In early January 1913, he traveled there and visited Rönnebeck and von Freyburg. His letters thereafter criticized Paris and the French, only to compliment all things German. Hartley's trip inspired his decision to move to Berlin as soon as he could. He clarified his decision to live there to Stieglitz in this way: "I have learned that what I came for is not to find art but to find myself + this I have done—I want to go somewhere away from the art whirl and produce myself—and in Germany I find the creative condition and it is there that I must go."[57]

Berlin became the imperial capital to the newly federated principalities of Germany upon the country's triumph in the Franco-Prussian War in 1871. As a major metropolis, it rivaled Paris, London, and New York City at the century's end. In 1871, Berlin boasted a population of 826,000 and, by the start of World War I, claimed more than four million inhabitants. It became the cultural mecca for all of Germany and much of Central Europe, a thriving center for progressive architecture, literature, music, theater, and the visual arts. At the same time, it was home to Kaiser Wilhelm II's conservative court and, as such, was a staging area for exercises in imperial pomp and pageantry.

"I like Berlin extremely," wrote the infatuated Hartley.[58] Shortly after moving there, he confided to Stieglitz that he had "every sense of being at home among Germans + I like the life color of Berlin. It has movement and energy and leans always a little over the edge of the future . . . It is essentially the center of modern life in Europe. . . . The military adds so much in the way of a sense of perpetual gaiety here in Berlin. It gives the stranger like myself the feeling that some great festival is being celebrated always."[59] To Stein he wrote, "There is an interesting source of material here—numbers + shapes + colors that make one wonder—and admire—It is essentially mural this German way of living—big lines and large masses—always a sense of pageantry of living. I like it—[.]"[60]

That "pageantry of living" soon became the subject of Hartley's painting. Yet, the work he did in Berlin from 1913 through 1915 grew out of crucial experiments he had begun in Paris in 1912. There he had produced first a series of still lifes and then a group of abstract

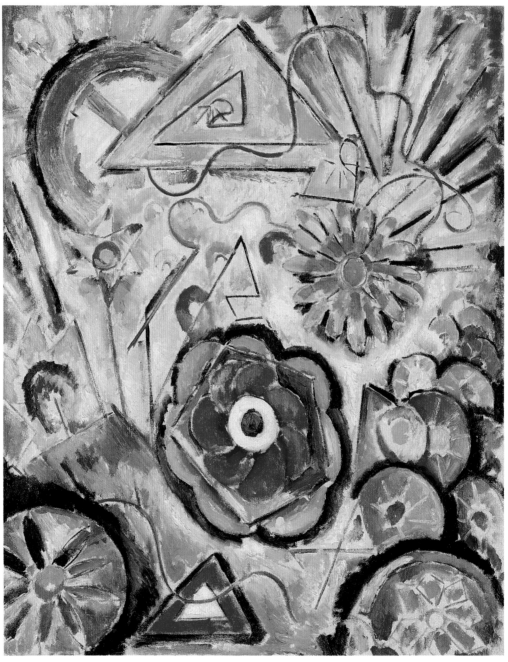

MARSDEN HARTLEY, *ABSTRACTION WITH FLOWERS*, 1913. OIL ON CANVAS, FREDERICK R. WEISMAN ART MUSEUM, BEQUEST OF HUDSON WALKER FROM THE IONE AND HUDSON WALKER COLLECTION.

compositions that he intended as evocative "portraits of moments."[61] These works comprised an initial attempt to sort through and incorporate ideas he had gained from James' *The Varieties of Religious Experience* as well as Richard Bucke's *Cosmic Consciousness* (1901) and other writings on mystical subjects. He worked to allow his pre-conscious self a greater role in the making of the painting and called his process a "style of automatic writing."[62]

In part, Hartley responded to James in his new interest in the preconscious state. In *The Varieties of Religious Experience*, James argued, "mystical experiences are as direct perceptions of fact for those who have them as any sensations ever were for us." He added, "it is that our normal waking consciousness, rational consciousness we call it, is but one special type of consciousness, whilst all about it, parted from it by the filmiest of screens, there lie potential forms of consciousness entirely different. . . . *No account of the universe in its totality can be final which leaves these other forms of consciousness quite disregarded.*"[63] So, as Hartley investigated other forms of consciousness, William James was his guide.[64]

Abstraction with Flowers (1913) (p. 24) is one of Hartley's first attempts in Europe both to devise a radical pictorial vocabulary and to create work that derived, to a far greater extent than his earlier painting had, from his subjective self. It is one of the works he produced by "writing automatically," that is, through a process of relinquishing rational concentration in favor of intuitive urges. "I do not think first but after," he explained, "allowing the spirit to do its own dictating . . . the particular sphere I live in when I work has a language of its own."[65]

Hartley seized this excited interest in the inner, intuitive self out of his discovery of James, his contact with Stein, and the confluence of their ideas with American transcendentalism. In a direct paraphrase of James, he explained to Stieglitz the new goals for his art. "There are sensations in the human consciousness beyond reason," he wrote, "and painters are learning to trust these sensations and make them authentic on canvas. [T]his is what I am working for."[66] Hartley made specific this connection between his hopes for his newest work and Stein's example when he wrote her from Berlin: "I have always liked very much all I have read of yours because it always had for me . . . a going into new places of consciousness—which is what I want to do also—to express a fresh consciousness of what I see + feel around me—taken directly out of life."[67]

Take from life he did. *Abstraction with Flowers* and other related paintings of 1912 and 1913 represent an extreme in Hartley's career.[68] Never before or again would the artist stray so far from the palpable world. Once in Berlin, he turned from such abstraction. Hartley rejoiced in the events and scenes about him, scenes "directly out of life," and recorded them through the lens of his own experiences and in an original pictorial language. Hartley declared his belief in the coupling of subjective and objective to Franz Marc, saying, "I have only this contact with life itself—. . . No matter where my perceptions wander I wish my feet to walk on the earth—having no vision except of earth elements."[69]

Portrait of Berlin (1913) (below), a painting from early in Hartley's stay, demonstrates his heightened concern for "earth elements." The structural arrangement of the work steps only a few degrees away from that of *Abstraction with Flowers*. A grid of motifs and symbols spreading in pulsing rhythms across the picture surface remains. However, boldly colored soldiers on horseback, plumed helmets, the numeral 8, and triangles now replace the pastel lines, flowers, and stars. The gusto of life in the Prussian capital has displaced mystical visions.

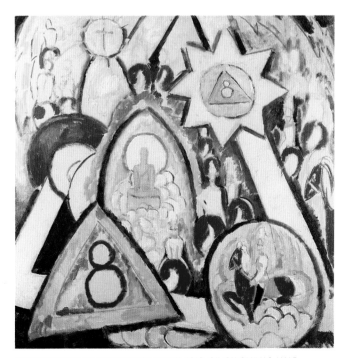

MARSDEN HARTLEY, *PORTRAIT OF BERLIN*, 1913. OIL ON CANVAS, YALE COLLECTION OF AMERICAN LITERATURE, BEINECKE RARE BOOK AND MANUSCRIPT LIBRARY, YALE UNIVERSITY.

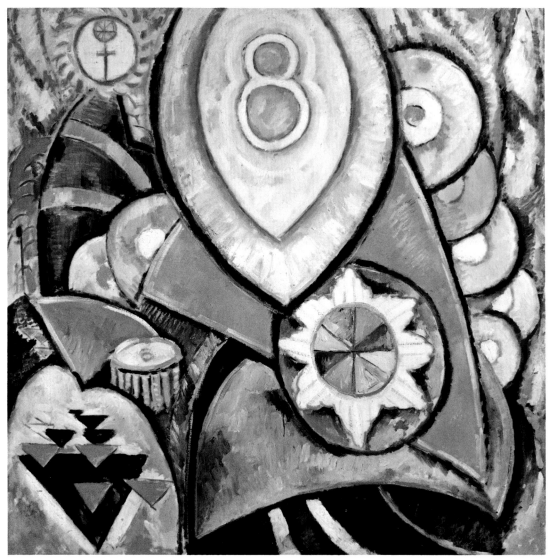

MARSDEN HARTLEY, *PAINTING NO. 48*, 1913. OIL ON CANVAS, THE BROOKLYN MUSEUM, DICK S. RAMSAY FUND.

At first glance, some of this new imagery seems not so new. But the stars, triangles, and numbers that Hartley adopted in 1913 are not remote inventions of automatic writing. He observed them in his wanderings about Berlin. He noticed, for example, that the eight-pointed star appeared everywhere—on the Kaiser's lapel, on breast pockets and foreheads, on tablecloths and sidewalks. Even Frederick the Great, Hartley wrote to Stein, is depicted with the same star over his heart. To Stieglitz, he reported that he had finished a canvas that was a "presentation of the number 8 as I get it from everywhere in Berlin."[70] Possibly he was referring to *Painting No. 48* (1913) (p. 26, cat. 11), a work with a large 8 at its center.[71] The numeral 4 also intrigued him. It was his house number, and he was impelled to "learn what 4 means."[72]

One constant of life in Wilhelmine Berlin, an aspect that greatly impressed Hartley and entered his art, was the spectacle of the imperial court. Kaiser Wilhelm and members of his court perpetually shuttled about the city and between his residences in Berlin and nearby Potsdam, accompanied at all times by a phalanx of the imperial guard. Hartley likened this display to the circus and admitted that his fondness for the nobility's regalia stemmed from his early love of Barnum and Bailey. He felt there was "a sense of magic in seeing royalty pass."[73] He sent numerous postcards to friends rhapsodizing about the "Kaiser regime" and its "crowd parade pageantry public glamour—and the like."[74] (p. 22 and endpapers) In his autobiography, he recalled his enthusiasm for,

THOSE HUGE CUIRASSIERS OF THE KAISER'S SPECIAL GUARD—ALL IN WHITE—THE WHITE LEATHER BREECHES SKIN TIGHT—HIGH PLAIN ENAMEL BOOTS—THOSE GLEAMING BLINDING MEDIEVAL BREAST PLATES OF SILVER AND BRASS—. . .—INSPIRING HELMETS WITH THE IMPERIAL EAGLE—AND THE WHITE MANES HANGING DOWN—THERE WAS SIX FOOT OF YOUTH UNDER ALL THIS GARNITURE—. . . THAT IS HOW I GOT IT—AND IT WENT INTO AN ABSTRACT PICTURE OF SOLDIERS RIDING INTO THE SUN—[.][75]

The Warriors (1913) (p. 17, cat. 14) may very well be the painting Hartley describes. In this painting and others that foreground the conspicuous military presence in Berlin, he records the public and the private. The public, because the daily spectacle of military processions and maneuvers around the city enraptured him. The private, because he had personal connections to men serving in the army. This representation of military imagery is a piece of the code that connects Hartley to the homosexual subculture in which he took part.

In a statement he wrote for a 1914 exhibition at Stieglitz's gallery, Hartley made the point that, however abstract and disjointed his pictorial syntax, the new Berlin paintings were not ethereal musings. Instead, they depicted things seen. He explained,

A PICTURE IS BUT A GIVEN SPACE WHERE THINGS OF MOMENT WHICH HAPPEN TO THE PAINTER OCCUR. . . . IT IS ESSENTIAL THAT THEY OCCUR TO HIM DIRECTLY FROM HIS EXPERIENCE. . . . A REAL VISIONARY BELIEVES WHAT HE SEES. THE PRESENT EXHIBITION IS THE WORK OF ONE WHO SEES—WHO BELIEVES IN WHAT IS SEEN—AND TO WHOM EVERY PICTURE IS AS A PORTRAIT OF THAT SOMETHING SEEN.[76]

These lines underscore the fact that he was pursuing subjectivity and objectivity with equal vigor. He describes himself as a visionary—elsewhere, he declares that his essential nature is mystical. At the same time, however, he stresses the value he gives to what is palpably before one's eyes and available to touch. *Seeing*, then, is his catchword for the ability to discern intuitively an ineffable essence in the swirl of activity that was pre-war Berlin. Hartley's paintings record the dynamic of

LEFT: MARSDEN HARTLEY, *MILITARY SYMBOLS 1*, CIRCA 1913–1914. CHARCOAL ON PAPER, THE METROPOLITAN MUSEUM OF ART, ROGERS FUND, 1962.

RIGHT: MARSDEN HARTLEY, *MILITARY SYMBOLS 2*, CIRCA 1913–1914. CHARCOAL ON PAPER, THE METROPOLITAN MUSEUM OF ART, ROGERS FUND, 1962.

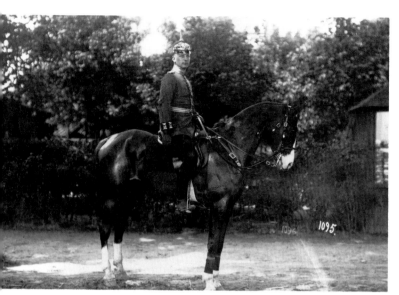

OTTO STREICH, *PRUSSIAN OFFICER*, 1913. PHOTOGRAPH, YALE COLLECTION OF AMERICAN LITERATURE, BEINECKE RARE BOOK AND MANUSCRIPT LIBRARY, YALE UNIVERSITY.

phenomenal experience — *that* is his subject matter — distilled through his own perceptions and language. In keeping with the transcendentalist ethos, he relies on his singular, internal sensitivities to perceive, identify, and communicate expressively that which he witnesses in the traffic of common experience. His pictorial vocabulary for such expression was necessarily radical, for he intended to establish himself as a peer to Gertrude Stein and others in the avant-garde he admired.

While Hartley was extraordinarily productive in Berlin, bouts of an inability to paint did strike him occasionally. One such phase came with the outbreak of World War I in August 1914. Then, on October 7, 1914, Karl von Freyburg died on the Western Front. Within several weeks, however, Hartley returned to the easel and began work on the War Motif series. In a letter to the American collector Duncan Phillips after Hartley's death, Arnold Rönnebeck gave his interpretation of the iconography of imagery in these paintings. The numbers, patterns, and symbols generally have referents, Rönnebeck wrote. For example, "K.v.F." stands for Karl von Freyburg. The numeral 4 alludes to the fact that, according to Rönnebeck, von Freyburg served in the fourth regiment of the Kaiser's guard. He added that the checkerboard pattern reflects von Freyburg's love of chess. The Iron Cross was awarded Rönnebeck and von Freyburg, a fact that encouraged Rönnebeck to claim that he, too, was being symbolically depicted.[77]

Little concrete information exists regarding the nature of Hartley's relationship to von Freyburg. Hartley scarcely mentions him in letters before his friend's death in battle. Afterward, he became very focused on von Freyburg, calling him "one of the dearest friends I ever had."[78] Six letters from von Freyburg to Hartley survive, but they are not particularly illuminating.[79]

A cache of photographs belonging to Hartley recently came to light that includes a photograph taken by a Berlin firm of a uniformed German on horseback (left).[80] In all likelihood, the image is that of von Freyburg. In his letter to Duncan Phillips, Rönnebeck wrote that von Freyburg "was shot from his horse," suggesting that he was in a cavalry regiment.[81] However, there is insufficient detail in the uniform to identify the regiment of the man in the picture. A letter von Freyburg wrote in 1913 discusses a photograph of himself "in parade-dress" that he had enclosed with the letter, and this evidence suggests that the photograph is of Hartley's German friend and was separated from the original letter.

Works such as *Portrait of a German Officer* (1914) (p. 29) and *Painting No. 47, Berlin* (1914–1915) (p. 29, cat. 10) directly commemorate von Freyburg's death, because the references to him are abundant. Even the axial composition of *Painting No. 47, Berlin*, for example, imparts a figural resonance and connotes a human presence. On a broader level, these early paintings in the series bespeak the tragedy of lost youth and heroic death, a tragedy mourned and articulated by many artists and writers of the war era.

Yet, personal loss and wartime tragedy constitute but one level of meaning in the complicated symbolism of these paintings. Hartley's own statements about this work at the time suggest that he intended them to be seen as much more than simple autobiography. While the paint was still wet, he expressed the belief that his new work was "a direct continuance of what I had on a bigger + simpler scale."[82] He explained that he was "no longer that terror stricken thing with a surfeit of imaginative experience undigested — I am contented with what I feel[,] see + hear + a real clarity of light pervades."[83]

As Hartley continued with the War Motif series, the autobiographical references diminished, opening ground for other readings of the artist's content. The agitated mix of motifs clustered at the center of *Portrait* (circa 1914–1915) (p. 9, cat. 12), for example, gives way to a hieratic matrix of elements spread evenly across the expanse

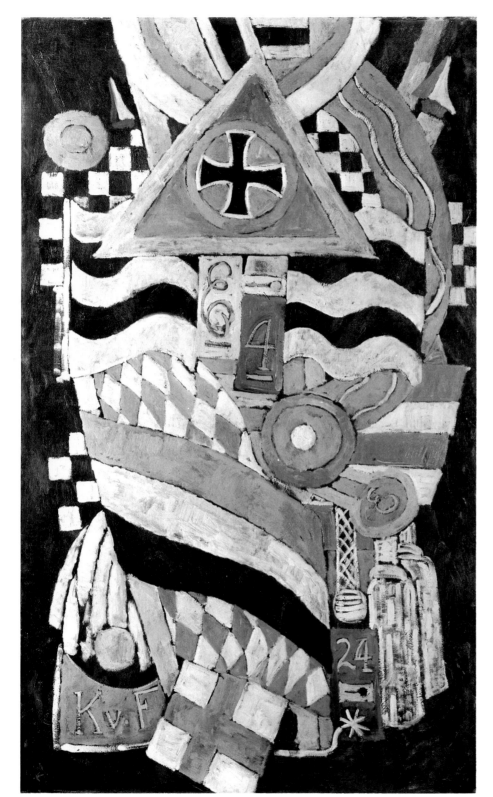

MARSDEN HARTLEY, *PORTRAIT OF A GERMAN OFFICER*, 1914. OIL ON CANVAS, THE METROPOLITAN MUSEUM OF ART, THE ALFRED STIEGLITZ COLLECTION, 1949. PLATES, P. 44.

RIGHT: MARSDEN HARTLEY, *PAINTING NO. 47, BERLIN*, 1914–1915. OIL ON CANVAS, HIRSHHORN MUSEUM AND SCULPTURE GARDEN, SMITHSONIAN INSTITUTION, GIFT OF JOSEPH H. HIRSHHORN, 1972. PLATES, P. 45.

MARSDEN HARTLEY, *MILITARY*, 1913. OIL ON CANVAS, WADSWORTH ATHENEUM, HARTFORD, THE ELLA GALLUP SUMNER AND MARY CATLIN SUMNER COLLECTION FUND.

TOP LEFT: MARSDEN HARTLEY, *MILITARY*, 1914–1915. OIL ON CANVAS, THE CLEVELAND MUSEUM OF ART, GIFT OF NELSON GOODMAN. PLATES, P. 55.

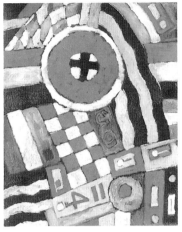 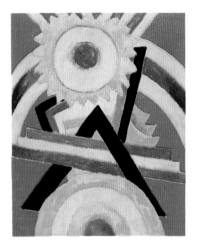 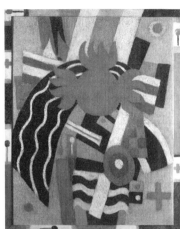

LEFT: MARSDEN HARTLEY, *BERLIN ABSTRACTION*, 1914–1915. OIL ON CANVAS, COLLECTION OF THE CORCORAN GALLERY OF ART, MUSEUM PURCHASE, GALLERY FUND. PLATES, P. 52.

CENTER: MARSDEN HARTLEY, *PRE-WAR PAGEANT*, 1914. OIL ON CANVAS, COLUMBUS MUSEUM OF ART, GIFT OF FERDINAND HOWALD.

RIGHT: MARSDEN HARTLEY, *THE AERO*, CIRCA 1914. CANVAS WITH PAINTED FRAME, NATIONAL GALLERY OF ART, WASHINGTON, ANDREW W. MELLON FUND.

of the picture plane in *Military* (1914–1915) (p. 30, cat. 5). The sense of a central figural presence evaporates. Further, the numbers and signs that covertly identified Karl von Freyburg have disappeared. *Painting No. 46* (p. 51, cat. 9), *Berlin Abstraction* (above) (both 1914–1915), and *Military*, later paintings in the series, contain few if any encoded signs. Seen in sequence, these three works also demonstrate the way Hartley inserted an increasing order to his arrangements and evened the decorative stress across the whole of the painting surface.

A comparison of *Military* from 1913 (p. 30) and *Military* from 1914–1915 (p. 30, cat. 5) further clarifies what Hartley meant by "a direct continuance of what I had." The jumbled assembly of emblems, the strong forms and bold colors, and the reliance on martial paraphernalia persist throughout his German work. So, too, does his fundamental philosophical approach. In 1913 as in 1915, Hartley struggled to produce images that indexed his experience of the world around him. With the advent of war, the military iconography assumes different connotations. While martial processions in Berlin no longer constituted chance comings-and-goings of the court, Hartley continued to rely on this imagery, because it still conditioned his experience in the city.

He made use of portraiture, as concept and artistic genre, to clarify how his paintings recorded his experiences. In this he clearly drew from Stein and her experiments, but many other avant-garde artists at the time, notably Andrew Dasburg and Charles Demuth, also mined this genre.[84] For several of the works from 1913 to 1915, Hartley used the word *portrait* in his titles — *Portrait of Berlin*, *Portrait Arrangement*, and *Portrait of a German Officer*, for example. In his autobiography, he described his work of the period as "portraits of moments." In conjunction with his 1915 exhibition in Berlin, he said of his work:

PICTURES THAT I EXHIBIT ARE WITHOUT TITLES AND WITHOUT DESCRIPTIONS. THEY DESCRIBE THEMSELVES. THEY ARE CHARACTERIZATIONS OF THE 'MOMENT,' EVERYDAY PICTURES OF EVERY DAY, EVERY HOUR.[85]

"Portraits of moments," "characterizations of the 'Moment,'" "a portrait of that something seen" — these are a few of the phrases Hartley devised to express the fundamental premises of his art. In it, he attempted a fusion of the internal and the external. He relied not only on his personal experience and subjective self but also on phenomenal, empirical reality. True to his transcendentalist heritage, he made it his artistic goal to bridge the chasm created by Western dualism and unite ineffable spirit and

tangible, observable form. Thus when he argued in 1916 as he displayed his German paintings in New York that "I have expressed only what I have seen," it was important to know the background for his statement to catch his meaning. *Seeing* itself, as noted, had special connotations for Hartley. His aim while in Berlin in the early 1910s, as he explained to Gertrude Stein, was to "express a fresh consciousness of what I see and feel around me" and thereby to exhibit "a vividly revealing aspect of enlarging experience."[86] This aim conditioned all of Hartley's paintings from Berlin. It is a defining, though little discussed, aspect of his War Motif series.

Hartley's German paintings resist single readings. They are sited in time and place, in theory and style at an important crossroad. The ways that the paintings speak of his homosexuality constitute another critical layer of meaning, one that builds upon their significance in the history of American art. In fact, Hartley's homosexuality was first openly acknowledged by the art historian Barbara Haskell in her monograph accompanying the artist's retrospective at the Whitney Museum of American Art in 1980. While the date of this public recognition may at first seem tardy, public mention of an individual's homosexuality in any field occurred rarely before the advent of the gay rights movement in the late 1960s and early 1970s. Up to that time it carried a social stain, and in many places, open acknowledgment of one's homosexuality brought the fear of criminal prosecution. The Berlin Hartley knew early in this century, however, was singularly tolerant of gay life. It was there that the formation of gay culture and emancipation *began*. From the middle of the nineteenth century, several respected Berlin-based scientists and psychologists worked toward clinical explanations for homosexuality, hoping through their efforts to encourage acceptance. The first organizations in the world to study the subject and support acceptance of homosexuals were formed in Berlin. And it was there, late in the nineteenth century, that the first attempts to decriminalize homosexuality were made. By the time of Hartley's first visit in 1913, the city's gay milieu was strong enough to make him feel at ease there. Shortly after settling there, he reported that he had "every sense of being at home among the Germans."[87] Hartley had finally found an essential side of himself reflected in a vibrant and validating subculture. It is vital to know something about the history of homosexuality in Germany generally, and Berlin specifically, in order to understand Hartley's German paintings. For in them, along with the other conditions of life already discussed, Hartley both recorded aspects of the city's gay sphere and expressed his sexual feelings.

Among the earliest advocates of a greater understanding of homosexuality was Karl Heinrich Ulrichs (1825–1895). He published a series of books in the mid- and late nineteenth century offering a new vocabulary for and scientific understanding of same-sex love. He was the first scientist anywhere to argue that "homosexuals do not choose their orientation or fall into it as a form of vice."[88] An *urning* (in English, uranian) loved in accordance with natural instincts because he combined a man's body with the sexuality and psyche of a woman.[89]

Carl von Westphal (1833–1890) published the first psychiatric study of homosexuality in 1869, and Richard von Krafft-Ebing (1840–1902) classified homosexuality in his broad 1886 study of sexual deviance, *Psychopathia sexualis*. At the very least, these publications had the effect of raising awareness about homosexuality. Only with the sweeping industrialization of the nineteenth century and consequent growth of urban centers did homosexuals associate in appreciable numbers, enabling a cultural identity to be forged. Acknowledging urban gay communities, both authors encouraged a repeal of Paragraph 175, the German law that made the practice of what Westphal termed "contrary sexual feeling" (*konträre Sexualempfindung*) a criminal offense.[90]

In 1897 the physician and early sexologist Magnus Hirschfeld (1868–1935) founded the Scientific-Humanitarian Committee (Wissenschaftlich-Humanitäres Komitee) to educate the public about homosexuality and promote the abolition of Paragraph 175.[91] Like Westphal and Krafft-Ebing, he pushed for a scientific explanation of homosexual behavior and understood homosexuality to be congenital.[92] One of the committee's initial efforts was to circulate a petition in 1897 calling for the repeal of Paragraph 175. In that year, 900 signatures were obtained. By 1914 thousands of signatures had been amassed, including those of Martin Buber, George Grosz, Gerhart Hauptmann, Herman Hesse, Karl Jaspers, Thomas and Heinrich Mann, Rainer Maria Rilke, Arthur Schnitzler, and Stefan Zweig.[93] Hirschfeld's committee also published a journal, the *Annual Report on Sexual*

Intermediates (*Jahrbuch für sexuelle Zwischenstufen*), from 1899 through 1923. In 1919 Hirschfeld established the Institute of Sexual Science (Institut für Sexualwissenschaft), which became the first clinic anywhere to provide sexual counseling. It also distributed financial aid to homosexual victims of blackmail, which, not surprisingly, occurred often at a time when same-sex relations were illegal.[94]

The efforts of Hirschfeld and others before him provided a way to see homosexuality through the lens of medical science. This new approach and medical definition, however contrary to the understanding many people have today for the construction of sexual preference and gender identity, gave homosexuals in turn-of-the-century Germany a way to understand their difference, to come to terms with it, to ask for the abolition of punishment for their difference, and slowly to reveal that part of themselves in public.[95] As the historian Michael Bronski maintains, "before the nineteenth century, there were homosexual acts, but no homosexuals."[96]

Adolf Brand's Community of Self-Owners (Gemeinschaft der Eigenen), a second early homosexual organization in Berlin, coalesced to foster and cater to this forming identity. *The Self-Owner* (*Der Eigene*), published from 1896 to 1931, was the world's first homosexual journal. At its peak, it boasted a circulation of 1,500.[97] Brand (1874–1945) was an anarchist and activist, strong-willed and impetuous. He was often at ideological odds with Hirschfeld. Hirschfeld's biological explanations were anathema to Brand, who sought a culturally based definition for homosexuality. On the whole, Brand's activities promoted the importance of homoerotic culture and tradition.

Both Hirschfeld's and Brand's organizations operated within the context of a sizable gay population in Berlin. In a 1914 publication, Hirschfeld revealed that he had been given a list of twenty to thirty thousand homosexuals known to the police by the commander of the Berlin police division handling homosexual matters in 1900.[98] In his 1914 study *Prostitution in Europe*, Abraham Flexner devoted a chapter to Berlin and characterized the city as "the main mart" for homosexual prostitution. He estimated the total number of gay men to be "some 30,000," adding that "forty resorts [bars] are tolerated by Berlin police."[99] Presumably, these counts were low, because they would have included only the openly and identifiably gay population and not those who were more circumspect in their activities.

This strong subculture of homosexuals in Germany, and Berlin in particular, in the fin-de-siècle was unique. It was the size and significance of this subculture that gave rise to these early efforts to lessen the repression homosexual men and women then experienced. The scholar Harry Oosterhuis argues rightly that "before the Second World War, homosexual emancipation was largely a German phenomenon."[100] In fact, when in 1896 the British authors Havelock Ellis and John Addington Symonds finished their landmark *Sexual Inversion*, the first part in the three-volume *Studies in the Psychology of Sex*, they were able to find a publisher in Germany but not in England.[101] Even the French saw homosexuality as the German vice, *"le vice allemande."*[102]

No historical sketch of gay Berlin in the early twentieth century is complete without a review of a scandal that raged in Germany, and reverberated far beyond its borders, for two years. Known as the Eulenburg Affair, it drove the link between homosexuality and Germany into the national and international consciousness. The scandal also broadcast to the world the fact that homosexuality was common in the German military. The resonances of the affair were deep enough to remain potent in the traffic and cultural lore of Berlin through the post-World War I years of the Weimar Republic. While Marsden Hartley might not have had a detailed knowledge of this scandal—indeed, there is no record of how deeply he was aware of it—he could not have escaped its legacy, which, the historian James Steakley argues convincingly, "contributed to the making of modern homosexuals."[103]

Philipp Prince zu Eulenburg-Hertefeld (1847–1921), a Prussian noble from the Mark Brandenburg territory just outside Berlin, gave the scandal its name. The journalist Maximilian Harden publicly named Eulenburg and Kuno Count von Moltke (1847–1923), since 1905 the military commandant of Berlin, as homosexuals in 1907. A series of trials ensued that resembled a comedy of errors and extended until 1909. The scandal garnered international press coverage in large part because the two men were close friends of the German Kaiser.

Eulenburg and Wilhelm II (1859–1941) met in 1886, two years before the Kaiser's ascension to the throne. They became fast friends, and in 1889, Wilhelm described Eulenburg as his "bosom friend—the only one I have."[104] Wilhelm joined the fall hunts at Liebenberg, Eulenburg's estate, and became a part of his social circle. The Liebenbergers were all noble, all roughly the same age,

LEE SIMONSON, *MARSDEN ADOPTS GERMANY*, 1913. WATERCOLOR ON PAPER, YALE COLLECTION OF AMERICAN LITERATURE, BEINECKE RARE BOOK AND MANUSCRIPT LIBRARY, YALE UNIVERSITY.

all artistically inclined, and all male. Another important bond among them was their homosexuality. According to the historian Isabel Hull, "they were a group of conservative nobles, many of them more attracted to men than to women, all of them more attracted to art than to 'duty,' talented, ambitious, and more than a little smug, who chose to interpret their [sexual] variance as cultural elitism."[105] Wilhelm appreciated their cultured intelligence, arrogance, esprit, and homoerotic ways.[106] Most historians now believe that Kaiser Wilhelm was himself bisexual and "went through life neither realizing or accepting [the extent of] his own homosexuality."[107]

Wilhelm was also terribly arrogant.[108] This was a man who refused to admit that he had 'just a little cold,' because so assured was his greatness that he was capable only of a great cold.[109] "All of you know nothing," he once barked at his admirals. "I alone know something, I alone decide."[110] He was further capable of an unseemly lording over other royalty. The king of Italy, a small man, once visited Wilhelm's yacht. As he readied to come aboard, Wilhelm called out before a German-speaking Italian officer, "Now watch how the little dwarf climbs up the gangway."[111] In 1905 he pinched the seat of the duke of Saxe-Coburg-Gotha. Five years later, he slapped King Ferdinand of Bulgaria firmly on the behind in public, and then refused to apologize. With these gestures calculated to embarrass, he was likely displaying his awareness that both the duke and the king were homosexuals.[112]

Eulenburg and other members of the Liebenberg circle were able to manage Wilhelm's mercurial behavior tactfully. They played to his interests, one of which was a "love of uniforms, of jewelry, of dressing-up, and of childish games played in all-male company."[113] Magic shows, vulgar farces, and silhouette-dramas were a regular part of Liebenberg after-dinner festivities. One of the Liebenbergers, Georg von Hülsen, wrote about plans for entertainment at the then upcoming 1892 Liebenberg hunt.

LIKE ATHENA FROM JUPITER'S HEAD, AN IDEA SPRINGS OUT OF MINE. YOU MUST BE PARADED BY ME AS A CIRCUS POODLE!— THAT WILL BE A 'HIT' LIKE NOTHING ELSE. JUST THINK: BEHIND SHAVED (TIGHTS), IN FRONT LONG BANGS OUT OF BLACK OR WHITE WOOL, AT THE BACK UNDER A GENUINE POODLE TAIL A MARKED RECTAL OPENING AND, WHEN YOU 'BEG,' IN FRONT A FIG LEAF. JUST THINK HOW WONDERFUL WHEN YOU BARK, HOWL TO MUSIC, SHOOT OFF A PISTOL OR DO OTHER TRICKS. IT IS SIMPLY SPLENDID!! . . . IN MY MIND'S EYE I CAN ALREADY SEE H.M. LAUGHING WITH US.[114]

Kuno Count von Moltke, the second figure in the Eulenburg Affair, was nicknamed "Tütü" by the Liebenbergers. Did the insider's name derive from Moltke's spoof performances in ballet attire? The journalist Harden gave him the epithet "Sweets," a reference both to Moltke's known yen for chocolates and to his sexual orientation. "Sweet" was then slang for homosexual. Eulenburg was called "Phili" and "Philine," even "her" in one letter.[115] And, to all Liebenbergers, the Kaiser was known as "the Darling."

Harden's motivation in exposing Eulenburg and Moltke was political.[116] His political and personal connections ran deep enough in Germany to gather the most incriminating secrets, which he used to pursue his own agenda for his country. He disagreed with the kind of *Personalpolitik* or personal rule that Eulenburg, as the Kaiser's closest confidante, had helped to establish. In the several decades before Wilhelm's ascension to power, Chancellor Otto von Bismarck had forged a system of *Realpolitik*, based on an intricate network of treaties among nations and emissaries committed to sustaining the delicate statesmanship that was required to guarantee a balance of power in Europe. Wilhelm replaced this system with a monarch-centered authority and *Weltpolitik*, a confrontational conduct of state whose goal was to secure more colonial acreage and world influence. Eulenburg supported personal rule less as an ideological policy and more as a form for decision-making, for he also believed in a peaceful and orderly conduct in foreign affairs and a conservative domestic policy.

In 1902 Eulenburg had resigned his diplomatic post as ambassador in Vienna under the threat of blackmail for his homosexuality.[117] His good connections with the court momentarily cooled but warmed again when he hosted a Liebenberg hunt in 1905. When Germany forfeited claim to France for rule in Morocco at the 1905 Algéçiras Conference, Harden and others believed that Eulenburg, close again to the Kaiser, had orchestrated the détente and thus sabotaged Germany's imperialist expansion into North Africa. Likely, they overestimated his influence. Nonetheless, it was this territorial concession that incensed Harden and ignited the Eulenburg Affair.[118]

In the fall of 1906, Harden published two articles in the periodical *The Future* (*Die Zukunft*), each of which slyly hinted at the homosexual behavior of two prominent,

though unidentified figures.[119] In the second article, "the Harpist" (as Harden nicknamed Eulenburg for his musical abilities) and "Sweetie" (Moltke) have a dialogue in which they agonize over their predicament, wondering what more Harden will reveal and how "the Darling" will react. Harden let the matter simmer until April 27, 1907, when, in a third article, he named Eulenburg and Moltke as "perverts."[120]

Eulenburg, cleverly, did not seek retribution against Harden but nonetheless cleared his name — for the moment. He went to the district attorney in his home district and, having been accused of violating Paragraph 175, turned himself in, all the while stating he was innocent of Harden's charge. The local authorities conducted an investigation and cleared Eulenburg of the charge in July 1907.

Moltke, meanwhile, sued Harden for libel. At the October 1907 trial, Moltke's former wife, Lili von Elbe, submitted damaging testimony, claiming that they had had sexual relations only on the first two nights of their two-year marriage and that when they had subsequently shared a bed, Moltke had put a pan of water between them to thwart her amorous urges. Serving as an expert witness, Magnus Hirschfeld judged Moltke to be homosexual, linking generalizations about known homosexual behavior with similar behavior by Moltke. The third witness was an enlisted soldier named Bollhardt from the regiments in Potsdam, the site of the imperial residence and garrison for troops on the outskirts of metropolitan Berlin. Bollhardt asserted that sexual relations between officers and the troops were not only common but common knowledge. He described parties he had attended that were hosted by Johannes Count von Lynar—a former major in the Garde-du-Corps whose homosexuality was exposed earlier in 1907—at which Moltke, as military commandant of Berlin, also was a guest. Bollhardt talked about the sex appeal of the cuirassier's uniform, with its skintight white breeches and high black boots. He said that soldiers who wore the uniform on public streets made themselves vulnerable to homosexual solicitations. At this, the courtroom audience broke out in laughter. Bollhardt quickly added that wearing a cuirassier's uniform off duty had recently been banned, so military men were now saved this embarrassment.[121] One does not wonder long why reports from the trial grabbed international attention. Political cartoonists made great capital of the water pan and breeches. After seven days in court,

Moltke was found guilty of Harden's charge. However, several days later the trial was voided due to faulty procedure, and the state prosecutor called for a retrial.

At the retrial, Moltke and Eulenburg took the stand and defended themselves and the wholesome tradition of chivalrous male friendship. Hirschfeld retracted his earlier judgment of Moltke. Medical experts testified that Moltke's former wife suffered from hysteria, so her claims were discredited. In January 1908, Moltke was cleared of Harden's accusations, and Harden, convicted of libel, was sentenced to four months in prison.

Harden, however, was not to be outdone. A journalist colleague in Bavaria, Anton Städele, published an article for Harden purporting that Eulenburg had paid Harden off to cease his attacks. Harden then sued Städele for libel, making use of the resulting trial to present incontrovertible evidence against Eulenburg. Under oath at Moltke's retrial, Eulenburg had testified that he had never violated Paragraph 175, a misstep that was to have serious consequences. Harden produced two witnesses. The first, Georg Riedel, admitted that, in 1881, when he was a young man serving in the military, he had had sex with Eulenburg. The second witness, Jakob Ernst, confessed to far more. In 1883, at age nineteen, he had met Eulenburg and entered into an affair with him that continued over two decades. Ernst told of the double life he had led. He was a Bavarian fisherman and happy family man who also served as Eulenburg's companion on trips to Munich, Berlin, Zurich, the Riviera, and elsewhere. Harden won his libel suit. Städele was fined, but Harden reimbursed him.

The outcome of the trial led to Eulenburg's being brought up on perjury charges in June 1908. These proceedings never reached a resolution, however. On several occasions when court convened, Eulenburg either collapsed or passed out and was deemed by doctors unable to continue. He was able, by turns, to postpone court dates or fall apart at the court appearances he did manage to make right up to his death in 1921. A second retrial of the Moltke vs. Harden case took place in April 1909, and Moltke was yet again found innocent.

The drawn-out saga captured headlines the world over. The trials drew immense crowds, for this scandal let the international public into the bedrooms of elite members of the German kaiser's inner circle. Other Liebenbergers also were charged with homosexuality and went to trial. For titillated readers, the press reported

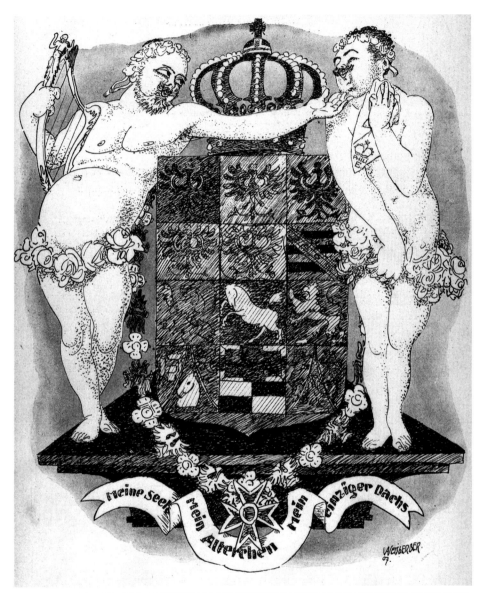

NEW PRUSSIAN COAT-OF-ARMS. EULENBURG APPEARS ON THE LEFT AS "THE HARPIST." MOLTKE IS ON THE RIGHT
WITH A HANDKERCHIEF BEARING EULENBURG'S NICKNAME, "PHILI." *JUGEND* NO. 45 (OCTOBER 28, 1907): 1028.

on defining characteristics of homosexual men and their means of interaction. A guide was even published in Germany to help explain behaviors discussed at the trials to an unknowing audience.[122] Like the scandalous 1895 trial of Oscar Wilde in England, the Eulenburg Affair became a watershed event both nationally and internationally. As James Steakley writes, "attitudes and forms of behavior that had heretofore been quite acceptable now became suspect. Parents were reluctant to allow their sons to enter the military or even move from the country to the city."[123] In effect, this sequence of events in Germany, Steakley argues further, "dramatically accelerated the emergence of the modern homosexual identity by stimulating and structuring public perceptions of sexual normalcy and abnormalcy."[124] The immediate response of the German public to the scandal was on the

BERLIN CENSUS. OFFICER: "HOW MANY CHILDREN?" RESPONSE: "TWO DAUGHTERS, A BOY, THREE SEXUAL INTERMEDIATES, AND ONE HOMOSEXUAL." *JUGEND* NO. 49 (NOVEMBER 30, 1905): 974.

whole not positive. Nonetheless, the Eulenburg Affair did not have a long-lasting negative impact on the vital, well-established gay subculture in Berlin.

While the affair demonstrated to the general public that the German military, a refuge and "el dorado" for Kaiser Wilhelm, harbored a significant homosexual contingent, the scandal was not the first demonstration of this fact. Magnus Hirschfeld had pointed to a strong homosexual presence in the military ranks when he wrote in 1904 about a phenomenon particular to gay Berlin, the *Soldatenkniepen* or soldiers' bars.[125] Certainly, too, the presence of homosexuals in the ranks had had some effects that would have been well-known within the military itself. Between 1904 and 1907, twenty officers and fifteen lesser-ranked military men were court-martialed on charges of homosexuality. From 1906 to 1907, six officers committed suicide under threat of blackmail for their same-sex activities.[126] And, much more publicly, Count Moltke was himself forced to resign as military commandant of Berlin in the wake of the scandal.

Because memories of the Eulenberg Affair were still in the air when Hartley lived in Berlin, many Germans looking at his paintings would have been able to make a connection between the scandal and his use of military motifs — which began before the war with *The Warriors* (p. 17, cat. 14) and *Portrait of Berlin* (p. 25), both done in 1913, and continued in the War Motif series. Quite simply, Hartley handled imagery that was charged with a specific connotation in Wilhelmine Berlin.

Certainly, wartime depictions of military men and paraphernalia are often taken as expressions of patriotism. However, Hartley was neither German nor in favor of the war. He employed this imagery to portray his experience, and his experience of imperial Berlin was very much conditioned by associations between military life and gay culture. Recent studies clarify that gay men have been an integral part of the military in the two world wars and long before. President Bill Clinton's goal to allow openly gay and lesbian members of the United States military to serve without fear of discharge brought this taboo topic into the light of day in 1993 and drew both outrage on the part of the military establishment and greater attention to the history of gays in the American armed forces.[127] The Eulenburg Affair is a rare instance in which the fact of such a presence was made public long before gay rights advocacy became a visible force in Western society.

Hartley came to Berlin already well aware that homosexual men were part of the German military. While living in Paris, he had frequented the Restaurant Thomas on the Boulevard Raspail, which was where he met Arnold Rönnebeck, Karl von Freyburg, and a circle of other Germans, a number of whom were military men. Many in this clique were homosexual. Once in Berlin, Hartley confided in a letter to Stieglitz that he "lived rather gayly in the Berlin fashion—with all that implies." Because the word *gay* did not begin taking on a homosexual connotation until the 1920s and 1930s and did not enter common parlance until the 1960s, it is impossible to know if Hartley used it here with that meaning in mind.[128] However, his aside—"with all that implies"—strongly suggests a polite signal to Stieglitz, who had himself lived in Berlin for six years, that Hartley was satisfying his sexual needs.[129]

Hartley's closest friends in Berlin, those with whom he presumably would have first tasted the notorious Berlin nightlife, had connections to the military.[130] "Military life provided the key and clue to everything then," Hartley later wrote of Berlin in the prewar days. "The tension was terrific and somehow most voluptuous in the feeling of power—a sexual immensity even in it."[131] Von Freyburg was already a lieutenant in the fourth regiment when war broke out.[132] Rönnebeck went into the service soon after hostilities erupted. In the year before the war and during its first months, Hartley evidently made numerous jaunts out to Potsdam, where von Freyburg was stationed. In a wartime letter to a good friend, Charles Demuth, another American expatriate gay painter, Hartley lamented that "I have not been near Potsdam since the war [began]—I don't know when I shall ever go again—there is too much there to remember."[133] Demuth had been part of the Restaurant Thomas crowd in Paris and had known von Freyburg. He also had visited Hartley in Berlin for two weeks in the summer of 1913, so may himself have been to Potsdam and in a position to appreciate this loss.

In his landmark book about British literature stemming from World War I, *The Great War and Modern Memory* (1975), Paul Fussell analyzes the phenomenon of homosexuality and homoeroticism as a central fact of writing about the war experience. A prominent theme in writing that came after the war, he confirms, was the expression of grief for "the beautiful suffering lads," a grief tinged with homoerotic feeling. In fact, Fussell demonstrates that with the advent of the war, "homoeroticism was now . . . licensed."[134] Thus, Hartley's War Motif paintings partake in a larger, international current. Like the British poets Siegfried Sassoon (who survived the war) and Wilfred Owen (who did not), Hartley fashioned works that marked the loss of idealized male youth, a loss strongly inflected by homoerotic fervor.[135]

Until very recently, gay men and lesbian women in the public eye retreated from an open disclosure of their sexual selves. This happened as a matter of self-preservation in a world of repressive social proprieties. "You can do anything you want," the gay composer Virgil Thomson once advised, "but just don't talk about it."[136] Instead, homosexual artists and writers before the mid-twentieth century built a language of codes and signs into their work that provided a key to its veiled meaning

EL DORADO. OFFICER: "GOD BE PRAISED, NO WOMEN HERE—THE PURE EL DORADO." EL DORADO WAS ALSO THE NAME OF WEIMAR BERLIN'S MOST POPULAR AND NOTORIOUS CABARET, WHICH CATERED TO A HOMOSEXUAL, LESBIAN, AND TRANSGENDER CLIENTELE. *LUSTIGE BLATTER* 22, NO. 45 (NOVEMBER 5, 1907): 7.

for those initiated to the special language. The study of gender construction in recent years has taught us much about the artful concealment and repertoire of coded gestures formulated by homosexuals to reveal themselves, but only to the knowing and discreet few. A primary symbol in Oscar Wilde's code was the green carnation. Marsden Hartley's, from 1913 to 1915, was the German military uniform.

Hartley's War Motif series represents a culmination of twenty years of his artistic development—not an ending point but an authoritative mastery achieved along the way. Further, these works are declarative statements of gay identity, for the symbolism is transparent to those with knowledge of Hartley's life circumstances and the climate of prewar Berlin. Staunch reprobation for stepping beyond the bounds of socially acceptable sexual behavior led Hartley—like so many others—to construct a language in his art to speak of his difference. The paintings also are a sophisticated reformulation of American transcendentalist principles, however, in the updated dress of radical early modernism. They speak eloquently of the cultures and milieus Hartley bridged—American, German, bohemian, military, avant-garde, and homosexual.

The French critical theorist Roland Barthes claimed that "it is impossible to write without labeling yourself."[137] If we read the products of Hartley's brush as pictorial scripts for his artistic vision, then we can see his German paintings as charts to his identity—complex but definitive. For Hartley, it was not possible to paint without revealing himself, without labeling for the viewer just who he was.

NOTES

1 Marsden Hartley to Alfred Stieglitz, November 3, 1914, Yale Collection of American Literature, Beinecke Rare Book and Manuscript Library, Yale University. Hereafter cited as YCAL.

2 Hartley to Stieglitz, February 1913, YCAL.

3 Hartley to Stieglitz, March 15, 1915, YCAL.

4 Frank as quoted in Juergen Schebera, "Berliner Künstlerlokale der zwanziger Jahre," Berliner Tagesspiegel (March 6, 1988): Weltspiegel section, 3.

5 Hartley to Stieglitz, May 9, 1919; and idem, "Somehow a Past," unpublished autobiography, n.d., unpaginated, YCAL.

6 For a detailed analysis of Hartley's stylistic sources in these paintings, see Barbara Haskell, Marsden Hartley, exh. cat. (New York: Whitney Museum of American Art and New York University Press, 1980), 44–45. See also Gail Levin, Marsden Hartley: Six Berlin Paintings, exh. cat. (New York: Salander-O'Reilly Galleries, 1992).

7 Hartley to Stieglitz, March 15, 1915, YCAL.

8 Hartley boasted that this gallery, located on Pariserplatz, was in the same building as Max Liebermann's home. Both the respectable address in central Berlin and

proximity to Liebermann, one of Germany's leading painters as president of the Berliner Secession from 1898 to 1910, demonstrate the significance of this exhibition for Hartley. Hartley to Stieglitz, August 5, 1915, YCAL.

9 "American Artist Astounds Germans," New York Times (December 19, 1915): 4; and Lothar Brieger, "Sonderausstellung Marsden Hartley," Berliner Zeitung am Mittag no. 269, Erstes Beiblatt (October 25, 1915): n.p.

10 Marsden Hartley, "Foreword," Camera Work no. 48 (October 1916): 12.

11 In particular, see Charles Caffin, "New and Important Things in Art: Latest Work by Marsden Hartley," Camera Work no. 48 (October 1916): 59–60; and Robert K. Martin, "Reclaiming Our Lives," Christopher Street 4 (June 1980): 32–38.

12 For a discussion of Emerson's strong impact on the cadre of artists surrounding Stieglitz, see Matthew Baigell, "American Landscape Painting and National Identity: The Stieglitz Circle and Emerson," Art Criticism 4, no. 1 (1987): 27–47; and Charles C. Eldredge, "Nature Symbolized: American Painting from Ryder to Hartley," The Spiritual in Art: Abstract Painting, 1890–1985, exh. cat. (Los Angeles: Los Angeles County Museum of Art; New York: Abbeville Press, 1986).

13 Hartley, "Somehow a Past," YCAL. Hartley biographer Townsend Ludington argues that Essays affected the artist profoundly and claims that Hartley carried a copy of the book with him constantly from 1898 to 1903. "The Early Career of Marsden Hartley," unpublished paper delivered at "Marsden Hartley: A Life in the Arts," symposium, University Art Museum, University of Minnesota, Minneapolis, June 2, 1986.

14 For Hartley's correspondence with Whitman's friend and biographer Horace Traubel, see William Innes Homer, Heart's Gate: Letters between Marsden Hartley and Horace Traubel, 1906–1915 (Highlands, N.C.: Jargon Society, 1982).

15 See Thomas W. Gaehtgens, "Paris-München-Berlin: Marsden Hartley und die europäische Avantgarde," Kunst um 1800 und die Folgen (Munich: Prestel Verlag, 1988), 368.

16 Hartley to Edith Halpert, July 12, 1933. As quoted in "Letters from Germany, 1933–1939," Archives of American Art Journal 25 (1985): 3–28.

17 Ralph Waldo Emerson, as quoted in Stanley M. Vogel, German Literary Influences on American Transcendentalists (Hamden, Conn.: Archon Books, 1970), 63.

18 Ralph Waldo Emerson, "Nature," Selections from Ralph Waldo Emerson, Stephen Whicher, ed. (Boston: Houghton, Mifflin, 1957), 31.

19 Ibid., 24.

20 William Henry Channing, as quoted in Vogel, German Literary Influences, 162.

21 Emerson, "Experience," The Essays of Ralph Waldo Emerson, A. R. Ferguson and J. F. Carr, eds. (1841, 1844; repr. Cambridge, Mass.: Harvard University Press, 1987), 261.

22 Hartley to Stieglitz, May 1913, YCAL.

23 Gail Scott traces the importance of Hartley's transcendentalist impulses with sophistication. See Gail R. Scott, ed., "Introduction," On Art by Marsden Hartley (New York: Horizon Books, 1982), 19–57.

24 Clement Greenberg, "Art," The Nation 159 (December 30, 1944): 810.

25 See Haskell, Hartley, 17.

26 Hartley to Horace Traubel, February 10, 1907. As quoted in Homer, Heart's Gate, 24.

27 Hartley to Anne Traubel, May 31, 1911. As quoted in Homer, Heart's Gate, 76.

28 See Homer, Heart's Gate, 10.

29 Emerson, "Art," Essays, 209; and "The Over-Soul," Essays, 160.

30 Whitman as quoted in Justin Kaplan, "Half Song-Thrush, Half Alligator," American Heritage 31 (October–November 1980): 63. Whitman later distanced himself from any acknowledged debt to Emerson, a point Kaplan explains in this article and his biography of the poet. See Justin Kaplan, Walt Whitman, A Life (New York: Simon and Schuster, 1980).

31 See Matthew Baigell, "The Influence of Whitman on Early-Twentieth Century American Painting," The Mickle Street Review 12 (1990): 99–113; and idem, "Walt Whitman and Early-Twentieth Century Art," in Walt Whitman and the Visual Arts, Geoffrey M. Sill and Roberta K. Tarbell, eds. (New Brunswick, N.J.: Rutgers

University Press, 1992), 121–141.

32 See Monika Schaper, *Walt Whitman's Leaves of Grass in deutschen Übersetzungen* (Frankfurt: Peter Lang, 1976); and Eve Kosofsky Sedgwick, "Toward the Twentieth Century," *Between Men: English Literature and Male Homosocial Desire* (New York: Columbia University Press, 1985), 201–217.

33 Hartley to Franz Marc, June 2, 1913, as quoted in Patricia McDonnell, ed., "Marsden Hartley's Letters to Franz Marc and Wassily Kandinsky, 1913–1914," *Archives of American Art Journal* 29 (1989): 40. Hartley also used this piece to head his artist's statement for his 1914 exhibition at 291.

34 Gertrude Stein, *The Making of Americans* (1925; condensed version, New York: Harcourt, Brace, 1934), 230.

35 Wendy Steiner, *Exact Resemblance to Exact Resemblance: The Literary Portraiture of Gertrude Stein* (New Haven: Yale University Press, 1978).

36 Ibid., 44–45.

37 Gertrude Stein, "Pablo Picasso," *Camera Work* special number (August 1912): 29.

38 Gertrude Stein, "From a Play by Gertrude Stein on Marsden Hartley," *Camera Work* no. 45 (January 1914): 17. The complete play was published in Gertrude Stein, "IIIIIIIIII," in *Geography and Plays* (1922; repr., New York: Haskell House, 1967), 189–198.

39 In fact, the line "A cook can see" is a comment on Hartley's culinary abilities. Stein and Toklas visited his studio and enjoyed the cucumber sandwiches he served. See Hartley, "Somehow a Past," YCAL.

40 For a comparative analysis of Stein's idea of the "continuous present" and James' concept of "stream of consciousness," see Steiner, *Exact Resemblance*, 46–47.

41 Gertrude Stein, "Portraits and Repetition," *Lectures in America* (1935; repr., New York: Vintage Books, 1975), 183.

42 William James, "Does Consciousness Exist?," in *Essays in Radical Empiricism* (1912; repr., Cambridge, Mass.: Harvard University Press, 1976), 4.

43 Hartley to Stieglitz, October 22, 1913, YCAL. Ludington supports the importance of this book for Hartley, arguing that "James' study was the centerpiece in Hartley's coming to understand what he felt." Townsend Ludington, *Marsden Hartley: The Biography of An American Artist* (Boston, Little, Brown, 1992), 111.

44 Emerson was a friend of the James family and colleague of Henry James, Sr.

45 William James, *The Principles of Psychology*, 3 vols. (1890; repr., Cambridge, Mass.: Harvard University Press, 1981), 1: 185.

46 William James, *The Varieties of Religious Experience* (1902; repr., Middlesex, N.Y.: Penguin Books, 1987), 498.

47 William James, *Radical Empiricism*, 6, 7.

48 William James, *Collected Essays and Reviews* (1920; repr., New York: Russell and Russell, 1969), 379. Italics from the original.

49 William James, *Radical Empiricism*, 29. Italics from the original.

50 Hartley to Stieglitz, December 20, 1912, YCAL.

51 He later recognized that "the best asset I have had all along over here is Gertrude Stein." Hartley to Stieglitz, October 22, 1913, YCAL.

52 Hartley to Stieglitz, May 1913, YCAL.

53 Gertrude Stein to Stieglitz, undated (1913), YCAL.

54 Hartley to Stieglitz, October 22, 1913, YCAL. Stein later purchased these drawings to help Hartley financially.

55 Gertrude Stein, "From a Play by Gertrude Stein on Marsden Hartley," *Camera Work* no. 45 (January 1914): 17–18.

56 Stein to Hartley, undated (1913), YCAL.

57 Hartley to Stieglitz, February 1913, YCAL.

58 Hartley to Stieglitz, August 1913, YCAL.

59 Hartley to Stieglitz, May/June 1913, YCAL.

60 Hartley to Stein, August 1913, YCAL.

61 Hartley, "Somehow a Past," YCAL.

62 Ibid.

63 William James, *Religious Experience*, 423, 388. Italics from the original.

64 Other artists and philosophers also advocated an emphasis on the subconscious and/or spiritual at the turn of the century. Hartley acknowledges some of them, such as Henri Bergson, in his letters. Much has been made of the influence Kandinsky exerted on Hartley. Yet, the two had divergent philosophical positions, as Hartley recognized early on and stated himself. See Patricia McDonnell, "Spirituality in the Art of Marsden Hartley and Wassily Kandinsky, 1910–15," *Archives of American Art Journal* 29 (1989): 27–33.

65 Hartley to Stieglitz, May/June 1913, YCAL.

66 Hartley to Stieglitz, September 28, 1913, YCAL.

67 Hartley to Stein, October 18, 1913, YCAL.

68 Gail Scott suggests that Hartley's reading of *The Varieties of Religious Experience* inspired him to explore a range of texts by or about mystics. See Gail R. Scott, *Marsden Hartley* (New York: Abbeville Press, 1988), 39. This exposure prompted Hartley to paint abstractions.

69 Hartley to Franz Marc, May 13, 1913, Archiv für Bildende Kunst, Germanisches Nationalmuseum, Nuremberg. As quoted in McDonnell, ed., "Hartley's Letters to Marc and Kandinsky": 35–44.

70 Hartley to Stieglitz, August 1913, YCAL.

71 Haskell draws this connection, *Hartley*, 32.

72 Hartley to Stein, June 1913, YCAL.

73 Hartley, "Somehow a Past," YCAL.

74 Ibid.

75 Ibid.

76 Hartley, "Foreword to His Exhibition," *Camera Work* no. 45 (January 1914): 17.

77 Arnold Rönnebeck to Duncan Phillips, n.d. (after 1943), YCAL. For an extended quotation of this letter, see Gail Levin, "Wassily Kandinsky and the American Avant-Garde, 1912–1950," Ph.D. diss., Rutgers University, 1976, 129. For greater elaboration of the iconographic sources for these paintings, see William H. Robinson, "Marsden Hartley's *Military*," *Bulletin of the Cleveland Museum of Art* 76, no. 1 (January 1989): 2–26.

78 Hartley to Stieglitz, March 15, 1915, YCAL.

79 The letters are at YCAL.

80 Gail Levin, "Photography's Appeal to Marsden Hartley," *Yale University Library Gazette* 68 (October 1993): 12–42.

81 Arnold Rönnebeck to Duncan Phillips, n.d. (after 1943), YCAL.

82 Hartley to Stieglitz, April 6, 1915, YCAL.

83 Hartley to Stieglitz, November 8, 1914, YCAL.

84 See Patricia Everett, "Andrew Dasburg's Abstract Portraits, Homages to Mabel Dodge and Carl Van Vechten," *Smithsonian Studies in American Art* 3 (Winter 1989): 73–87; Steven Watson, *Group Portrait: The First American Avant-Garde*, exh. cat. (Washington, D.C.: National Portrait Gallery, 1991); and Robin Jaffee Frank, *Charles Demuth: Poster Portraits, 1923–1929*, exh. cat. (New Haven: Yale University Art Gallery, 1994). Haskell was the first to note that, in this series, Hartley created portraiture similar to Stein's, *Hartley*, 45.

85 Hartley as quoted in "American Artist Astounds Germans," *New York Times* (Sunday, December 19, 1915), sec. 6, p. 4.

86 Hartley to Stein, October 18, 1913, YCAL; and idem, "Somehow a Past," YCAL.

87 Hartley to Stieglitz, May/June 1913, YCAL.

88 Quoted in James D. Steakley, *The Homosexual Emancipation Movement in Germany* (New York: Arno Press, 1975), 8.

89 Ulrich's name for homosexual men stems from Plato's *Symposium*, in which the patron goddess of men who love other men is Aphrodite Urania. The term *uranian* became a popular one for homosexual men up through World War I.

90 Carl von Westphal, "Die konträre Sexualempfindung," *Archiv für Psychiatrie und Nervenkrankheiten* no. 2 (1869): 73–108; and Richard von Krafft-Ebing, *Psychopathia sexualis* (Stuttgart: F. Enke, 1886). Von Westphal's term *contrary* later became *inverted*. *Invert* itself became another widely used word for homosexual. The term *homosexual* itself was coined in an 1869 open letter from Karoly Maria Kertbeny (a.k.a. Karl Maria Benkert) to the Prussian minister of justice calling for a

repeal of legislation against same-sex love.

91 Paragraph 175 was not stricken from the books in this period. For a history of this law and its antecedents in Germany, see Hermann Sievert, "Das Anomale Bestrafen: Homosexualität Strafrecht und Schwulenbewegung im Kaiserreich und in der Weimarer Republik," *Ergebnisse* 24 (April 1984): 8–130.

92 See James D. Steakley, ed., *The Writings of Dr. Magnus Hirschfeld: A Bibliography* (Toronto: Canadian Gay Archives, 1985).

93 The final list of names was published in *Jahrbuch für sexuelle Zwischenstufen* 23 (1923): 228–235.

94 The Nazis raided Hirschfeld's institute shortly after coming to power in 1933. They burned twelve thousand books in the extensive library and used the institute's files in efforts to track and persecute homosexuals.

95 The urge to define homosexuality as a biological phenomenon continues today, as documented in Darrell Yates Rist, "Are Homosexuals Born That Way?," *The Nation* 255, no. 12 (October 19, 1992), 424–429; and Dean Hamer and Peter Copeland, *The Science of Desire: The Search for the Gay Gene and the Biology of Behavior* (New York: Simon and Schuster, 1994).

96 Michael Bronski, "The Making of Gay Sensibility," *Culture Clash: The Making of a Gay Sensibility* (Boston: South End Press, 1984), 9. Jeffrey Weeks also argues this point in his *Coming Out: Homosexual Politics in Britain from the Nineteenth Century to the Present* (London and New York: Quartet Books, 1977).

97 Brand adopted the journal's name from the philosopher Max Stirner (an important precursor to Friedrich Nietzsche), whose main work was *Der Einzige und sein Eigentum* (1844). Harry Oosterhuis, ed. *Homosexuality and Male Bonding in Pre-Nazi Germany* (London and New York: Harrington Park Press, 1991), 3–4.

98 Magnus Hirschfeld, *Die Homosexualität des Mannes und des Weibes* (Berlin: Louis Marcus, 1914), 1,002.

99 Abraham Flexner, *Prostitution in Europe* (New York: Century, 1914), 31–32. One wonders if the figure also came from police records, since Flexner took his information regarding the number of gay locales from the police.

100 Oosterhuis, *Homosexuality*, 1.

101 Havelock Ellis and John Addington Symonds, *Das konträre Geschlechtsgefühl* (Leipzig: G. H. Wigand, 1896). In fact, this book contains an appendix, "Love of Soldiers and Related Matters" ("Soldentenliebe und Verwandtes"), on the special appeal of soldiers to homosexual men, 285–304.

102 James D. Steakley, "Iconography of a Scandal: Political Cartoons and the Eulenburg Affair in Wilhelmine Germany," *Hidden from History: Reclaiming the Gay and Lesbian Past* (New York: New American Library, 1989), 247.

103 Ibid., 233.

104 As quoted in Isabel Hull, "Kaiser Wilhelm II and the 'Liebenberg Circle,'" *Kaiser Wilhelm II: New Interpretations* (Cambridge, England: Cambridge University Press, 1982), 202.

105 Ibid., 201.

106 See John C. G. Röhl, "The Emperor's New Clothes: A Character Sketch of Kaiser Wilhelm II," *Kaiser Wilhelm*, 23–61.

107 Ibid., 48.

108 Wilhelm's brazen arrogance drew the attention of the international press any number of times. See, for example, Wilhelm Schüssler, *Die Daily-Telegraph-Affaire* (Göttigen: Musterschmidt, 1952).

109 Röhl, "The Emperor's New Clothes," 40. Also see Robert Graf von Zedlitz-Trützschler, *Zwölf Jahre am deutschen Kaiserhof* (Stuttgart, Berlin, and Leipzig: Deutsche Verlag Anstalt, 1924), 173.

110 Röhl, "The Emperor's New Clothes," 29. Friedrich von Holstein to Eulenberg, March 3, 1897. As quoted in John C. G. Röhl, *Philipp Eulenbergs politische Korrespondenz*, 3 vols. (Boppard am Rhein: H. Boldt, 1976, 1979), 3: 1,795.

111 As quoted in Röhl, "The Emperor's New Clothes," 34. See Bernhard Fürst von Bülow, *Denkwürdigkeiten*, 2 vols. (Berlin: Verlag Ullstein, 1930), 2: 472.

112 Röhl, "The Emperor's New Clothes," 48.

113 Ibid., 36.

114 Hull, "Kaiser Wilhelm," 203. Georg von Hülsen's brother Dietrich performed a balletic *pas seul* for the Kaiser in November 1908. Afterward, he died of a heart attack while still clad in his tutu and large feather hat, leaving the Kaiser in a highly embarrassing situation just when the Eulenburg Affair was in full swing.

115 Ibid., 198.

116 Harden marshaled homophobia toward political ends. He had been among the initial supporters of Magnus Hirschfeld's committee and later admitted to him that the Eulenburg Affair had been the greatest political blunder of his career. Steakley, "Iconography," 254; and Hull, "Kaiser Wilhelm," 246.

117 Hull, "Kaiser Wilhelm," 209; and Steakley, "Iconography," 238.

118 The present summary is necessarily brief because the complicated political dimensions of the Eulenburg Affair are well beyond the scope of this essay.

119 Maximilian Harden, "Praeludium," *Die Zukunft* 57 (November 17, 1906): 251–266. "Dies irae," *Die Zukunft* 57 (November 24, 1906): 287–302.

120 Maximilian Harden, "Roulette," *Die Zukunft* 59 (April 27, 1907): 117–130.

121 Hugo Friedländer, *Interessante Kriminal-Prozesse von kulturhistorischer Bedeutung*, 12 vols. (Berlin-Grunewald: Berliner Buchversand, 1920), 11: 44. As quoted in Steakley, "Iconography," 241.

122 J. L. Caspar, *Das Treiben der Homosexuellen: Volle Aufklarung zum Verständnis der Andeutung und "halben Worte" im Moltke-Harden Prozess* (Leipzig: Leipziger Verlag, 1907).

123 Steakley, "Iconography," 254.

124 Ibid., 235.

125 Magnus Hirschfeld, *Berlins Drittes Geschlecht* (1904; repr., Berlin: Verlag rosa Winkel, 1991), 90.

126 As quoted in Steakley, "Iconography," 239. See Adolf Brand, "Paragraph 175," in *Documents of the Homosexual Rights Movement in Germany, 1836–1927* (1907; New York: Arno, 1975), 2.

127 Randy Shilts, *Conduct Unbecoming: Gays and Lesbians in the U.S. Military, Vietnam to the Persian Gulf* (New York: St. Martin's Press, 1993); and Allan Bérubé, *Coming out under Fire: The History of Gay Men and Women in World War Two* (New York: Free Press, 1990).

128 Hartley to Stieglitz, March 15, 1915, YCAL; and Wayne Dynes, ed., *Encyclopedia of Homosexuality* (New York: Garland, 1990): 456.

129 Townsend Ludington believes this comment refers to a heterosexual relationship Hartley was then having. See Ludington, *Hartley*, 36.

130 Hartley's enjoyment of the famous Berlin nightlife is documented. He complained to Stieglitz about the imposition of a 1 a.m. curfew after the war began. Hartley to Stieglitz, March 15, 1915, YCAL. Hartley's friend Robert McAlmon also modeled the character Carrol Timmons, an American habitué of the liberated Berlin scene, on Hartley in his 1925 short story "Distinguished Air."

131 Hartley, "Somehow a Past," YCAL.

132 Arnold Rönnebeck to Duncan Phillips, n.d. (after 1943), YCAL.

133 Hartley to Charles Demuth, n.d., YCAL.

134 Paul Fussell, *The Great War and Modern Memory* (London, Oxford, and New York: Oxford University Press, 1975), 282. See especially his chapter "Soldier Boys," 270–309. *Lad* became a term for a gay youth after the publication of A. E. Housman's book of poems *A Shropshire Lad* in 1896.

135 For further analysis of the gay content in Hartley's art, see Jonathan Weinberg, *Speaking for Vice: Homosexuality in the Art of Charles Demuth, Marsden Hartley, and the First American Avant-Garde* (New Haven: Yale University Press, 1993).

136 Quoted in K. Robert Schwarz, "Composer's Closet Open for All to See," *New York Times* (June 19, 1994): 24.

137 Roland Barthes, *Writing Degree Zero* (London: Cape Editions, 1967), 7.

HARTLEY

[WAR MOTIFS]

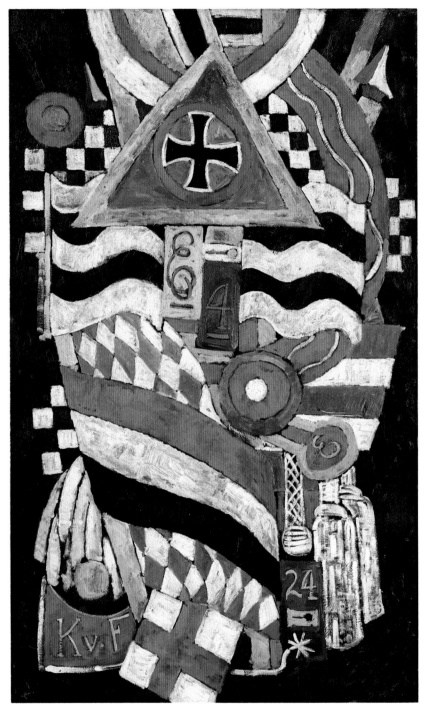

PORTRAIT OF A GERMAN OFFICER, 1914. OIL ON CANVAS, THE METROPOLITAN MUSEUM OF ART, THE ALFRED STIEGLITZ COLLECTION, 1949.

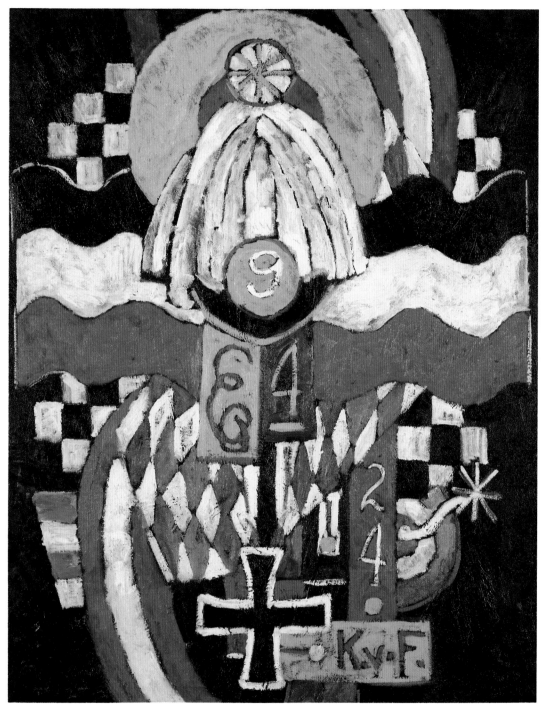

PAINTING NO. 47, BERLIN, 1914–1915. OIL ON CANVAS, HIRSHHORN MUSEUM AND SCULPTURE GARDEN, SMITHSONIAN INSTITUTION, GIFT OF JOSEPH H. HIRSHHORN, 1972.

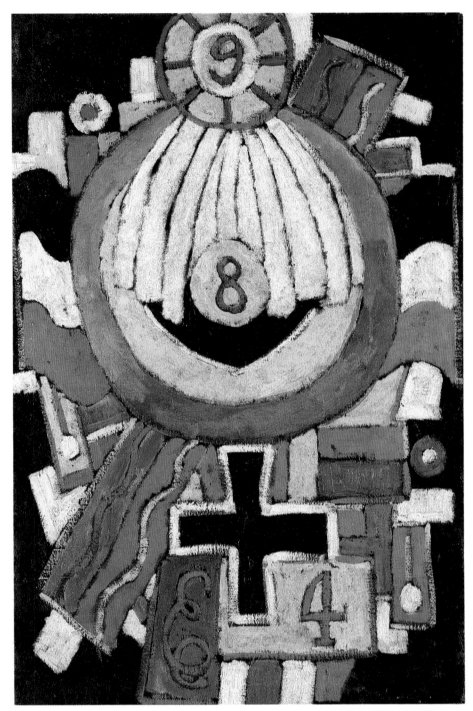

PORTRAIT, CIRCA 1914–1915. OIL ON CANVAS, FREDERICK R. WEISMAN ART MUSEUM, BEQUEST OF HUDSON WALKER FROM THE IONE AND HUDSON WALKER COLLECTION.

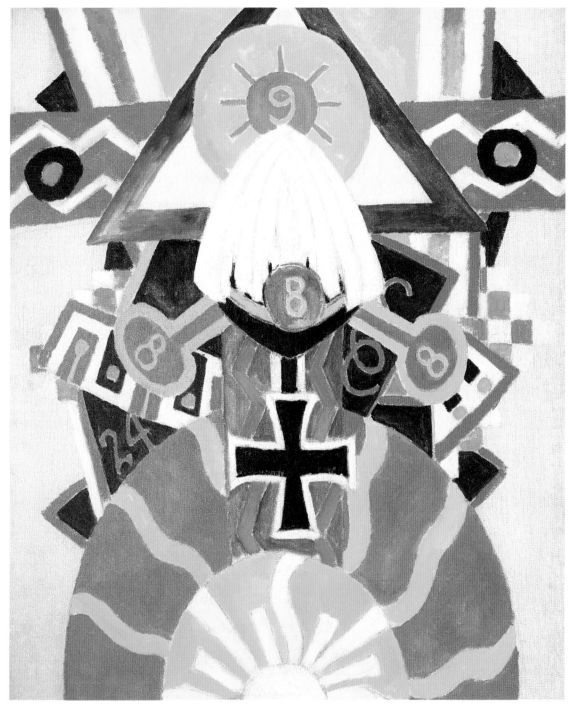

PAINTING NO. 49, BERLIN, 1914–1915. OIL ON CANVAS, FROM THE COLLECTION OF MR. AND MRS. BARNEY A. EBSWORTH.

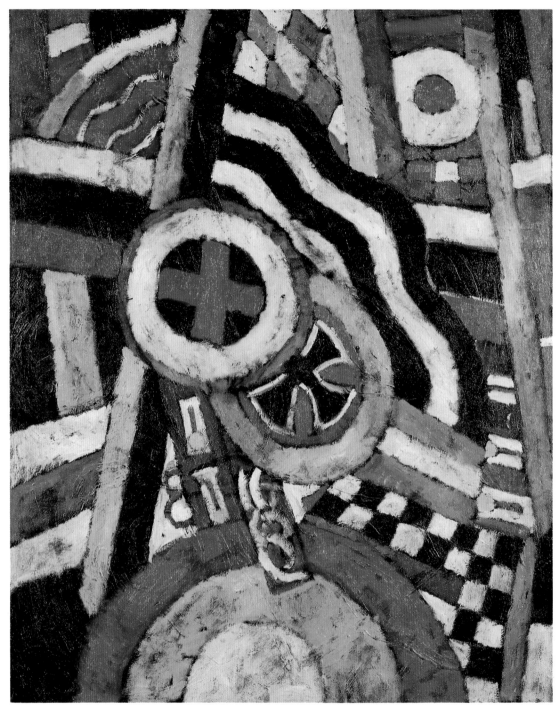

PAINTING, NUMBER 5, 1914–1915. OIL ON CANVAS, COLLECTION OF WHITNEY MUSEUM OF AMERICAN ART, GIFT OF AN ANONYMOUS DONOR.

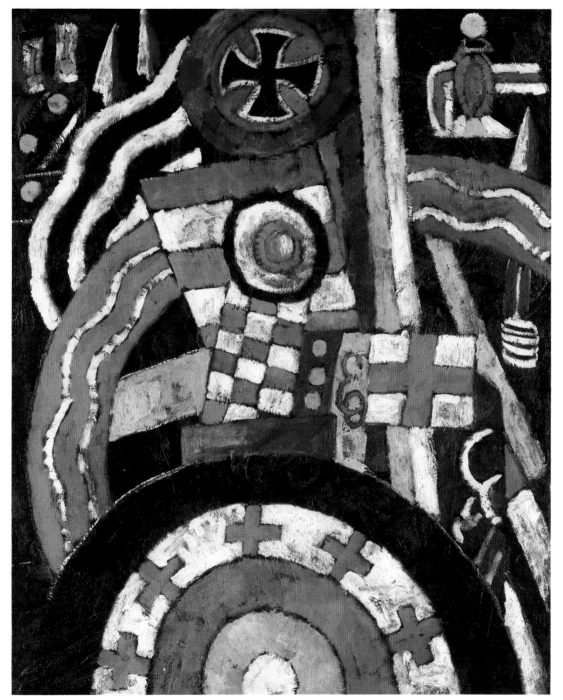

ABSTRACTION (MILITARY SYMBOLS), 1914–1915. OIL ON CANVAS, THE TOLEDO MUSEUM OF ART, PURCHASED WITH FUNDS FROM THE LIBBEY ENDOWMENT, GIFT OF EDWARD DRUMMOND LIBBEY.

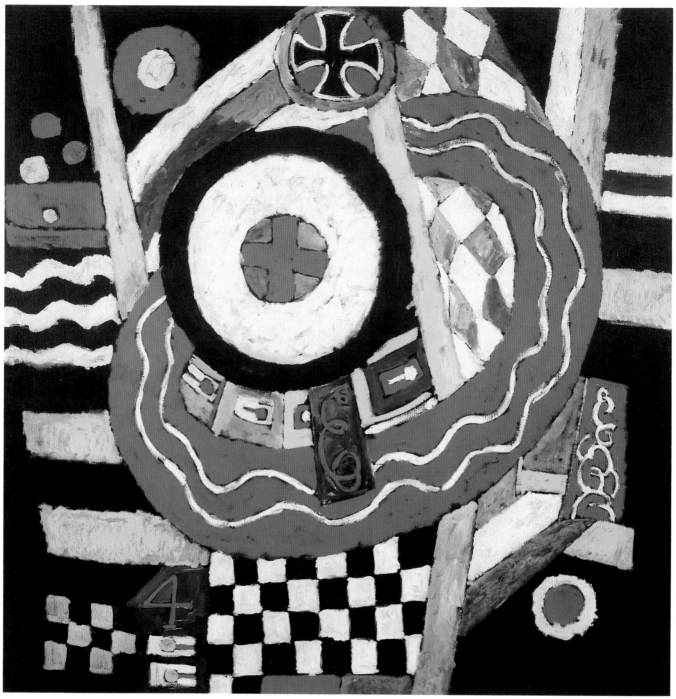

THE IRON CROSS, 1915. OIL ON CANVAS, COLLECTION OF WASHINGTON UNIVERSITY GALLERY OF ART, ST. LOUIS, MISSOURI, UNIVERSITY PURCHASE, BIXBY FUND, 1952.

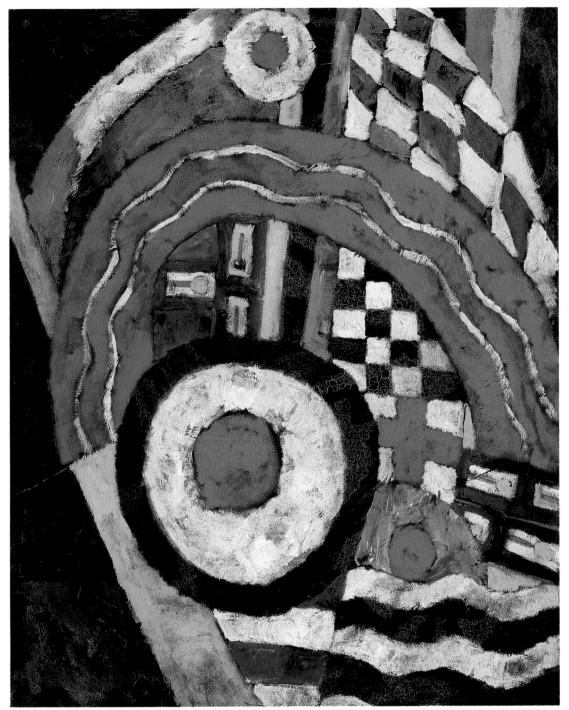

PAINTING NO. 46, 1914–1915. OIL ON CANVAS, ALBRIGHT-KNOX ART GALLERY, BUFFALO, NEW YORK, PHILIP KIRWEN FUND, 1956.

52

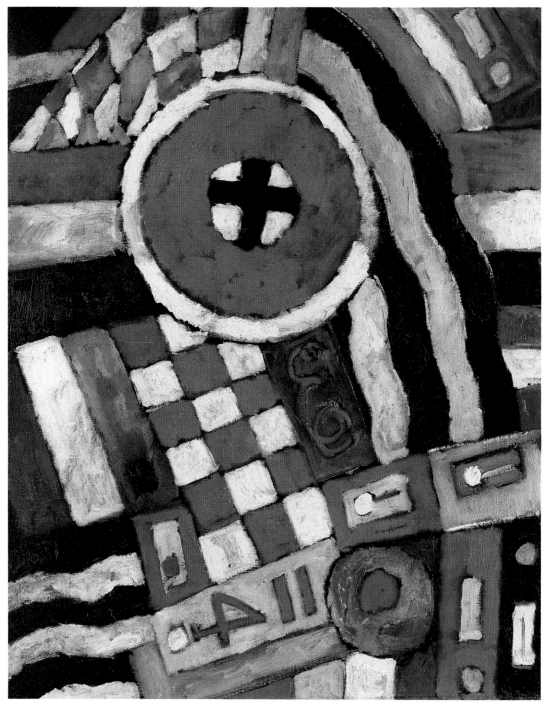

BERLIN ABSTRACTION, 1914–1915. OIL ON CANVAS, COLLECTION OF THE CORCORAN GALLERY OF ART, MUSEUM PURCHASE, GALLERY FUND.

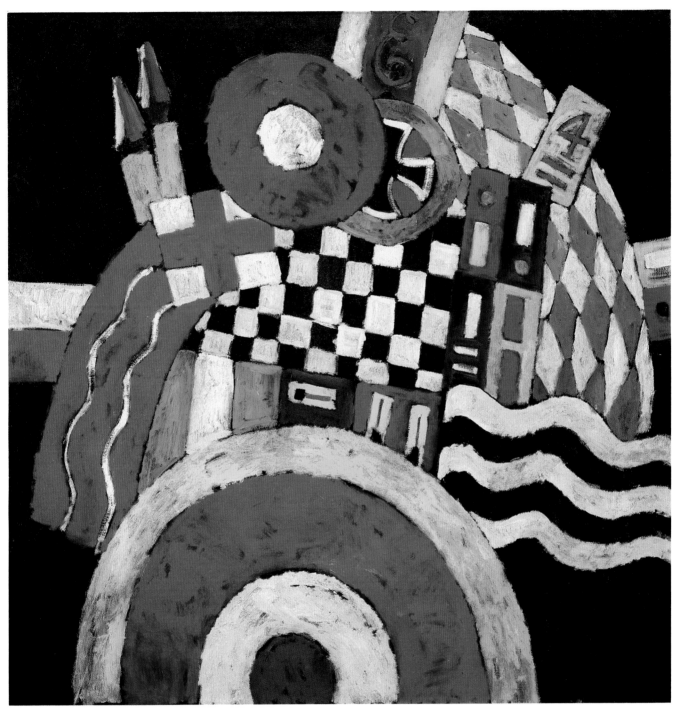

E, 1915. OIL ON CANVAS, THE UNIVERSITY OF IOWA MUSEUM OF ART, MARK RANNEY MEMORIAL FUND.

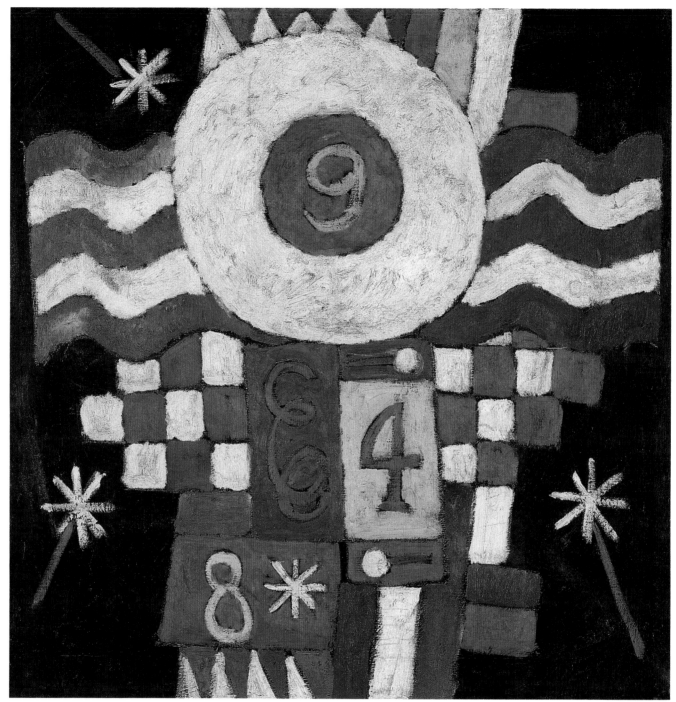

54

COLLECTION OF NUMBERS, DESIGNS AND LETTERS SEEN BY ME AT THE BEGINNING OF THE WAR IN BERLIN—MILITARY IN THEIR NATURE, 1914–1915. OIL ON CANVAS, YALE COLLECTION OF AMERICAN LITERATURE, BEINECKE RARE BOOK AND MANUSCRIPT LIBRARY, YALE UNIVERSITY.

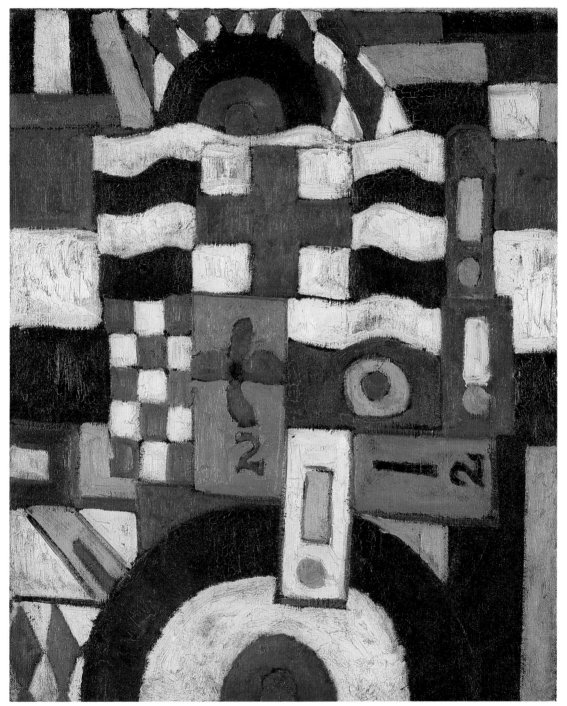

MILITARY, 1914–1915. OIL ON CANVAS, THE CLEVELAND MUSEUM OF ART, GIFT OF NELSON GOODMAN.

TRUTH, FRIENDSHIP, AND LOVE

SEXUALITY AND TRADITION
[IN ROBERT INDIANA'S HARTLEY ELEGIES]

MICHAEL PLANTE

The island of Vinalhaven lies several miles off the coast of Maine, in Penobscot Bay. In the nineteenth century it was the site of a flourishing granite industry, now long since expired. Today, most of the island's 1,100 inhabitants work in Maine's active fishing industry. It was to Vinalhaven that Robert Indiana repaired in 1978, leaving behind the New York City art world that had boosted him to prominence some twenty years earlier. After visiting a friend on the island, he acquired an Odd Fellows hall and decided to live there year-round (p. 58). Restoration of the hall (called Star of Hope) occupied his energies for the better part of a decade. And, given the island's relentlessly harsh climate, Star of Hope is likely to demand his attention for some time to come.

After moving to Vinalhaven, Indiana discovered that the building he had rented as a storage facility to absorb the overflow of his possessions sat nearby a house said by residents to have been occupied by the painter Marsden Hartley during the summer of 1938 (p. 58). Significantly, Hartley had himself returned to Maine after the failure of an exhibition of his work at Alfred Stieglitz's An American Place gallery in New York in the spring of 1937. In the introduction to the catalogue accompanying that exhibition, he declared himself the "painter from Maine."[1]

And it was on Vinalhaven that Hartley found the "middle aged men . . . so strong and muscular so normal & healthy looking" who would constitute the bank of homoerotic imagery that characterized his late work.[2] It was the discovery that he shared Vinalhaven with Hartley, and the recognition of what he calls "Hartley's tragedy"— his mourning of the young brothers Donny and Alty Mason, who drowned in the summer of 1936—that inspired Indiana to begin a series of paintings based upon Hartley's work. From 1989 to 1994, he produced a group of eighteen canvases that constitute a tribute he calls the Hartley Elegies.

There are vital parallels between the lives of the two artists. Both Indiana and Hartley left New York out of disaffection with the art world. Both found in Maine the solitude to produce a significant body of work. And both were homosexual artists who found the ruggedness of Maine life attractive, while having to cope with the absence of a gay subculture on this small island. "I'm always driven by subject matter," Indiana said in the summer of 1994, "and I simply was very moved by Hartley's tragic life. . . . It seemed that he was simply plagued with misfortune. And in a sense, I feel that I have also been plagued with misfortune. Just my exile to Maine has been a misfortune."[3]

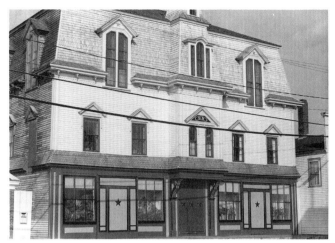

STAR OF HOPE, INDIANA'S RESIDENCE, VINALHAVEN, MAINE, 1994.

HARTLEY'S 1938 RESIDENCE ON VINALHAVEN, MAINE, 1994.

Yet, there also are pointed differences between the two men's lives. On the material level, Indiana has profited greatly from the sale of his art, while Hartley struggled continually to earn a living from his paintings. (He was pleased to be able to live on Vinalhaven for a dollar a day.) Additionally, attitudes toward homosexuality have changed in the years since the June 27–29, 1969, Stonewall riot, which was sparked when patrons of a gay bar, the Stonewall Inn, in New York City's Greenwich Village resisted police harassment. The riot attracted a number of political activists, including the poet Allen Ginsberg, who told a reporter that "the guys there were so beautiful. They've lost that wounded look that fags all had ten years ago."[4] Dubbed the "Hairpin Drop Heard 'round the World" because of the participation of drag queens, Stonewall increased general awareness of homophobia in the United States and is generally seen as marking the start of the present gay rights movement. As a result of the increased acceptance of homosexuality in the ensuing quarter-century, an artist such as Indiana has been able to live as an openly gay man and to represent his sexuality in his art more forthrightly than Hartley could.[5]

But it was the parallels between himself and Hartley that planted the idea for the Elegies, pictures that memorialize not only Marsden Hartley but also his relationship with, and mourning of, his "German officer," Karl von Freyburg. An army lieutenant, von Freyburg had befriended Hartley in Paris in 1912, and their relationship continued when Hartley moved to Berlin the next year. Von Freyburg was killed in battle early in World War I. The Elegies represent Indiana's deep interest in those two

men, and he makes plain the facts of their relationship, something Hartley presented in a veiled form in his War Motif series, which is focused largely on von Freyburg. Though the Hartley Elegies comprise Indiana's most extended painting series to date (with the exception of the continuing Love series), they represent only the most recent example of his homages, begun in the 1960s, to important American painters such as Charles Demuth and poets such as Hart Crane and Walt Whitman. In these, Indiana reworks those creators' pictorial and poetic symbols and iconography in order to reinvest them with his own meanings.

Indiana's interpretations of Hartley's and Demuth's paintings can be seen as a kind of collaboration with these historical figures. By including Crane and Whitman, too, his guiding purpose appears to be the construction of an American cultural pantheon in paint. His work has not exclusively concerned itself with this practice, but he has employed it consistently. In the past, this homage to American art and literature has been viewed as a specifically anti-European tactic by this most American of postwar artists. During the 1960s, when American art seemed to turn away from European examples, Indiana provided one of the clearest examples of what strictly American subject matter might look like.

However, two other facts are significant in a historical assessment of Indiana's production. First, he found his source material in the work of poets (Crane, Whitman, and also Gertrude Stein) whose literary sensibilities correspond to his own. The painters whom he has quoted, notably Demuth and Hartley, employed words, numbers, and symbols to function as emblematic references, in

ways similar to those Indiana has pursued throughout his career. Second, although Indiana's literary references do constitute the formation (or re-formation) of an American artistic pantheon, that construction intersects with Indiana's own identity as a homosexual man, particularly since most of the artists and writers to whom Indiana has referred in his work were gay and lesbian.

In a group of works he has called the Literary paintings, Indiana mined the history of American homosexual writers and painters to create a lineage reaching up to himself and other gay artists of his period.[6] These canvases mark a searching on the artist's part for a language to describe his own experience as a gay man as he situated his work within a gay heritage. It is significant that he began creating these tributes at the start of the 1960s, following a decade when the words *communist* and *homosexual* were both synonymous with "un-American." Paradoxically, in his 1960s work, Indiana used obvious American subject matter to encode a homosexual narrative, one that was patriotic and culturally significant in its inclusion of major figures of American art and literature who also were homosexuals. An examination of these first homages is essential to an understanding of the Hartley Elegies, for in them Indiana employed pictorial tactics that clearly prefigure those used in the later series. These and other pictures presented an account of American homosexuality that stood in vivid contrast to the versions generated by McCarthyism in the 1950s. They also were attempts to revive the conflation of nationalism and sexuality that poets such as Whitman had established.

INDIANA IN NEW YORK CITY

Robert Indiana developed the style and motifs that form the backbone of his art in the New York City of the late 1950s and early 1960s. It was there and then that he began producing works that made use of hard-edged images combined with texts and various sorts of lettering to create a painting style that would be identified as uniquely his own. During the early 1960s, following the first real market success of abstract expressionism, many American critics began shifting their attention away from Europe and European-trained artists. The result was a remarkable boom in the New York art market that brought with it a proliferation of galleries and other viewing spaces, and a concomitant surge in exhibitions of work by young American artists. The acceleration of art-making and art-selling was heightened by the simultaneous presence of two generations of American avant-garde artists: the long-established and recently successful abstract expressionists, and the newly established and instantly successful younger pop, minimalist, and color field artists. There resulted a largely self-referential forum—both critically and artistically—for American art, one that often excluded work from Europe.

Unlike the preceding generation of American artists, those who emerged in the late 1950s and matured in the 1960s possessed a sureness of direction that led to the swift development of signature styles and virtually ready-made classifications. Also, the critical apparatus was quickly set in place for contextualizing this new art. While the paint was still wet, these works were explicated by an impressively astute corps of young critics, including Michael Fried, Rosalind Krauss, and Barbara Rose, who cut their teeth on the new art. However, a certain insularity arose as these critics concerned themselves with articulating a distinctively new, therefore American, aesthetic sensibility. They inherited this position from the most potent critical voice of the 1940s and 1950s, Clement Greenberg, who had attempted to shatter the tradition of Paris and rebel aesthetically from all other residual Continental traditions.[7]

No artist was better poised at the beginning of the 1960s to profit from this renewed interest in "Americanness" than Robert Indiana. Having arrived in New York in 1954, he had observed the downtown milieu of the abstract expressionists, which included exhibition spaces, studios, and meeting-places such as the Cedar Bar. In fact, his first loft was on Fourth Avenue, next door to Willem de Kooning's studio. He frequently watched the older artist at work. It was this kind of firsthand exposure that led him to conclude that he was not interested in the paintings of the abstract expressionists nor in the aesthetic issues that concerned them. Indiana saw their work as overly involved with European artistic issues. Indeed, he declared his disdain for European art. "I propose to be an American painter," he asserted early in his career, "not an internationalist speaking some glib Esperanto; possibly I intend to be a Yankee."[8]

During the 1960s, Indiana's work was routinely grouped alongside that of the other New York-based artists who were later credited with creating pop art: Roy

Lichtenstein, Claes Oldenburg, James Rosenquist, Andy Warhol, and Tom Wesselmann. While Indiana's paintings and constructions of the late 1950s and early 1960s have been difficult to classify, the pop label has served as well as any other. Still, he does not always employ the popular cultural references characteristic of the group.

Certainly, the references in Indiana's work to high cultural figures such as Whitman and Crane fit the pop category less well than his mass-culture-oriented works from the same time, such as *The Green Diamond Eat* and *The Red Diamond Die* (1962) (above). Outside that category, there exist two additional contexts for Indiana's art. The first is

ROBERT INDIANA, *THE GREEN DIAMOND EAT* AND *THE RED DIAMOND DIE*, 1962. OIL ON CANVAS, COLLECTION WALKER ART CENTER, MINNEAPOLIS, GIFT OF THE T. B. WALKER FOUNDATION, 1963.

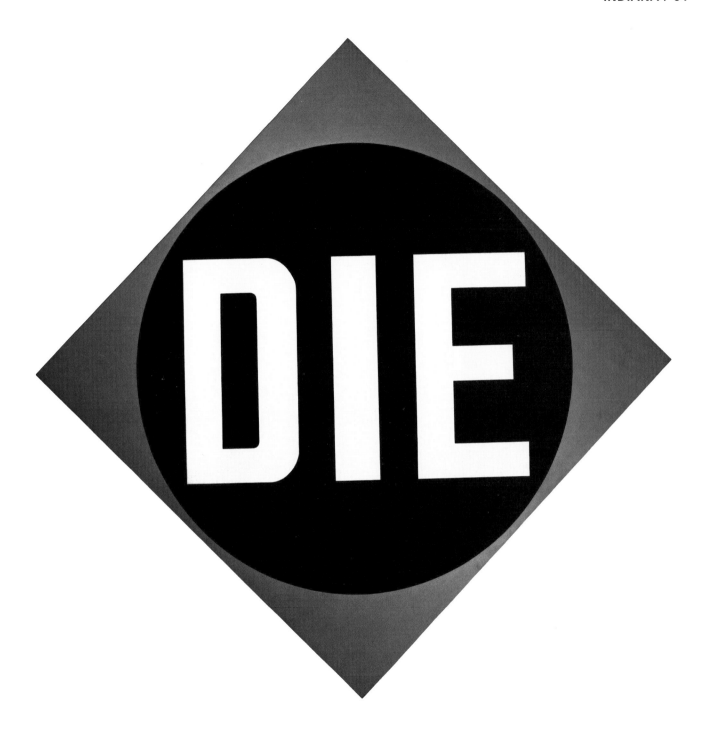

with the artistic community around Coenties Slip, and the second is with the other homosexual artists of the period.

Indiana moved into a loft on Coenties Slip, at the southern tip of Manhattan, in 1956. The slip was part of the nineteenth-century maritime district facing the East River and the Brooklyn Bridge. He later wrote that "this heady confluence of all the elements—the rock, the river, the sky, and the fire of ships and commerce—created a natural magnetism that drew a dozen artists to the slip."[9] Those who eventually gravitated there included Ellsworth Kelly, Agnes Martin, James Rosenquist, Lenore Tawney, and Jack Youngerman, among others. Indiana had been

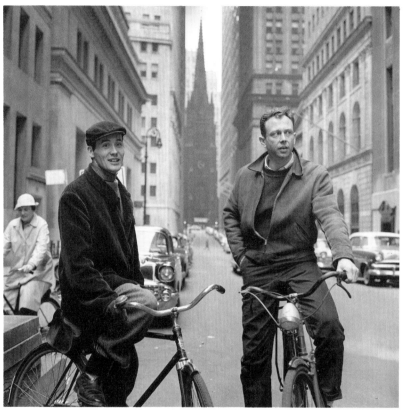

HANS NAMUTH, *ROBERT INDIANA AND ELLSWORTH KELLY*, 1958. BLACK-AND-WHITE PHOTOGRAPH, COLLECTION OF THE ARTIST'S ESTATE. INDIANA IS ON THE LEFT.

living in a studio on West Sixty-third Street and working at Frederick's, an art supply store, shortly after his arrival in New York. One day, Ellsworth Kelly, recently returned to the United States after seven years in Paris, came into the store to buy a Matisse postcard displayed in the window. The two artists started a relationship that lasted for several years, but within a short time both Kelly and Indiana moved into separate lofts on the slip.[10] Indiana remembers that "by being the most important person in my life, [Ellsworth] influenced a little bit of art history."[11]

Kelly had returned from living abroad with a painting style quite foreign to New York City.[12] His hard-edged pictures, which were first shown at the Betty Parsons Gallery in 1956, were a revelation to Indiana. It took a few years for Kelly's influence to sink in, but in 1963

Indiana said that his meeting Kelly represented "my first head-on contact with painting of any geometric or clean, hard-edged style. I never knew a painter who worked in this manner."[13] The first pictures Indiana produced in the 1960s were characterized both by a profusion of references to targets, billboards, and road signs, and by an attention to the hard-edged abstraction he had learned from Kelly. His mature work of the 1960s struck a balance between references to popular culture on the one hand and to advanced modernist abstraction on the other. *The American Dream, I* (1961) (p. 63) contrasts target formats filled with the symbols of pinball machines and jukeboxes with a brown and black background that functions visually as a hard-edged painting. The background, complete with four white tondo shapes, is sketched in the

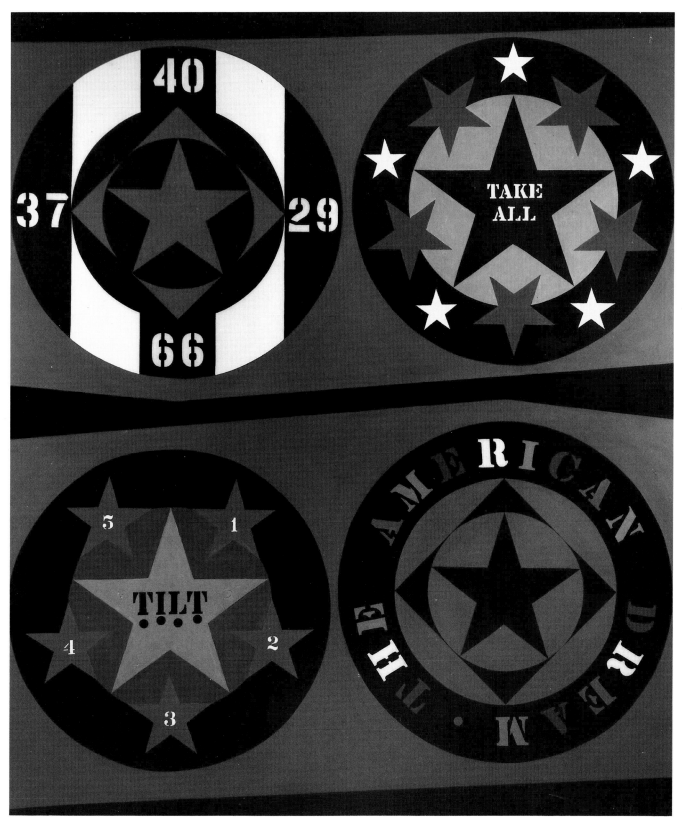

ROBERT INDIANA, *THE AMERICAN DREAM, I,* 1961. OIL ON CANVAS, THE MUSEUM OF MODERN ART, NEW YORK, LARRY ALDRICH FOUNDATION FUND.

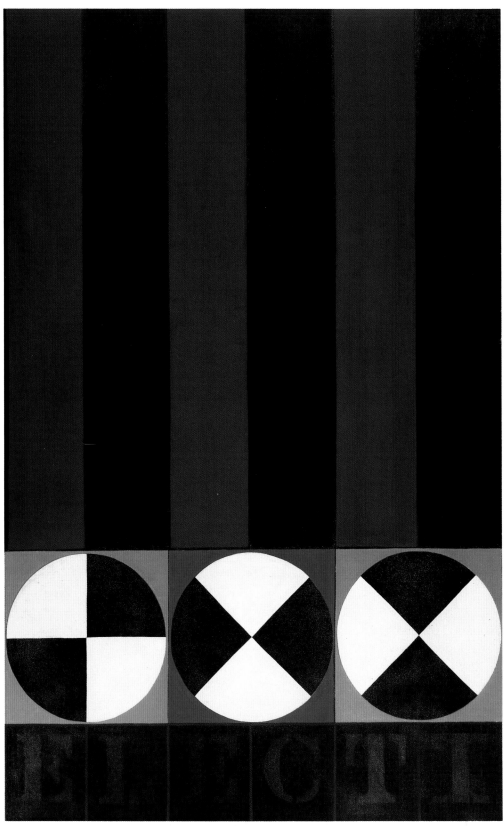

ROBERT INDIANA, *ELECTI*, 1960–1961. OIL ON CANVAS, COLLECTION OF THE ARTIST.

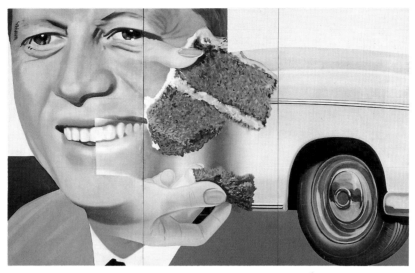

JAMES ROSENQUIST, *PRESIDENT ELECT*, 1960–1961. OIL ON MASONITE, MUSÉE NATIONAL D'ART MODERNE, CENTRE GEORGES POMPIDOU, PARIS.

artist's diary of February 2–3, 1959, as an abstract painting entitled *Agadir*. A later addition to the diary page notes that the picture was repainted, with references to pinball machines and jukeboxes incorporated, to become *The American Dream, I*.

The artists on Coenties Slip soon found a common bond in their opposition to abstract expressionism; and for Indiana this proved to be a decisive period professionally and intellectually. He achieved his first critical and material successes in 1961 and 1962, as he catapulted to art world fame with other artists on the slip *and* with other pop artists such as Warhol and Lichtenstein. In a diary entry early in 1962, Indiana recounted going to the Museum of Modern Art to see his painting *The American Dream, I* and noted that "every painter on the slip" was then represented in the collection.[14] He shared with many of his contemporaries a feeling of cultural renewal following the election of President John F. Kennedy in November 1960. His painting *Electi* (1960–1961) (p. 64) commemorated the event. The original painting, called *Election*, was damaged while being moved from the David Anderson Gallery to Indiana's studio. The artist repaired the picture—"Election" was shortened to "Electi"—and after Kennedy's death it became a metaphor for the eclipsed career of the assassinated President.[15] With its brown and black striations, *Electi* is a mysterious pictorial representation. The letters e-l-e-c-t-i symbolize the event, while the tondo-shaped wheels stand for the televised computers used during election coverage

that year. With its somber color scheme, it celebrates American culture with the same kind of deadpan delivery seen in the contemporaneous American Dream series.

Electi is very different from James Rosenquist's more conventionally pop *President Elect* (1960–1961) (above), with its juxtaposition of Kennedy's portrait, cars, and processed foods. Rosenquist moved into a loft on Coenties Slip in 1960, so it is likely that each artist knew of the other's election painting. If the multiple references in Rosenquist's painting make it seem richly textured, *Electi*'s dark gray lettering on a black background makes that work resist a straightforward legibility. The painting is obviously meant to be read, but at the same time, it strains beyond the viewer's immediate grasp.

Indiana's paintings from the 1960s demonstrate that he had more interest in current events and politics than did his fellow pop artists.[16] This is reflected, in part, in the diaries he kept from 1959 through 1963. For example, his sculpture *French Atomic Bomb* (1960) was initially sketched in the diary below a notation that France had detonated its first atomic bomb in the Sahara Desert in early 1960. A sketch for *Cuba* (1962) appears in an entry dated April 27, 1962 (p. 66), and refers to the problematic state of U.S.-Cuban relations. He made the wood construction entitled *U-2* (1960) in response to the downing of an American reconnaissance plane over the Soviet Union in May 1960.[17]

ROBERT INDIANA, ARTIST'S SKETCH-
BOOK, *CUBA*, APRIL 27, 1962 (DETAIL).
INK AND COLORED MARKER ON PAPER,
COLLECTION OF THE ARTIST.

ANDY WARHOL, *RACE RIOT*, 1964. OIL AND SILKSCREEN ON CANVAS, MUSEUM
OF ART, RHODE ISLAND SCHOOL OF DESIGN, ALBERT PILAVIN MEMORIAL
COLLECTION OF TWENTIETH-CENTURY AMERICAN ART.

Indiana's interest in current events took a turn toward a more directly political engagement in two series of works from the early and mid-1960s dealing with racism and the antiwar movement. "I am stuck with an old-fashioned purpose," he says of these images. "I haven't done a painting without a message."[18] The first picture of the 'Yield' series, *Yield Brother* (1962), a gift for the Bertrand Russell Peace Foundation, was a specific response to Russell's plea for worldwide support for his peace program.[19] "[T]hat the countryside is peppered with 'Yield' signs," Indiana has observed, "hasn't affected the national consciousness much — particularly in our least yielding region entrenched as it is in the doctrines of white supremacy."[20]

His concern with racism led Indiana just three years later to produce the Confederacy series (1965–1966), aimed at the thirteen Secessionist states "where citizens were willing to die for the perpetuation of human slavery."[21] In *The Confederacy: Louisiana* (1966) (p. 67), as in all the pictures from the series, Indiana instructs in circular lettering: "Just as in the anatomy of man every nation must have a hind part." It is interesting to compare these overtly political images with Warhol's Race Riot

series (1963–1964). *Race Riot* (1964) (above) is readily identifiable to viewers who followed the mass-media coverage of the large-scale civil-rights demonstrations and riots in Birmingham, Alabama, in 1963. Warhol made ironic use of a widely reproduced press photograph for his picture.[22] *Race Riot* captures a row of spectators looking away from the brutal scene of a police dog biting a man. Indiana's Confederacy series is less dramatic but more political than Warhol's because he used text to comment on racism rather than to represent it enigmatically through an image, as Warhol did. The series is perhaps the most straightforwardly political of his 1960s work.

It is this political impulse that unifies much of the subject matter of the last thirty-five years of Indiana's art. While the subject of homosexuality as presented in the Hartley Elegies may not seem political per se, these pictures occupy a position within a tradition of social concerns on which Indiana's body of work is built. Further, though the subject matter of the Elegies may at first glance seem highly personal, it has been the lesson of the past twenty years, from the women's movement to AIDS activism, that the personal *is* the political.

ROBERT INDIANA, *THE CONFEDERACY: LOUISIANA*, 1966. OIL ON CANVAS, KRANNERT ART MUSEUM AND KINKEAD PAVILION, UNIVERSITY OF ILLINOIS, CHAMPAIGN .

THE HOMOSEXUAL TRADITION

In order to contextualize the Hartley Elegies fully, it is important to identify the extent to which Indiana's earlier paintings constructed a homosexual narrative, one that became a vehicle through which the artist could mark his own identity as part of the gay subculture of lower Manhattan, even as he formed a connection with the past. These pictures built a historic, homosexual identity—informed by art world references—within the context of pre-Stonewall gay culture. The Stonewall riot constituted the watershed of the gay rights movement nationally and helped establish a climate in which gay women and men were able to speak with increasing freedom about their sexual and emotional experiences. The pictures discussed in this section were painted in the decade before Stonewall, when homosexuality was spoken of in coded references. Indiana abandoned the use of such references by 1989, when he began the Hartley Elegies. In a sense, he "uncoded" Hartley's paintings and made their homoerotic content explicit.

The paintings from the 1960s that constitute a homosexual narrative can be read in several different ways. For example, some of them take as their topic the environs of Coenties Slip and lower Manhattan and have frequently been interpreted in relation to their New York subject matter. However, one must note that Indiana sees significance in the ways the circumstances of his life have intersected with those of Hartley, Crane, and Whitman. The art historian Susan Elizabeth Ryan has termed Indiana's impulse to connect with historical figures through the common bond of place "autogeography."[23] He visualized the connection among history, geography, and psychology in his painting *The Geography of the Memory* (1960/1992) (p. 69). Though his pictures can be read as autogeography, it is critical to keep in mind that the artists and poets he focuses on are homosexual men and women. Therefore, these pictures are assessed here as part of a continuous exploration of the codes and themes of homosexual representation.

The homosexual content of Indiana's pictures is significant within the context of the emergence of a gay self-consciousness among artists just prior to Stonewall. In this way, his Literary paintings—like paintings of the same period by Johns and Rauschenberg—allow us to measure the artist's attempts at enunciating a homosexual identity. In these Indiana paintings, we can gauge how homosexuality is represented, to quote the literary historian Thomas E. Yingling, "once [the homosexual] 'appears' in culture, and once he begins to understand himself as a being of a certain (stigmatized) social order."[24] The challenge in examining the Literary paintings is a positioning of homosexuality as central rather than marginal to the ways we understand the work of homosexual artists and their relationship to our culture. The homosexual narrative built by Indiana's paintings has been overlooked for so long, I think, because they are not homoerotic, nor even titillating in the way that, say, Rauschenberg's *Bed* (1955) is. Though the subjects of these paintings are not obviously sexual, they contain homosexual discourses nonetheless—content that until lately has been elided by critics and historians. The Whitman scholar Michael Moon's arguments about the poet are applicable here: the homosexual content in the works of both Whitman and Indiana is "at all points interactive with other politics or economies [and] for the most part not specifically or obviously erotic."[25]

Indiana's mature painting style developed within the homosexual subculture that formed in the art world in the late 1950s. Besides Ellsworth Kelly, the homosexual artists who lived or worked in the area around Coenties Slip then included Johns, Rauschenberg, John Cage, and Cy Twombly. While Twombly did not have a studio on the slip, he used Indiana's loft in 1956 to prepare for an exhibition at the Stable Gallery. There were many connections between these artists: Twombly and Rauschenberg had been in a relationship in the early 1950s; Kelly had known Cage (who lived nearby on Corlears Hook) in Paris, and through Cage met Rauschenberg in 1954.[26] Indiana became part of this social set when he moved to Coenties Slip, and, on at least one occasion, Johns and Rauschenberg employed him to assist them with the commercial window displays they installed for department stores under the pseudonym Matson-Jones.[27]

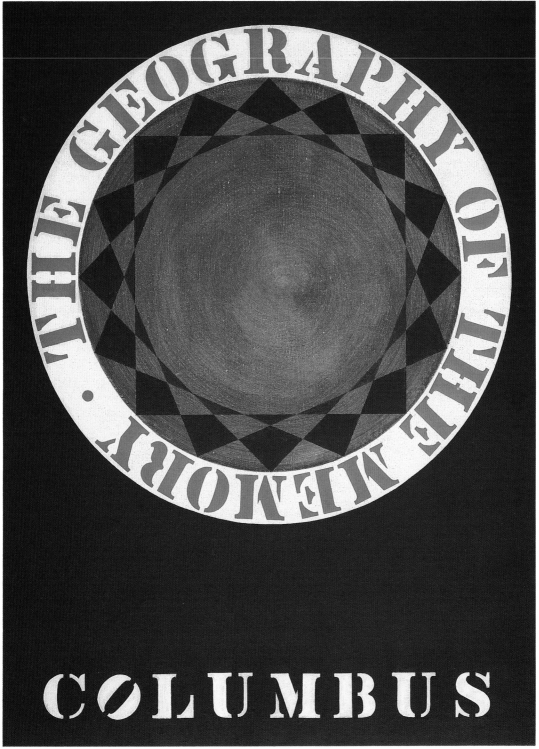

ROBERT INDIANA, *THE GEOGRAPHY OF THE MEMORY*, 1960/1992. OIL ON CANVAS, COLLECTION OF THE ARTIST.

Like the other artists who worked on Coenties Slip, homosexual painters found themselves working in opposition to the heroics and perceived machismo of abstract expressionism. As Andy Warhol recounted in his and Pat Hackett's book *POPism*, the post-abstract expressionist sensibility was a "homosexual one."[28] For homosexual artists, the revelatory quality of abstract expressionism was distasteful. They spent their lives behind a veil of discretion, of double-entendre, and in the closet. Therefore, the idea of a diaristic painting practice predicated on the idea of projecting emotive states onto the canvas seemed implausible and implied a universality of feeling that was not imaginable. The literary historian Robert K. Martin writes of a similar prohibition against feelings in the work of homosexual poets:

> FOR A HETEROSEXUAL MAN . . . THE ADOPTION OF A SOCIAL DEFINITION OF SEXUALITY IS LIKELY TO BE UNCONSCIOUS. BUT FOR THE HOMOSEXUAL MAN, WHO MUST REPEATEDLY OBSERVE THE DIFFERENCES BETWEEN HIS OWN SEXUALITY AND THE PREVAILING ASSUMPTIONS ABOUT 'EVERYMAN,' SEXUAL DEFINITION IS A MATTER OF INDIVIDUAL STRUGGLE AND PERSONAL DECISION . . . THE HOMOSEXUAL IS CONFRONTED WITH THE IMPLICATIONS OF HIS SEXUAL NATURE.[29]

Yet, as the art historian Kenneth Silver observes about the art that emerged in the post-abstract expressionist milieu—the coded compositions of Johns, Rauschenberg, and I would add, Indiana—there "are closets and there are closets." His point is that although much was hidden from view, much was nevertheless revealed, albeit cryptically.[30] The critique of abstract expressionism that Johns and Rauschenberg launched was a deconstructive practice predicated on abstract expressionism's own language—the painterly touch, the rub, and the brushstroke—which the two artists used to unravel abstract expressionist claims to authenticity of feeling. Indiana, on the other hand, bypassed painterly abstraction in favor of a tighter paint handling, a subject matter based on mass culture and consumerism, and the addition of text. Speaking of the opposition between Johns-Rauschenberg and abstract expressionism, the art historian Jonathan Katz has argued:

> THE ABSTRACT EXPRESSIONISTS HELD FAST TO A LARGELY PRE-WAR HEROIC MYTHOLOGY OF THE DISINTERESTED, DISSIDENT INTELLECTUAL CAPABLE OF A UTOPIAN TRANSFORMATIVE ENTERPRISE THROUGH THE LABOR OF MAKING ART. QUEER ARTISTS, IN CONTRAST, DID NOT TURN THEIR BACKS ON THE WORLD BUT RATHER DID WHAT THEY HAD ALWAYS DONE, CONSTRUCTING DISTINCTIONS THROUGH THE RECONTEXTUALIZATION OF THE EXTANT CODES OF CULTURE, REWORKING THOSE CODES TO THEIR OWN BENEFIT. . . . THESE PICTURES DID NOT SEEK TO EVOKE A WORLD APART, A NEW UTOPIA OF THE SUBLIME LIKE ABSTRACT EXPRESSIONISM, BUT RATHER TOOK THE COMMODIFIED RELATIONS OF EVERYDAY LIFE AND TRIED TO DO SOMETHING WITH THEM.[31]

This analysis would certainly fit Indiana's more pop-inflected work, such as *The American Dream, I*. However, it also can be applied as a measure of the Literary paintings, in which he recontextualizes a historical formation—the history of gay artists and poets—"rearranging" it so that the homosexual references are disguised behind a system of codes.

As Johns and Rauschenberg found art world fame in the late 1950s, they became more emphatic that the closet door stay closed. They distanced themselves from other gay artists, especially "swish" artists such as Warhol.[32] Certainly, Indiana felt slighted by them. Describing a studio visit by Johns in 1962, he noted that "Jasper made a . . . point of liking one thing: my deer's head."[33] Indiana was sensitive to the fact that Johns liked the trophy but not the paintings. Despite the rejection, he found Johns and Rauschenberg appealing for obvious reasons: they were two of the most important artists in New York, and they were a couple. Yet, the closet loomed large, and fear that the truth of their relationship would be revealed eventually fractured the union. In 1990 Rauschenberg spoke of their fear of having the fact of their relationship revealed publicly: "What had been tender and sensitive became gossip. It was sort of new to the art world that the two most well-known, up and coming studs were affectionately involved."[34]

The fear of exposure homosexual artists felt in the 1950s was compounded by the homophobia unleashed by Cold War politics. During the postwar years, gay men and women were torn between greater cultural recognition of their existence and the backlash that visibility engendered. Two landmark books by the biologist and sex researcher Alfred C. Kinsey, *Sexual Behavior of the Human Male* (1948) and *Sexual Behavior of the Human Female* (1953)—together commonly known as the Kinsey

Report—revealed an incidence of homosexuality that was considerably higher than presupposed. The Kinsey Report offered a scientific foundation for homosexual practice that could have spawned a widespread revision of attitudes toward gay men and women, a move from the popular notion that homosexuals were "perverts" and toward a perception of homosexuality as a natural part of the sexual realm.[35] The wealth of data Kinsey assembled implicitly encouraged those men and women still struggling in solitude with their sexual identity to accept their homosexuality and search out sexual comrades. As the historian John D'Emilio argues, Kinsey's work "gave an added push at a crucial time to the emergence of an urban gay subculture."[36]

However, the tenor of the McCarthy period was such that the Kinsey Report helped spark a backlash against homosexuals. During the late 1950s and early 1960s, gay men still risked arrest and harassment for attending gay bars and clubs. In particular, there was a major law enforcement crackdown on gay bars in New York City during 1959 and 1960. In D'Emilio's words, "Every evening spent in a gay setting, every contact with another homosexual or lesbian, every sexual intimacy carried a reminder of the criminal penalties that could be exacted at any moment."[37] In 1953 President Dwight D. Eisenhower issued Executive Order 10450, which expanded the parameters of the loyalty program created during the Truman administration to exclude from government employment anyone who engaged in "sexual perversion." As a result, during the course of the decade thousands of gay men and women were blackmailed, blacklisted, and hounded out of government and military jobs. One measurement of the proliferation of homophobia during this period is the rise in numbers of homosexuals discharged from the military. In the late 1940s, about one thousand were discharged per year. This figure doubled by the mid-1950s, and tripled by the early 1960s.[38]

The pall of immorality that already hung over the public perception of homosexuality now widened to include Communism, under the general category of un-American activities. In a July 17, 1950, *New York Post* interview with the journalist Max Lerner, Nebraska Republican Senator Kenneth Wherry commented: "I don't say every homosexual is a subversive, and I don't say every subversive is a homosexual. But a man of low morality is a menace in the government, whatever he is, and they are all tied up together."[39] The senator's sentiments were typical of the period.

Within this context, Indiana's Literary paintings carry a political meaning that is more engaged than previously understood. In these works, he focuses on artists who were both gay and American, and whose work—especially that of Crane and Whitman—was instrumental in the creation of our shared notions of a historical, national character. Thomas Yingling notes that Whitman's poetry—especially *Leaves of Grass*—has been made the central poetic text of American democracy, primarily through submersion of any homoerotic content and an emphasis on its celebrations of American character.[40] The sexual content of work by authors such as Whitman and Crane usually was glossed over by discussions of nationalism, as critics misread, ignored, or simply did not see the ways in which these poets used their texts as vehicles for announcing their homosexuality. Thus in the national-sexual matrix, texts such as those by Whitman signify homosexuality while operating within the language of nationalism. Indiana's accomplishment was to take his cue from Whitman and Crane and embed references that divulged his sexual identity, if only to a specific audience. As an artist, he was able to operate simultaneously within both languages—the homosexual and the national—with a fair degree of confidence regarding the obscurity of the sexual content for audiences not attuned to the references.

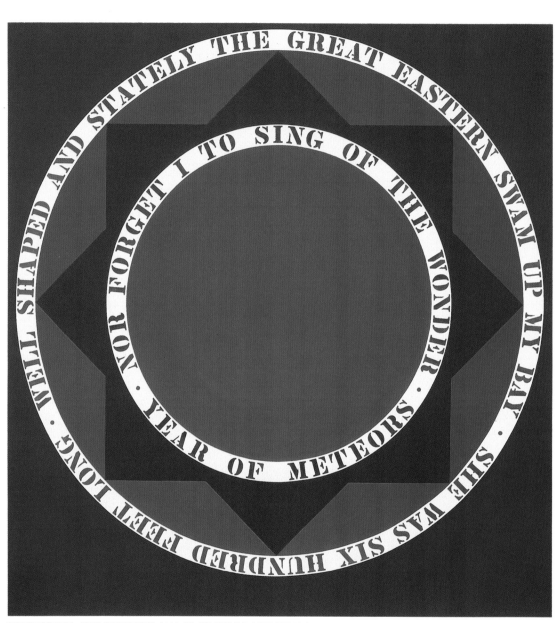

ROBERT INDIANA, *YEAR OF METEORS*, 1961. OIL ON CANVAS, ALBRIGHT-KNOX ART GALLERY, BUFFALO, NEW YORK, GIFT OF SEYMOUR H. KNOX, 1962.

Indiana's *Year of Meteors* (1961) (p. 72), takes its title from Whitman's poem of 1859–1860, included in *Leaves of Grass*. The poem catalogued a year of "spectacles and wonders," not the least of which was the Atlantic crossing of the steamship *Great Eastern*, whose arrival in New York Whitman watched from the Brooklyn side of the harbor. On the painting, Indiana quotes some of Whitman's lines: "Nor forget I to sing of the wonder,/well-shaped and stately the Great Eastern swam up my bay, she was 600 feet long." This is an example of Indiana's sense of "auto-geography," as he sought to connect with Whitman through the common bond of place. Through his studio window on Coenties Slip, Indiana surveyed a view of New York harbor that Whitman also may have had. It is possible to read *Year of Meteors* in several ways, certain of them not sexualized. Unquestionably, Indiana embeds none of the obvious sexual clues that we find, say, in Johns' *Target with Plaster Casts* (1955) (right). As a homosexual text, Indiana's painting has none of the erotic frisson that comes from Johns' simultaneous telling and not-telling of his sexuality. Johns' example is key here, for he was influential to Indiana during this period on many levels. Indiana learned how much the closet could conceal or accommodate by studying Johns' works, the sexual content of which went unnoticed by critics until recently.

Yet, *Year of Meteors* was legible as a homosexual text for those viewers who understood its subcultural codings. The theorist Eve Kosofsky Sedgwick documents that, earlier in the century, Whitman's works functioned "as badges of homosexual recognition" in England.[41] In New York in the 1950s, references to Whitman conjured an association with homosexual identity, especially when a homosexual artist or writer voiced that reference. Thus Indiana's painting signifies far more than the two Whitman lines quoted in it. Whitman, even when he saw himself most clearly as a homosexual, identified himself with America.[42] The same can be said for Indiana—the Yankee painter—who constructed a family tree of great American homosexual artists who had also conflated their homosexuality and their nationalism.

In *The Melville Triptych* (1962) (pp. 74–75), Indiana once again raided American literature for inspiration, quoting a passage from Herman Melville's *Moby-Dick*. The painting consists of three panels focused on Ishmael's wanderings along the lower Manhattan waterfront.

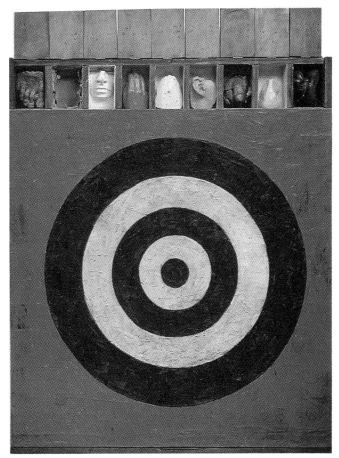

JASPER JOHNS, *TARGET WITH PLASTER CASTS*, 1955. ENCAUSTIC AND COLLAGE WITH PLASTER CASTS, COLLECTION OF LEO CASTELLI.

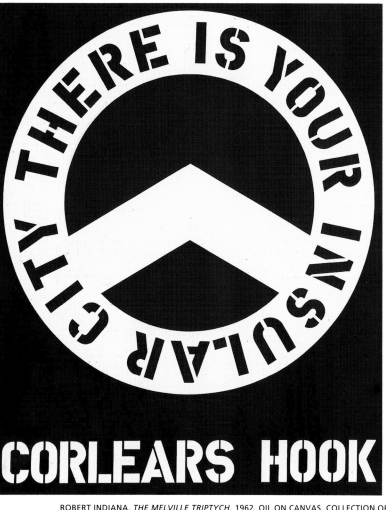

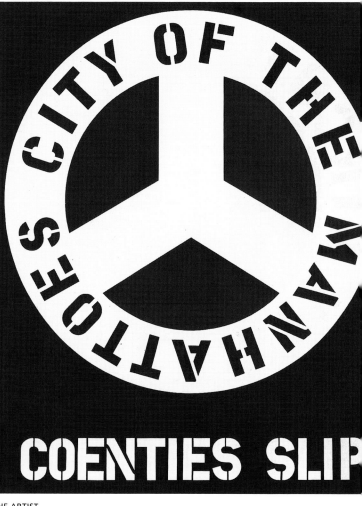

ROBERT INDIANA, *THE MELVILLE TRIPTYCH*, 1962. OIL ON CANVAS, COLLECTION OF THE ARTIST.

LEFT: CONSTANTIN BRANCUSI, *TORSO OF A YOUNG MAN*, CIRCA 1916. MAPLE ON LIMESTONE BASE, PHILADELPHIA MUSEUM OF ART, LOUISE AND WALTER ARENSBERG COLLECTION.

RIGHT: ROBERT INDIANA, ARTIST'S SKETCHBOOK, BRANCUSI'S *TORSO OF A YOUNG MAN*, JUNE 8, 1962 (DETAIL). INK AND COLORED MARKER ON PAPER, COLLECTION OF THE ARTIST.

Indiana has employed stencils, and the stark contrast of black-and-white figuration, to designate the "point of Corlear's Hook, the Y-Form of [Coenties] Slip, and the northward run of Whitehall" that form the highlights of Ishmael's narrative.[43] Here again, Indiana reaches across history, connecting himself, the fictitious Ishmael, and Melville's mid-nineteenth-century experience.

Much has been written about Melville's work and the homosexual content of *Moby-Dick*. This scholarly debate notwithstanding, the uninitiated reader can find clear homoerotic references in the novel—from Queequeg's husbandly embrace of Ishmael to the discussion of the whale's sperm.[44] The passage Indiana quotes is from the second and third paragraphs of the first chapter: "There now is your insular city of the Manhattoes Circumambulate the city of a dreamy Sabbath afternoon.

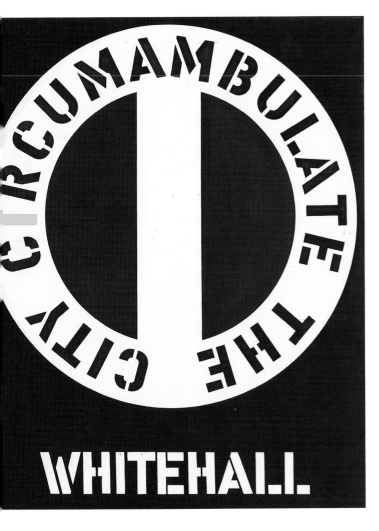

Go from Corlears Hook to Coenties Slip, and from then, by Whitehall, northward."[45] There is little that is sexual here, but when we continue from where Indiana leaves off, Melville rounds the piers of downtown New York:

WHAT DO YOU SEE?—POSTED LIKE SILENT SENTINELS ALL AROUND THE TOWN, STAND THOUSANDS UPON THOUSANDS OF MORTAL MEN FIXED IN OCEAN REVERIES. SOME LEANING AGAINST THE SPILES; SOME SEATED UPON THE PIER-HEADS; SOME LOOKING OVER THE BULWARKS OF SHIPS FROM CHINA; SOME HIGH ALOFT IN THE RIGGING, AS IF STRIVING TO GET A STILL BETTER SEAWARD PEEP. BUT THESE ARE ALL LANDSMEN . . . WHAT DO THEY HERE?[46]

In fact, as noted, the gay subculture of New York located itself along the waterfront of the slips. So this excerpt hypothetically describes Indiana's New York, a waterfront peopled by single men. The lore of the sea was still very much present on Coenties Slip in the late 1950s, par-

ticularly since so many of the buildings the artists occupied had formerly been sail lofts and ship chandleries. Indiana lived across the street from the Seamen's Church Institute, and many of the neighborhood artists—including Indiana and Kelly—would disguise themselves as sailors to take advantage of the cafeteria and showers there.[47]

Further support for a sexualized reading of *The Melville Triptych* can be found in the studies and preparatory notes Indiana made for the painting. In his journal on June 8, 1962, he noted that the inverted Y of the Coenties Slip panel was based on Constantin Brancusi's *Torso of a Young Man* (circa 1916) (p. 74). Brancusi's form is sketched out in Indiana's notebook (p. 74) along with the remark that it is "directly parallel to my 'Coenties Slip' form." Beneath the illustration, Indiana notes, "This is first form I drew in today for my new triad, that is 'The Melville Triad'."[48] Here is an important source for the disguised sexual subject of Indiana's painting, because it provides an example of Indiana's borrowing from art-historical sources as well as the careful coding with which the male figure—here derived from Brancusi—is embedded in his pictures. The reference to Brancusi remains appropriately covert in *The Melville Triptych* in ways similar to Brancusi's sculpture and *Moby-Dick* because all three deal with male sexuality in an elusive manner.

In discussing the homosexual discourse of Indiana's Literary paintings, it is important to recall that both Melville and Whitman were canonical literary figures in the 1950s, largely due to the Harvard professor F. O. Matthiessen and his 1941 book, *American Renaissance*. In fact, Matthiessen devotes nearly half of the book to those two writers.[49] Probably the most influential text in the critical literature of American studies, the book staked out the ground for what came to be termed the American Renaissance. Significantly, Matthiessen was a homosexual who took his own life immediately before he was to appear in front of the House Committee on Un-American Activities (known as HUAC). This committee was charged with ridding American institutions of communists, but it also identified, and professionally ruined, homosexuals in the process. Despite the circumstances surrounding his death, the imprint of Matthiessen's work survives inside the formation of American literature during the postwar years—a formation very much conditioned by gay culture, and, in this instance, by the closet.

Since Indiana's choice of Whitman and Melville as subjects for a series of paintings that were self-consciously literary and surreptitiously homosexual coincided with the establishment of an American literary canon during the postwar years, his selection of Hart Crane's epic 1930 poem, *The Bridge*, as a subject demands a different reading. Much misunderstood in his own lifetime, Crane had a paradoxical reputation in the 1950s. He was considered a central figure in the history of American poetry but was nonetheless found lacking. Critics after World War II thought his poetry "inchoate," intellectually "distorted," and an example of the "disease of his generation."[50] The casting about of such terms as *disease* guaranteed that

Crane would be read as a homosexual, though that word was never used. For intellectuals of Indiana's generation, the translation of such code terms was essential to unraveling their past and finding the "family tree" of homosexual artists.

Indiana's 1964 series of paintings focused on the Brooklyn Bridge is at once a salute to Joseph Stella and his paintings of the structure, begun in 1919, and an homage to Crane and his poem. Crane used the great span as a symbol of reunion and connection in the contemporary world. As a metaphor, the poem refuses to yield an obvious interpretation. In fact, it is difficult to pin specific meaning onto the text. Indeed, some have argued

ROBERT INDIANA, *THE BRIDGE (THE BROOKLYN BRIDGE)*, 1964. OIL ON CANVAS, THE DETROIT INSTITUTE OF ARTS, FOUNDERS SOCIETY PURCHASE, MR. AND MRS. WALTER BUHL FORD, II FUND.

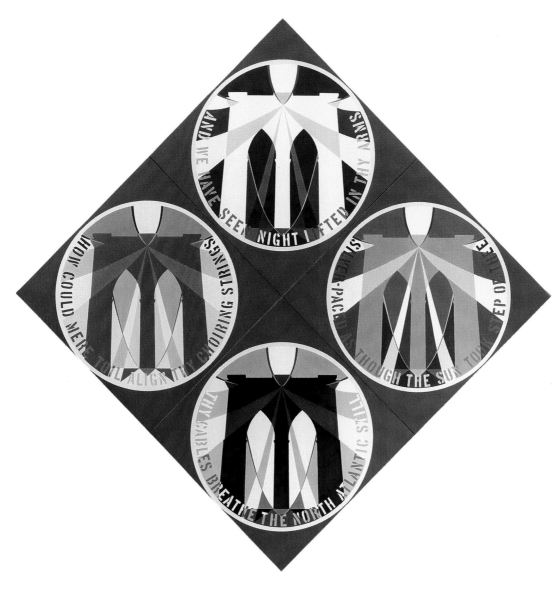

LEFT: JOSEPH STELLA, *THE VOICE OF THE CITY OF NEW YORK INTERPRETED: THE BRIDGE*, 1920–1922. OIL ON CANVAS, COLLECTION OF THE NEWARK MUSEUM, PURCHASE 1937 FELIX FULD BEQUEST FUND.

CENTER: MARSDEN HARTLEY, *EIGHT BELLS FOLLY: MEMORIAL TO HART CRANE*, 1933. OIL ON CANVAS, FREDERICK R. WEISMAN ART MUSEUM, GIFT OF IONE AND HUDSON WALKER.

RIGHT: JASPER JOHNS, *LAND'S END*, 1963. OIL ON CANVAS WITH STICK, SAN FRANCISCO MUSEUM OF MODERN ART, GIFT OF HARRY W. AND MARY MARGARET ANDERSON.

that the writer amended the punctuation merely to increase the poem's ambiguity.[51] For this reason, Crane's text might seem a curious choice for Indiana's series. Certainly, he was attracted by the bridge, which he could see from his studio window. Indiana did three major paintings of the bridge in 1964, and each developed from a source in Stella's series (above). Although Stella's is the first modernist account of the bridge, and the most famous, American artists as varied as Childe Hassam, John Marin, Georgia O'Keeffe, and Joseph Pennell also painted it. For early American modernists such as Marin and Stella, the Brooklyn Bridge became a "symbol of a new mode of existence," one that probably inspired Crane when he saw a Stella painting of the bridge reproduced in *The Little Review* during the autumn of 1922.[52]

The largest painting in Indiana's series is *The Bridge (The Brooklyn Bridge)* (1964) (p. 76). He used four square panels, tipped ninety degrees on axis, to create a lozenge (or diamond-shaped) canvas. On each panel, he executed a representation of the bridge in a range of gray tones, encircled by a gray band. Around the inside border of each circle, he inscribed lines from Crane's poem:

AND WE HAVE SEEN NIGHT LIFTED IN THY ARMS/—
HOW COULD MERE TOIL ALIGN THY CHOIRING STRINGS/—
SILVER-PACED AS THOUGH THE SUN TOOK STEP OF THEE/—
THY CABLES BREATHE THE NORTH ATLANTIC STILL/—[53]

An emphasis on Crane rather than Stella arose not from the poem itself, nor from Indiana's reading of it, but from the mythic figure Crane had become to homosexual authors and artists in the 1950s. Certainly, Crane—the tragic, homosexual poet—generated far more emotional resonance during the period than merely the symbolism of the Brooklyn Bridge would yield. Philip Horton's 1937 biography of the poet was republished in 1957 and widely read by artists and poets. It detailed the events leading up to Crane's 1932 suicide. He jumped from the ship *Orizaba*, 300 miles north of Havana. His death was the subject of Hartley's 1933 painting *Eight Bells Folly, Memorial to Hart Crane* (above). Thus Crane was interesting to both painters.

Perhaps the most immediate source for interpreting Crane's life, for Indiana, was Jasper Johns' *Diver* (1962) and the works related to it. When Johns and Rauschenberg ended their relationship in 1961, Johns returned to his native South Carolina and embarked on a group of paintings that revealed, through carefully coded references, his despondency.[54] In the paintings related to *Diver*, Johns memorialized Crane through the iconography of his shipboard suicide, allowing the poet's tragedy to represent his own melancholy. These works are unexpectedly emotional for the usually guarded Johns, and they mark a turning point in his art. In *Land's End* (1963) (above), Johns illustrates the account in Horton's biography

in which onlookers reported having seen Crane's outstretched arm in the waves for several seconds after he jumped.[55] Johns used his own handprint as a stand-in for Crane's, placing himself in the role of the drowning man. A downward arrow clearly marks the direction of the poet's fall and, by extension, Johns' as well. By comparison, Indiana's *The Bridge (The Brooklyn Bridge)*, painted a year after *Land's End*, appears less involved, and far less committed to revealing a personal self. Even so, by 1964, Indiana's painting carefully aligned itself with Crane and Hartley, and even with Johns.

Only with *The Demuth American Dream No. 5* (1962) (p. 79), his memorial to the painter Charles Demuth, did Indiana begin overtly incorporating his autobiography into the fabric of his pictures. The painting is one of five works he executed on the theme of Demuth's 1928 painting *The Figure Five in Gold* (right). Indiana's canvas is not just an homage but a significant reworking of the original. Demuth's composition was inspired by his friend William Carlos Williams' poem "The Great Figure." On his way to visit Marsden Hartley's studio, Williams had glimpsed a fire engine roaring past, and on the spot he wrote:

AMONG THE RAIN

AND LIGHTS

I SAW THE FIGURE 5

IN GOLD

ON A RED

FIRETRUCK

MOVING

TENSE

UNHEEDED

TO GONG CLANGS

SIREN HOWLS

AND WHEELS RUMBLING

THROUGH THE DARK CITY [56]

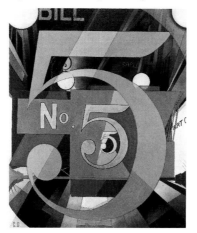

CHARLES DEMUTH, *THE FIGURE FIVE IN GOLD*, 1928. OIL ON COMPOSITION BOARD, THE METROPOLITAN MUSEUM OF ART, THE ALFRED STIEGLITZ COLLECTION, 1949.

RIGHT: JASPER JOHNS, *FIGURE 5*, 1955. ENCAUSTIC AND COLLAGE ON CANVAS, COLLECTION OF THE ARTIST.

In November 1923, Demuth began a series of poster portraits, i.e., emblematic depictions of American artists and writers who were his friends. In these, he meant to communicate something of the subject's psychological character by means of everyday objects, and mass-culture-derived lettering and numbering, all of which made reference to the personality of the portrait's subject.[57] This was a consummately nationalist pose to strike. Indeed, Demuth believed that the future of art rested in American hands, specifically in those of the poets and artists he portrayed.

Demuth's search for an American-based vernacular cobbled out of text and numbers led him to format these poster portraits in a way that resembled advertisements, "thus linking them to what was viewed as a singularly American genre."[58] In this way, his works—especially poster portraits such as *The Figure Five in Gold*—provided Indiana with a kind of preprocessed, nationalist model for transforming himself into the "Yankee" artist in the 1960s. In his poster portrait of Williams, Demuth used the poet's own work—the poem "The Great Figure"—as the iconographic basis of his portrait. The succession of fives, the spelling out of *Bill*, *Carlo*, and *Art Co.* (or *Tart Co.*, if the truncated T is extrapolated)—all are clues toward the identity of Williams, rounding out a cryptic depiction that had its source in portraits created by members of the Walter and Louise Arensberg circle, a group that included the major New York Dadaists. Equally compelling sources were Gertrude Stein's word-portraits, including those of Hartley and Picasso.

By turning to this tradition, Indiana aligned himself with the first American avant-garde, that is, the Stieglitz circle, which from World War I on strove to establish a quintessentially American art. The fact that the work of the Stieglitz circle was sometimes rooted in mass culture proved useful for Indiana, as that was in synch with the pop art aesthetic of the 1960s. This model was irresistible to the artist, who raised the stakes by embedding his

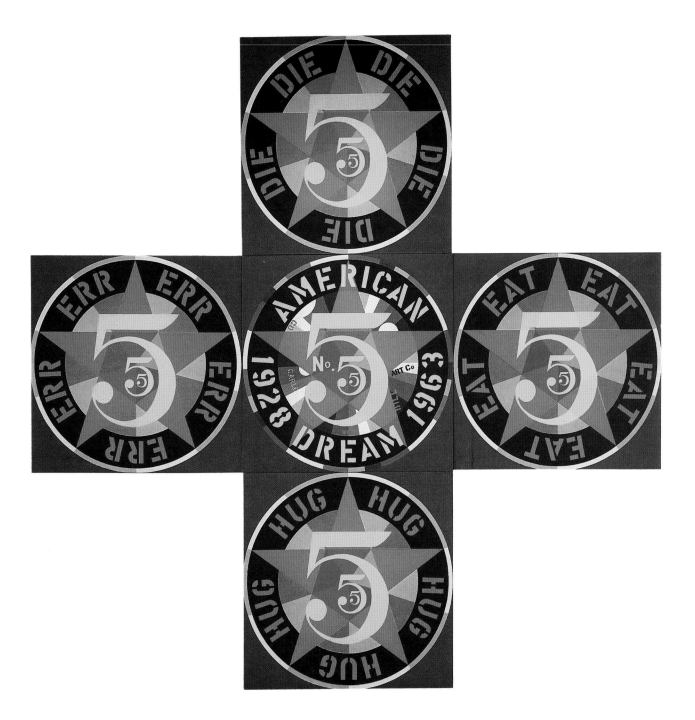

ROBERT INDIANA, *THE DEMUTH AMERICAN DREAM NO. 5*, 1962. OIL ON CANVAS, FIVE PANELS, ART GALLERY OF ONTARIO, TORONTO, GIFT FROM THE WOMEN'S COMMITTEE FUND, 1964.

autobiography within the iconography of the painting, along with the references to Williams.

Indiana's reworking of *The Demuth American Dream No. 5* consists of five panels assembled into the form of a Greek Cross. The central panel is the closest to Demuth's original, reproducing the text from his painting while surrounding it with the words *American Dream* and the years 1928 and 1963. Those years have double meanings: 1963 is the date of Indiana's painting and of William Carlos Williams' death; 1928 is the year of Demuth's canvas and of Indiana's birth. In the surrounding four panels, Indiana carried over the same sequence of fives from Demuth's painting, while adding his own pictorial vocabulary of words and stars, which were derived from his American Dream series. In the four panels that radiate from the central painting, Indiana presents the words *Die*, *Eat*, *Hug*, and *Err*, which were the visual talismans of this period for him.

The Demuth American Dream No. 5 is a kind of collision between Indiana's American Dream series and Demuth's painting. This picture belongs properly to the Literary series because it is another monument to a historically significant gay artist. The fact of Demuth's homosexuality circulated among gay artists and art historians in the 1950s, who were probably aware of the erotic watercolors he had made. Indiana adopted the design of the number five directly from Demuth's painting. Significantly, Johns had lifted the same five for a work of his own, *Figure 5* (1955) (p. 78), likewise an homage to Demuth.[59] Yet, Indiana's is by far the more complicated image, a kind of collaborative reworking that stretches historical boundaries. Indiana said that his version was "in direct dialogue with the original inspiration."[60] By saying this, he was announcing that what operates inside *The Demuth American Dream No. 5* is not strictly a quotation from a historical source but rather something more engaged—a "dialogue."

THE HARTLEY ELEGIES

The Demuth American Dream No. 5 corresponds to Indiana's Hartley Elegies, begun more than twenty-five years later. The Demuth homage represented far more than a mere appropriation, as Indiana saw himself reinvesting Demuth's work with additional content. At one level, of course, it is not really a collaboration, for Demuth was already dead when it was created. Yet, there is a component of physical concurrence here for Indiana, as he embeds himself—his iconography, his birth date, and so forth—onto the surface of Demuth's painting. And, in the same quotation in which he identifies his "dialogue" with Demuth, he refers to the panels surrounding the central picture—with its cruciform shape—as "[t]he head, the arms, the foot" of Demuth's composition, members that "echo and reinforce Demuth's composition."[61] Thus Indiana refers to his cruciform picture as a body, with a head and extremities. In this instance, Indiana invigorated Demuth's work by constructing a body around his original painting, making it more palpable as a physical presence. Its reading as a body aligns it with Rauschenberg's *Bed*, in which the body is figured through its absence.

By now, the extent to which Indiana's Literary paintings from the 1960s are situated in what Kenneth Silver terms a discourse of "gay identity" comes clearly into focus.[62] The addition of Demuth, then Hartley, to Indiana's pantheon came on the heels of the artist's recognition that two of the most important early American modernists were homosexuals.[63] Our understanding of the Hartley Elegies pivots around the operations of *The Demuth American Dream No. 5*, since the two sets of works are of a piece. The Demuth homage provided Indiana with the idea of having a "dialogue" with a deceased artist, a dialogue resulting in his own projection onto the surface of the original work. He repeated this approach in the Hartley Elegies, in which he constructed an emblematic or symbolic portrait of Hartley's relationship to Karl von Freyburg and projected his own identity into it.

What is most striking when examining the homosexual narrative that runs through Indiana's Literary paintings is the connectedness, of a historical and a social sort, that exists between the individual members of the gay family tree. This is the function of the homosexual

tradition, and it has led many gay artists and poets to develop a subject matter involving references to earlier gay artists. Gavin Arthur's 1978 essay "The Gay Succession" outlines a sequence of sexual pairings that began with Walt Whitman and culminated with Allen Ginsberg, and traces the legacy of American poetry along a sexual route.[64] This sense of artistic linkage was very much a part of gay liberationist intellectual life in the 1950s and 1960s, though it operated in various ways. For example, Ginsberg's announcement of his homosexuality in the 1950s was part of the poet's broader project to undermine middle-class American culture and its assumptions. In contrast, Indiana's project, begun in the 1960s, was keyed to establishing a "respectable" homosexuality, one with roots in intellectual life and culture, a homosexuality that would read as non-marginal within the field of cultural production.

This sense of community identity—the shared discourse of "gay identity"—is present in Indiana's paintings, especially in the Hartley Elegies. For in addition to establishing Hartley in a historical framework with other homosexual artists in the Elegies, Indiana defines him as a sexualized man. If one is struck by anything in the Elegies, it is the fact that Indiana has taken what was implicit in Hartley's War Motif series and made it explicit. While Hartley had reticently coded his series to represent von Freyburg, Indiana put that reticence aside and cast the Hartley-von Freyburg union in a heroic light. In pictures such as *KvF II* (p. 83, cat. 23), Indiana unites the two by painting their names around the central ring within the composition. The question of whether Hartley and von Freyburg were actually lovers has been temporarily set aside in the Elegies.

The Hartley Elegies series consists of eighteen paintings made from 1989 to 1994, all derived from the War Motif series.[65] They are grouped according to three basic formats. The first six paintings are traditional rectangles, while the next six are executed on diamond-shaped canvases. The final six pictures share a tondo (or circular) format. The use of shaped canvases, or irregular supports, was a staple of abstract and pop painting in the 1960s. Indiana uses the diamond-shaped format in the Elegies to a dramatic end, transforming their original source in Hartley into something far more hieratic. He makes them look more like signs and less like painting of any conventional sort.

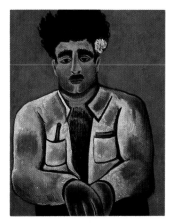

MARSDEN HARTLEY, *ADELARD THE DROWNED*, CIRCA 1938–1939. OIL ON ACADEMY BOARD, FREDERICK R. WEISMAN ART MUSEUM, BEQUEST OF HUDSON WALKER FROM THE IONE AND HUDSON WALKER COLLECTION.

As noted, Indiana was told after moving to Vinalhaven that Hartley had lived in a nearby house in 1938. In a 1981 interview, Indiana predicted that his first major paintings done on Vinalhaven would "be an homage to Hartley, just as I did my series of five paintings in memory of Demuth."[66] He went on to say that he would not make the War Motif series his subject. Initially, he planned to focus on Hartley's late Maine paintings, such as *Adelard the Drowned* (circa 1938–1939) (above), whose style and theme typify Hartley's 1938 work on the island. He executed such pictures as expressions of mourning over the 1936 deaths of his two young friends Donny and Alty Mason. *Adelard the Drowned* is a posthumous allegorical portrait of Alty, with whom he may have had a sexual relationship.[67]

Given his empathy for Hartley's period of mourning on Vinalhaven, Indiana chose not to focus on the allegorical paintings of the Mason family of the late 1930s. Instead, he went further back in Hartley's oeuvre, to the War Motif series, to locate a source for his tribute. He found a continuity between that series and the Mason family paintings, groups of works from two different times in Hartley's life. "It dawned on me after I saw more and more of the German military paintings that here was our real affinity," Indiana has stated. "That with his numbers, [Hartley and I] had a distinct relationship."[68]

One clear link between the two series of pictures is Hartley's framing of homosexual desire within the context of loss and mourning. The art historian Jonathan Weinberg argues that it was the subjects of war and death in the War Motif series that enabled Hartley to express his homosexuality. For Hartley, at least in his paintings, sexual desire is best expressed as mourning, when he "could take this risk because death desexualized and normalized Hartley's relationship with the officer."[69] These pictures depict desire without depicting sexual acts, without bodies, without complications. It is the motif

of mourning that Indiana sounds in his Elegies—as a testament to Hartley, as an acknowledgment of the role that mourning plays in much of Hartley's work, and as a recognition of the poignant role that mourning plays in the lives of gay men in the present age of AIDS.

Hartley began the War Motif series within a month of Karl von Freyburg's death, on October 7, 1914. While we cannot know whether Hartley and von Freyburg were lovers, Hartley "considered their relationship a spiritual marriage, worthy of worship."[70] Whatever the details of their attachment, the homosexual current that runs through the series is undeniable. The subject matter of the pictures—the presence of von Freyburg inside the homosexual subtext—is clear, even if it was hidden from all but a few. Weinberg argues that the system of veiled references in works such as *Portrait of a German Officer* (1914) (p. 29) "mirrors to some degree the obligation homosexuals felt to devise elaborate masks to hide their sexuality and feelings in most daily interchanges."[71] Certainly, homosexuality was not the only risky aspect of the War Motif paintings at the time they were made, for they bespoke a kind of fascination with Germany that of course was unacceptable in the United States during World War I.[72]

In his famous essay of 1917, "Mourning and Melancholia," Sigmund Freud noted that profound mourning involves a

TURNING AWAY FROM EVERY ACTIVE EFFORT THAT IS NOT CONNECTED WITH THOUGHTS OF THE DEAD. IT IS EASY TO SEE THAT THIS INHIBITION AND CIRCUMSCRIPTION IN THE EGO IS THE EXPRESSION OF AN EXCLUSIVE DEVOTION TO ITS MOURNING, WHICH LEAVES NOTHING OVER FOR OTHER PURPOSES OR OTHER INTERESTS.[73]

Freud's theory fits with Hartley's burst of energy on the War Motif canvases, since he turned his productive energy into memorializing his late friend. There is a sense in which Hartley's series is a high romantic *liebestod* (mourning the death of a loved one), a uniting of death and passion made all the more poignant by the fact that this was the only place where he felt comfortable announcing his love. And in this context, love cannot be separated from death. Hartley's pain is apparent in *Portrait* (circa 1914–1915) (p. 46, cat. 12), with its hieratic arrangement of medals, sashes, and emblems representing von Freyburg's military life painted against a black, expressionist backdrop. The art historian Whitney Davis argues that in Freud's account of fetishism, the fetish-image is a

"constructed memory-fantasy," a kind of "personal memorial" fashioned out of desire and born of vision.[74] It is this kind of vision of mourning that occupied Hartley in the War Motif series.

Viewing the series from the perspective of fetishism, one finds that Hartley put this group of paintings together using bits and pieces of von Freyburg's uniforms. He collaged and pasted the painted fragments of buttons and ribbons, cockades and shoulder straps, into "portraits" that were intended to symbolize the German officer.[75] By employing the soldier's uniform, Hartley summoned up one of the most powerful symbols of masculine power available. The art historian Norman Bryson's assessment of the power of the soldier's uniform rests in a construction of the masculine,

. . . IN WHICH MASCULINITY IS PRESENTED AS AN ARRAY OF IMAGOS, COMPELLINGLY IMPRESSIVE TO THE MALE SUBJECT TO WHOM THEY ARE ADDRESSED, AND AT THE SAME TIME DRAWING THEIR POWER TO EXCITE BY GENERATING A GLAMOUR TO WHICH THE SUBJECT ASPIRES BUT WHICH HE DOES NOT YET, AND PERHAPS NEVER CAN, POSSESS. THE HEROIC BODY EXISTS IN THE PERMANENT PLACE OF THE SUPERIOR MASCULINE TO WHICH THE SUBJECT IS ATTRACTED FROM A PLACE DOWN BELOW, OF INFERIORITY, ADORATION, EVEN ABJECTION.[76]

Bryson traces the power of the uniform to its ability to excite male viewers. Such excitement is clearly evident in Hartley's response to Kaiser Wilhelm's cuirassiers, in their "leather breeches skin tight."[77]

A review of Hartley criticism and scholarship reveals that he successfully hid the subject of his paintings for some time in the United States, especially the identity of the "German officer." Critics of his 1916 exhibition at Stieglitz's 291 gallery that included the War Motif series did not discuss the homosexual content of the works. Rather, they occupied themselves with Hartley's ineffective attempt, in an artist's statement accompanying the exhibition, to deflect the criticism that he and his Berlin paintings were pro-German. It was only after his death in 1943 that the sculptor Arnold Rönnebeck, Hartley's friend from Paris and Berlin and von Freyburg's cousin, decoded the symbolism of *Portrait of a German Officer* in a letter to the American collector Duncan Phillips. According to Rönnebeck, Hartley had relied on such emblems as the initials KvF, the numeral 24 (von Freyburg's age when he died), the Iron Cross (awarded to von Freyburg the day before he died), and items such as the Prussian flag to represent von Freyburg, the object

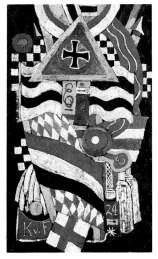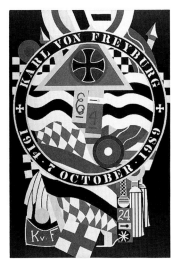

LEFT: MARSDEN HARTLEY, *PORTRAIT OF A GERMAN OFFICER*, 1914. OIL ON CANVAS, THE METROPOLITAN MUSEUM OF ART, THE ALFRED STIEGLITZ COLLECTION, 1949. PLATES, P. 44.

RIGHT: ROBERT INDIANA, *KVF I*, 1989–1994. OIL ON CANVAS, COLLECTION OF THE ARTIST. PLATES, P. 89.

of his desire. But if, to recall Kenneth Silver's phrase, "there are closets and there are closets," then the iconographic references in the War Motif series were legible to some—at least to Arnold Rönnebeck.

As mentioned, in his homage to Demuth, Indiana had chosen to quote that artist's *The Figure Five in Gold*, which is in the collection of the Metropolitan Museum of Art. Significantly, it is another painting from that museum—Hartley's *Portrait of a German Officer* (above)—that Indiana adopted as the specific model for the first of his Hartley Elegies, *KvF I* (above, cat. 22). The painting exerts a guiding influence on the rest of the series. Indiana summarizes Hartley's canvas pretty much verbatim, with the Iron Cross, flags, insignia, lettering, and so on all in place. The difference is to be found largely in the use of color and paint handling. Early in his work on the Elegies, Indiana declared that "Hartley had a very loose edge; I'm going to straighten him up, clarify him, and strengthen him."[78] Indiana transforms the thick, heavily worked surface of Hartley's picture, with its gray tones and mottled whites, into a smoothly executed painting composed of clearly defined, bright hues. The center of *KvF I* is taken up by a ring with Karl von Freyburg's name painted in white lettering on black. The bottom of the ring contains the date October 7, with the years 1914 and 1989. As mentioned, October 7, 1914, was von Freyburg's death date. On October 7, 1989, exactly seventy-five years later,

Indiana began work on the Elegies.[79] Unlike the Demuth series, which focused on only one painting, the Hartley homage makes reference to several of Hartley's most important pictures, including *Portrait of a German Officer*, *Painting No. 49, Berlin* (p. 47), and *Painting, Number 5* (p. 48. cat. 8) (both 1914–1915). In other works, such as *KvF II* (below), Indiana used quotations from several canvases to construct his image.

Perhaps the most important feature of the Hartley Elegies is first seen in *KvF II* (and again in *KvF VIII* [p. 96, cat. 28]). Here, Indiana has painted a ring containing both Hartley's and von Freyburg's names. With this labeling, he has changed the character of the original source, revealing that which Hartley had carefully concealed behind a veil of props and clues. It is one of Indiana's achievements in the Elegies to use the substance of Hartley's feelings for von Freyburg —his desire, his memory, his mourning—as the subject for his homage. In this way, Indiana accomplishes a tricky feat over the course of the series: the pictures themselves are not so much tributes to either man as they are tributes to their relationship. If there is an elegy here, it is to the tragedy

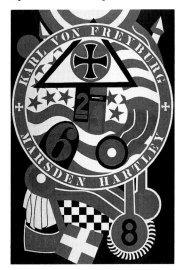

ROBERT INDIANA, *KVF II*, 1989–1994. OIL ON CANVAS, COLLECTION OF THE ARTIST. PLATES, P. 90.

of their relationship—tragic in its ending and tragic in Hartley's inability to speak directly of it, or of his feelings.

As suggested, there is a shared fascination with numerology evident in Indiana's and Hartley's work, particularly concerning the spiritual significance of specific numbers. This common interest has given Indiana the opportunity to quote Hartley's numerological symbols— as well as letters and initials—sometimes reinvesting them with additional, autobiographical meaning. For example, the numeral 8 appears throughout the War Motif series. Hartley associated it with various meanings, including the idea of cosmic transcendence. Additionally, Indiana quotes the letter E, which Hartley used frequently. Rönnebeck interpreted the E in *Portrait of a German*

STUDIO VIEW OF INDIANA'S *KVF*,
1991 (LEFT) AND *MARS*, 1990.
COLLECTION OF THE ARTIST.

Officer as an insignia for the patroness of his own regiment, Queen Elisabeth of Greece. (The E would then of course refer to Rönnebeck, not von Freyburg). Others have suggested that the E stands for Hartley's given first name, Edmund (though it is painted in a script that resembles the regimental E on German uniforms).[80]

Indiana's uses of the E are probably intended to represent Hartley, though he presents it in various ways. In *KvF I* and *KvF VII* (p. 95, cat. 27), among other works in the series, it appears in a German script copied from Hartley's paintings. In other instances, such as *KvF II*, the E is shown in the type of stenciled typography seen in Indiana's work of the 1960s and 1970s. In several of the Elegies, the E is paired with the numeral 4 (as it is in *Portrait*). The 4 was one of Hartley's references to von Freyburg, who, according to Rönnebeck, was a lieutenant in the fourth regiment of the Kaiser's guard.[81] In *Portrait* (p. 46, cat. 12), the number is shown against von Freyburg's shoulder strap. If we accept that the E stands for Edmund, then the joining of the E and the 4, in both Hartley's picture and in Indiana's series, represents an iconic pairing of the two men, side by side in the painting. This pairing is continued in two related sculptures, *Mars* (1990) and *KvF* (1991) (above), which Indiana made while working on the Elegies.

Indiana also uses the numeral 6 frequently in the Hartley Elegies. A single 6 can be found inside the ring in *KvF II*, and a doubled version—a 66—appears in *KvF IX* (p. 97). The number had a long-standing personal significance for Indiana (apart from any reference to Hartley or von Freyburg), and he had used it in such earlier paintings as *USA 666* (1964–1966) and *Polygon: Hexagon* (1962). In these works, the 6 refers to his father, who worked for the Phillips 66 oil company, and who "disappeared behind the big 66 sign in a westerly direction out Route 66" when he deserted his family.[82] In the Elegies, it may also be read as an inverted 9, a number with spiritual significance for Hartley that can be seen over the helmet at the top of *Painting No. 49, Berlin*.

Indiana goes beyond mere quotation by placing his personal symbols within the framework of his paintings dedicated to the Hartley-von Freyburg relationship. Various clues, such as the numeral 6 dropped into the text of the paintings, represent his attempts to make the relationship meaningful for himself, to connect himself to it—literally to "figure" within the pictures themselves. Indiana has spoken of his own relationship with a German officer, "a young man who had fought Americans in World War II and wound up emigrating to the U.S."[83] The Elegies must be read as invested with contemporary feeling—Indiana's empathy with Hartley and Hartley's unsuccessful love life—not merely as signs and symbols quoted from the past. For Indiana intended the Elegies to carry forward the mood of Hartley's *liebestod* and to represent Indiana's identification with it, particularly the sense of loss. He says that "these paintings, with one or two exceptions, are all black. These are paintings in the nineteenth-century concept of mourning. I am mourning the situation just as Hartley did at the time that he did them."[84]

Indiana marks his presence in the Hartley Elegies directly in *KvF III* (right, cat. 24) and *KvF IX* by referring to a famous speech by President Kennedy. Both paintings contain a ring with two quotations: "Ich bin ein Berliner" and "der Amerikanische Maler." The latter reference, of course, is to Hartley, the American expatriate who in a sense "came alive" during his time in Berlin. In this sense, Hartley is "der Amerikanische Maler"—the American painter—who achieved his first important series of paintings while living in the German capital. "Ich bin ein Berliner" also refers to Hartley's status as a Berlin resident, but it is likewise the signature line from Kennedy's address at the West Berlin City Hall on June 26, 1963. With a reported sixty percent of the city's residents in attendance and Cold War tensions running high, Kennedy won the hearts of West Germans when he said: "All free men wherever they may live are

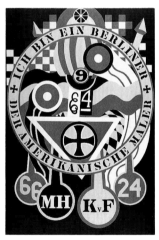

ROBERT INDIANA, *KVF III*, 1989–1994. OIL ON CANVAS, COLLECTION OF THE ARTIST. PLATES, P. 91.

citizens of Berlin. . . . And therefore, as a free man, I take pride in the words 'Ich bin ein Berliner.'"[85] As noted, Kennedy had figured in Indiana's painting *Electi*, and with the quote, Indiana refers to his own past as well as Hartley's. Indiana's comparison of Hartley and Kennedy is a tribute to these two men who both "put themselves forward to make a positive identification with Germany."[86] Four epaulets hang from the central circle of *KvF III*: two carry the initials MH (for Marsden Hartley) and KvF (for Karl von Freyburg); the other two epaulets are inscribed with the age of each man at his death, 24 for von Freyburg, and 66 for Hartley.

KvF IV (p. 92, cat. 25) takes as its model Hartley's *Painting, Number 5*, which is far more abstract than other paintings in the War Motif series. Its accumulation of flags, banners, badges, cockades, and other such items creates an almost seamless surface. This was Hartley's version of flat-patterned cubism at its best. Little of the space in the painting is defined, and it bears none of the figural qualities that characterize *Portrait*. Like its model, *KvF IV* is more abstract than the preceding three paintings in the series, yet Indiana seems to capitalize on the lack of symbols to plant autogeographical references both to himself and Hartley. His palette is reduced to a range of grays, similar to the grisaille treatment in *The Bridge (The Brooklyn Bridge)*. The ring is nearly centered, and in it Indiana has inscribed the names of places where Hartley lived: Lewiston (his birthplace), New York City, Berlin, Ellsworth, and Vinalhaven. Some of Hartley's places of residence are missing from this list, and some of the included places are ones where Indiana also has lived. Both Hartley and Indiana resided in New York City and on Vinalhaven; the reference to Ellsworth is probably both to Ellsworth, Maine, where Hartley died, and to Indiana's relationship with Ellsworth Kelly. Two other elements in the painting are references to the intersection between Indiana's and Hartley's lives. In the half-moon disk at the bottom, Indiana has inscribed the years 1938 and 1969, when each artist first visited Vinalhaven. Second, in the lower-right quadrant is a diagonally oriented gray strip with the initials TvB. This is a reference to Indiana's friendship with fellow Vinalhaven dweller and artist Tad Beck, humorously Germanized as "Theodore von Beck" in this arrangement.[87]

Robert Indiana is quick to join in the recognition that we do not really know whether Hartley and von Freyburg were lovers. Though Hartley wrote rapturously of von Freyburg, the German's letters to Hartley were reserved by comparison. Hartley avoids direct sexual references in *Portrait of a German Officer*, and so, too, does Indiana in his homages. Yet, if the context is not always a sexual one, it is at least a *homosocial* one. The term homosocial, a neologism, is useful in characterizing the kinds of structures that bind men in same-sex relationships—male bonding, though not necessarily of a sexual nature.[88]

The key to understanding the homosocial aspect of Indiana's Hartley Elegies rests in three words that appear in *KvF V* (p. 93, cat. 26) and *KvF X* (p. 98, cat. 29). In each picture is a ring bearing Hartley's and von Freyburg's names, above which are the words *Truth*, *Friendship*, and *Love*. This is a slight variation on the motto of the Independent Order of Odd Fellows, which was "Friendship, Love, and Truth."[89] The significant placement of this motto in the Hartley Elegies can be traced to Indiana's residence, the Star of Hope, which, it will be recalled, was formerly an Odd Fellows hall. *Friendship, Love, and Truth* was the kind of promise put forth by the numerous fraternal organizations that flourished in this country and abroad during the nineteenth and early twentieth centuries. The Odd Fellows were modeled on the Masons, and between them the two organizations had one million members in the United States in 1900.[90] The Odd Fellows was the very sort of organization that might be called homosocial: by excluding women, it emphasized men's independence from them and dependence upon one another.[91]

The Vinalhaven Odd Fellows hall thus provided Indiana with the perfect setting in which to frame his Elegies. Interestingly, the culture of fraternal societies such as the Odd Fellows was steeped in both ritual and coded identification symbols. One anti-Odd Fellows tract published in 1878 took exception to the system of signs that brothers in the order used: "all manner of signs with the hands and fingers, in order either to make one's self known to the brethren, to implore help, or to warn a brother; all manner of grips when shaking hands."[92] To this critic, such gestures seemed unhealthy and certainly un-Christian in their secrecy. There was aptness, then, in Indiana's adoption of the language of Odd Fellowship, with its fraternal affection, to characterize the Hartley-von

Freyburg relationship. Just as the Odd Fellows had relied on a system of codes to recognize each other, so did pre-Stonewall gay men depend on a system of shared signs for mutual identification, and for the purposes of developing a community.

In the Elegies, Indiana sought to represent Hartley's despondency over the loss of a "great friendship which ended in grief."[93] One can find significance in Indiana's transposition of the word *truth* from the last position in the Odd Fellows' motto — Friendship, Love, Truth — to first position in the Hartley Elegies — Truth, Friendship, Love. In making plain the terms of Hartley's love for von Freyburg, Indiana has insisted upon the truth, upon rewriting history to reflect positively the emotional and possibly sexual relationship that the two men had and that was veiled for so long. Perhaps Indiana's adjustment of the motto is meant as a reflection of contemporary gay relationships, in which the first insistence should be upon "truth" — as a refusal of the closet.

NOTES

1 Quoted in Townsend Ludington, *Marsden Hartley: The Biography of an American Artist* (Boston: Little, Brown, 1992), 258.

2 Ibid., 264.

3 Robert Indiana, interview with the author, July 30, 1994.

4 Quoted in John D'Emilio, *Sexual Politics, Sexual Communities: The Making of a Homosexual Minority in the United States, 1940–1970* (Chicago: University of Chicago Press, 1983), 232.

5 For a discussion of homosexuality in Hartley's work, see Jonathan Weinberg, *Speaking for Vice: Homosexuality in the Art of Charles Demuth, Marsden Hartley and the First American Avant-Garde* (New Haven: Yale University Press, 1993).

6 Indiana has called his paintings derived from subjects in American literature the Literary paintings.

7 For a discussion of the relations between Europe and America after World War II, see Serge Guilbaut, *How New York Stole the Idea of Modern Art*, trans. Arthur Goldhammer (Chicago: University of Chicago Press, 1983). For an account of the critical and artistic situation in New York in the early 1960s, see *Definitive Statements: American Art, 1964–66*, exh. cat. (Providence, R.I.: David Winton Bell Gallery of Art, Brown University, 1986).

8 Quoted in John W. McCoubrey, *Robert Indiana*, exh. cat. (Philadelphia: Institute of Contemporary Art, 1968), 9.

9 Robert Indiana, *Early Sculpture: 1960–62*, exh. cat. (London: Salama-Caro Gallery, 1991), 11; and Mildred Glimcher, *Indiana, Kelly, Martin, Rosenquist, Youngerman at Coenties Slip*, exh. cat. (New York: Pace Gallery, 1993), 7–8.

10 Robert Indiana, interview with Richard Brown Baker, September 12, 1963, Archives of American Art, Smithsonian Institution, Washington, D.C.

11 Paul Taylor, "Love Story," *Connoisseur* 221, no. 955 (August 1991): 94.

12 For information about Kelly's years in France, see Michael Plante, "The 'Second Occupation': American Expatriate Painters and the Reception of American Art in Paris, 1946–58" (Ph.D. diss., Brown University, 1992); and Yve-Alain Bois et al., *Ellsworth Kelly: The Years in France, 1948–1954* (Washington, D.C.: National Gallery of Art, 1992).

13 Indiana-Baker interview.

14 Indiana personal papers.

15 Susan Elizabeth Ryan, "Figures of Speech: The Art of Robert Indiana, 1958–73," (Ph.D. diss., University of Michigan, 1992), 157.

16 His major objection to the AIDS posters produced by Group Material, which appropriated the color and design of his Love paintings, is that they beat him to the punch. Indiana-author interview.

17 Virginia Mecklenburg, *Wood Works: Constructions by Robert Indiana*, exh. cat. (Washington, D.C.: Smithsonian Institution Press for the National Museum of American Art, 1984), 26.

18 Carl J. Weinhardt, Jr., *Robert Indiana* (New York: Harry N. Abrams, 1990), 80.

19 McCoubrey, *Robert Indiana*, 20.

20 Ibid.

21 Ibid.

22 *Works of Art from the Albert Pilavin Collection: Twentieth Century American Art* (Providence, R.I.: Museum of Art, Rhode Island School of Design, 1969), 1, 24.

23 Ryan, "Figures of Speech," 247.

24 Thomas E. Yingling, *Hart Crane and the Homosexual Text: New Thresholds, New Anatomies* (Chicago: University of Chicago Press, 1990), 2.

25 Michael Moon, "Disseminating Whitman," *South Atlantic Quarterly* 88 (Winter 1989): 251. As quoted in Yingling, *Hart Crane*, 5.

26 Jonathan Katz, "The Art of Code: Johns and Rauschenberg," in *Significant Others: Creativity and Intimate Partnership*, Whitney Chadwick and Isabelle de Courtivron, eds. (London: Thames and Hudson, 1993), 194.

27 Indiana-author interview.

28 Andy Warhol and Pat Hackett, *POPism: The Warhol '60s* (New York: Harcourt, Brace, Jovanovich, 1980), 11–13.

29 Robert K. Martin, *The Homosexual Tradition in American Poetry* (Austin: University of Texas Press, 1979), xvi.

30 Kenneth E. Silver, "Modes of Disclosure: The Construction of Gay Identity and the Rise of Pop Art," in *Hand-Painted Pop: American Art in Transition, 1955–62*, Russell Ferguson, ed. (New York: Rizzoli International Publications for the Museum of Contemporary Art, Los Angeles, 1992), 181–183.

31 Jonathan Katz, "Culture and Subculture: On the Social Utility of Queer Artists in Cold War American Art," paper presented at College Art Association annual conference, February 1990, unpublished manuscript.

32 Silver, "Modes of Disclosure," 193–194.

33 Indiana personal papers.

34 Paul Taylor, "Robert Rauschenberg: I Can't Even Afford My Work Anymore," *Interview* 20, no. 12 (December 1990): 146–148.

35 Salvatore J. Licata, "The Homosexual Rights Movement in the United States," *Journal of Homosexuality* 6, nos. 1 and 2 (Fall–Winter 1980–1981): 167.

36 D'Emilio, *Sexual Politics, Sexual Communities*, 37.

37 Ibid., 49–50.

38 John D'Emilio, *Making Trouble: Essays on Gay History, Politics and the University* (London: Routledge, 1992), 61.

39 Max Lerner, *The Unfinished Country: A Book of American Symbols* (New York: Simon and Schuster, 1959), 311–313; repr. in Jonathan Ned Katz, *Gay American History: Lesbians and Gay Men in the U.S.A.*, rev. ed. (New York: Meridian, 1992), 95.

40 Yingling, *Hart Crane*, 13.

41 Eve Kosofsky Sedgwick, *Between Men: English Literature and Male Homosocial Desire* (New York: Columbia University Press, 1985), 206.

42 Martin, *The Homosexual Tradition*, 167.

43 McCoubrey, *Robert Indiana*, 9.

44 This is an admittedly limited reading of *Moby-Dick*'s appeal as a subject for painting during the 1950s and 1960s in the United States. One could trace the appeal of Melville's novel as a Cold War text, and it inspired paintings during the period by Sam Francis, Paul Jenkins, and Jackson Pollock, among others.

45 Herman Melville, *Moby Dick* (New York: Modern Library, 1926), 1–2.

46 Ibid., 2.

47 Glimcher, *Coenties Slip*, 8.

48 Indiana personal papers.

49 See F. O. Matthiessen, *American Renaissance: Art and Expression in the Age of Emerson and Whitman* (London: Oxford University Press, 1941).

50 R. P. Blackmur, *Language as Gesture* (New York: Harcourt, Brace and Company, 1952), 316. As quoted in Yingling, *Hart Crane*, 17.

51 Paul Giles, *Hart Crane: The Contexts of* The Bridge (Cambridge, England: Cambridge University Press, 1986), 214.

52 Barbara Haskell, *Joseph Stella*, exh. cat. (New York: Whitney Museum of American Art and Harry N. Abrams, 1994), 100–105.

53 Hart Crane, *Complete Poems of Hart Crane*, ed. Marc Simon (New York: Liveright, 1986), 43–44. The painting reproduces lines 36, 30, 13, 14, and 24, respectively, of the introduction to *The Bridge*, entitled "To Brooklyn Bridge." There are small adjustments of punctuation, and line 36 actually reads: "And we have seen night lifted in *thine* arms," whereas Indiana substitutes *thy* for *thine.*

54 Katz, "The Art of Code": 205–206.

55 Philip Horton, *Hart Crane: The Life of an American Poet* (New York: Viking Press, 1957), 302; quoted in Roberta Bernstein, *Jasper Johns' Painting and Sculptures, 1954–74, 'The Changing Focus of the Eye'* (Ann Arbor, Mich.: UMI Research Press, 1985), 109. Bernstein notes on p. 231 that a copy of the Horton biography is in Johns' library.

56 Quoted in Weinhardt, *Robert Indiana*, 107.

57 Barbara Haskell, *Charles Demuth*, exh. cat. (New York: Whitney Museum of American Art and Harry N. Abrams, 1987), 172–173.

58 Ibid., 174.

59 Silver, "Modes of Disclosure," 185.

60 McCoubrey, *Robert Indiana*, 27.

61 Ibid.

62 Silver, "Modes of Disclosure," 185.

63 Ibid., 186.

64 Gavin Arthur, "The Gay Succession: Walt Whitman Slept with Edward Carpenter; Edward Carpenter Slept with Gavin Arthur; Gavin Arthur Slept with Dean Moriarty; Dean Moriarty Slept with Allen Ginsberg; Allen Ginsberg Slept with . . .," *Gay Sunshine Journal* 35 (1978): repr. in *Gay Roots: Twenty Years of Gay Sunshine*, ed. Winston Leyland (San Francisco: Gay Sunshine Press, 1991), 323–324.

65 For a discussion of the War Motif paintings, see Patricia McDonnell's essay in this catalogue.

66 Mary Swift, "Robert Indiana," *Washington Review* (December–January 1981–1982): 24–25; clipping file, National Museum of American Art, Washington, D.C.

67 Barbara Haskell, *Marsden Hartley*, exh. cat. (New York: Whitney Museum of American Art and New York University Press, 1980), 100.

68 Indiana-author interview.

69 Weinberg, *Speaking for Vice*, 159.

70 Quoted in Haskell, *Marsden Hartley*, 43.

71 Weinberg, *Speaking for Vice*, 32.

72 For a discussion of the issue of American nationalism and German culture, see Patricia McDonnell, "American Artists in Expressionist Berlin: Ideological Crosscurrents in the Early Modernism of America and Germany, 1905–1915" (Ph.D. diss., Brown University, 1991).

73 Sigmund Freud, "Mourning and Melancholia," in *A General Selection from the Works of Sigmund Freud*, John Rickman, ed. (New York: Anchor books, 1989), 125–126; quoted in Douglas Crimp, "Mourning and Militancy," in *Out There: Marginalization and Contemporary Cultures*, Russell Ferguson et al., eds. (Cambridge, Mass.: MIT Press, 1990), 235.

74 Whitney Davis, "HomoVision: A Reading of Freud's `Fetishism,'" *Genders* 15 (Winter 1992): 110.

75 For a detailed explanation of the various regalia represented in the War Motif series, see William Robinson, "Marsden Hartley's *Military*," *Bulletin of the Cleveland Museum of Art* 76, no. 1 (January 1989): 2–26.

76 Norman Bryson, "Géricault and `Masculinity'," in *Visual Culture: Images and Interpretations*, Norman Bryson et al., eds. (Hanover, N.H.: Wesleyan University Press and University Press of New England, 1994), 245.

77 Marsden Hartley, "Somehow a Past," unpublished memoir, unpaginated, Yale Collection of American Literature, Beinecke Rare Book and Manuscript Library, Yale University; quoted in Robinson, "Hartley's *Military*": 9.

78 Carl Little, "Robert Indiana at the Portland Museum of Art," *Art in America* 79, no. 10 (October 1991): 162.

79 Indiana-author interview.

80 Weinberg, *Speaking for Vice*, 152.

81 Robinson, "Hartley's *Military*," 16.

82 Robert Indiana, "Autochronology" in Ryan, "Figures of Speech," 443.

83 Susan Elizabeth Ryan, "Elegy for an Exile," *Art and Antiques* 20 (May 1991): 109.

84 Indiana-author interview.

85 Thomas G. Paterson, ed. *Kennedy's Quest for Victory: American Foreign Policy: 1961–1963* (Oxford: Oxford University Press, 1989), 55.

86 Indiana-author interview.

87 Ibid.

88 Sedgwick, *Between Men*, 1–2.

89 Aaron B. Grosh, *The Odd-Fellow's Manual: History, Principles, and Government of The Order, and the Instructions and Duties of Every Degree, Station and Office in Odd-Fellowship.* (Philadelphia: H. C. Peck and Theo. Bliss, 1858), 54.

90 Mary Ann Clawson, *Constructing Brotherhood: Class, Gender and Fraternalism* (Princeton, N.J.: Princeton University Press, 1989), 7.

91 Ibid., 17.

92 J. H. Brockmann, *Oddfellowship, Its Doctrine and Practice Examined in the Light of God's Word* (Chicago: Ezra A. Cook, 1878), 143–144.

93 Indiana-author interview.

INDIANA

[HARTLEY ELEGIES]

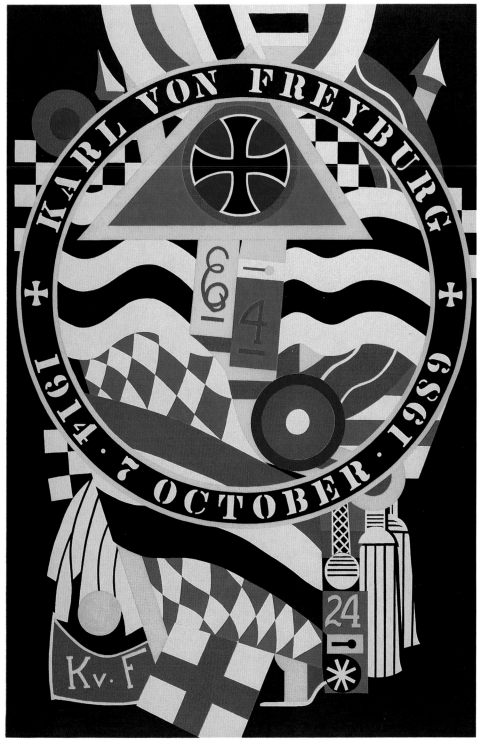

KVF I, 1989–1994. OIL ON CANVAS, COLLECTION OF THE ARTIST.

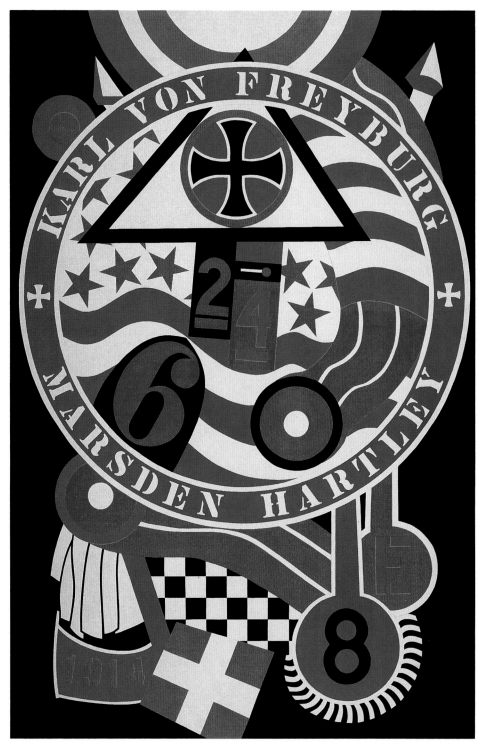

KVF II, 1989–1994. OIL ON CANVAS, COLLECTION OF THE ARTIST.

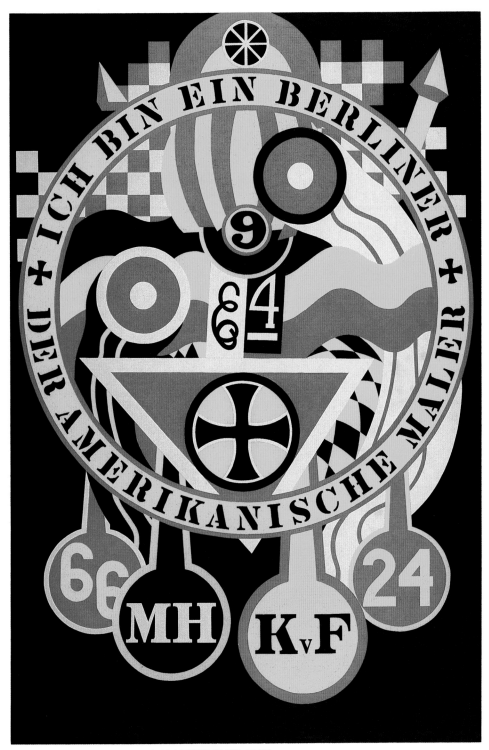

KVF III, 1989–1994. OIL ON CANVAS, COLLECTION OF THE ARTIST.

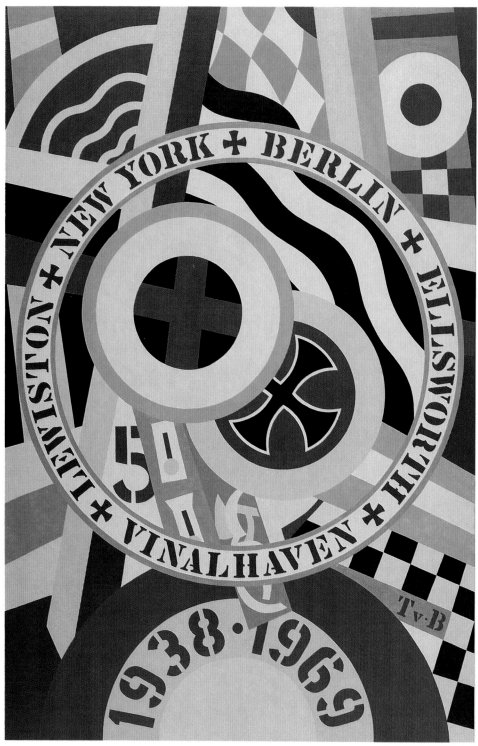

KVF IV, 1989–1994. OIL ON CANVAS, COLLECTION OF THE ARTIST.

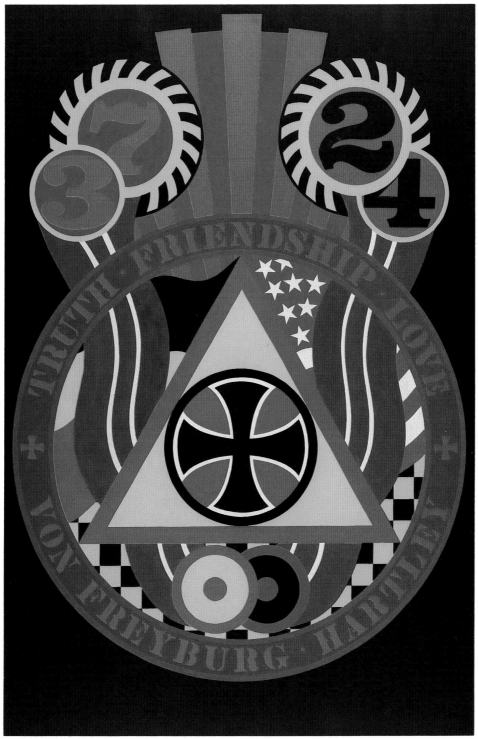

KVF V, 1989–1994. OIL ON CANVAS, COLLECTION OF THE ARTIST.

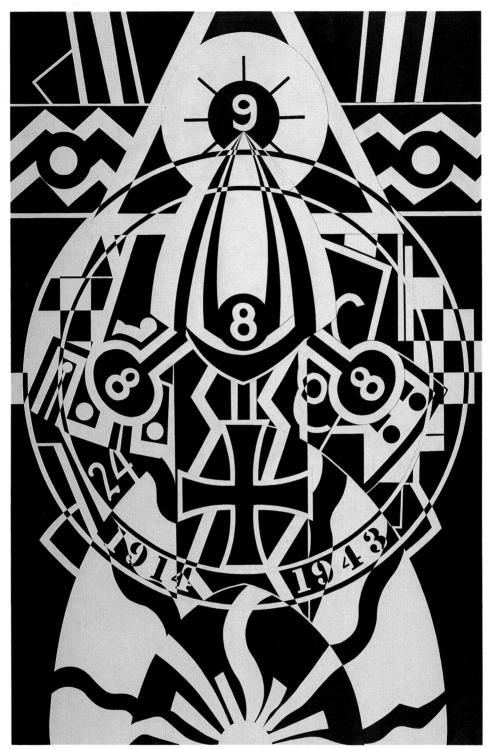

KVF VI, 1989–1994. OIL ON CANVAS, COLLECTION OF THE ARTIST.

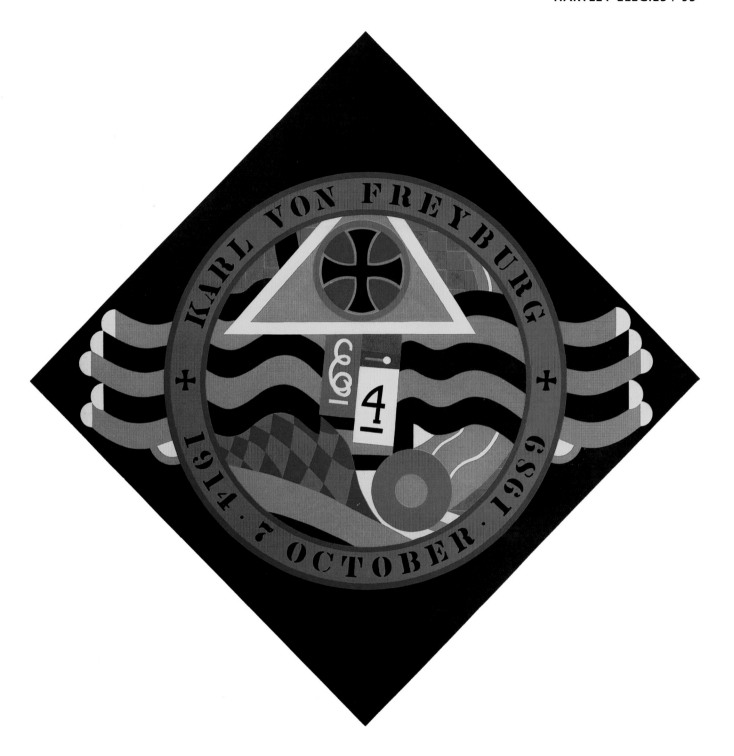

KVF VII, 1989–1994. OIL ON CANVAS, COLLECTION OF THE ARTIST.

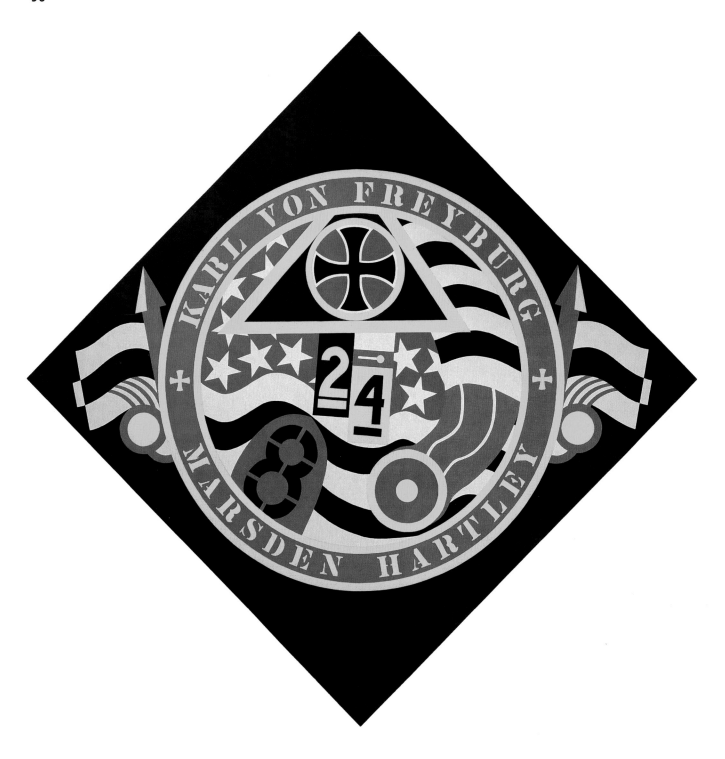

KVF VIII, 1989–1994. OIL ON CANVAS, COLLECTION OF THE ARTIST.

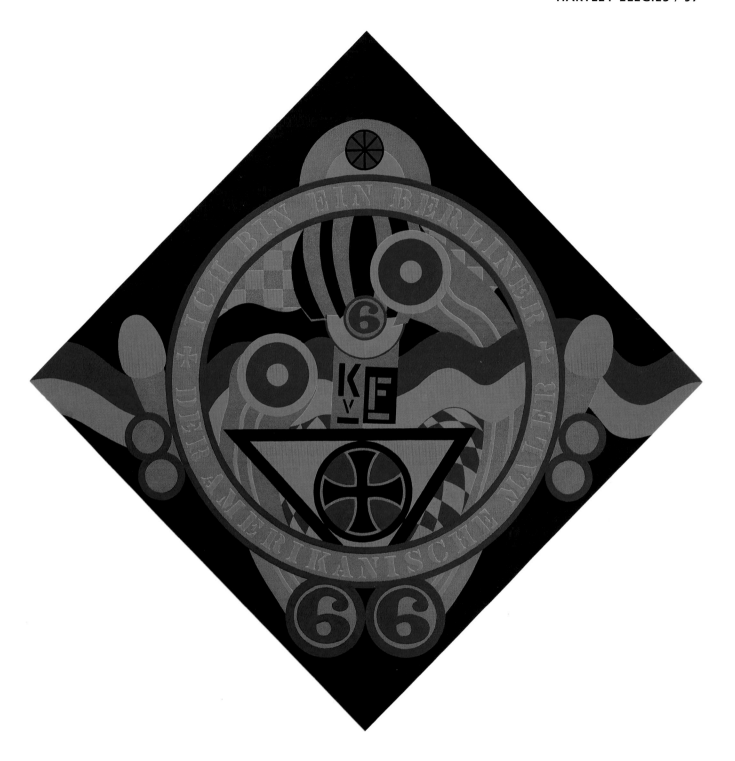

KVF IX, 1989–1994. OIL ON CANVAS, COLLECTION OF TAD BECK.

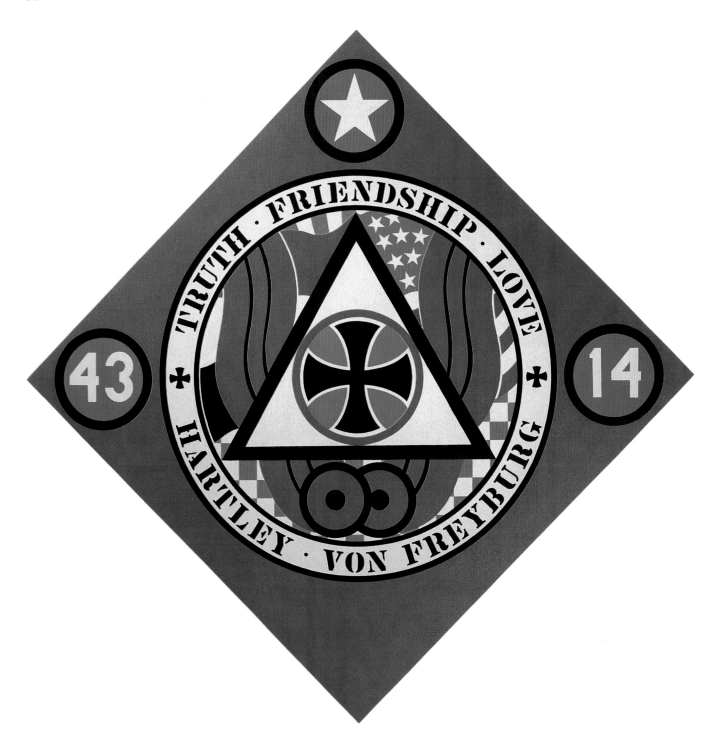

KVF X, 1989–1994. OIL ON CANVAS, COLLECTION OF THE ARTIST.

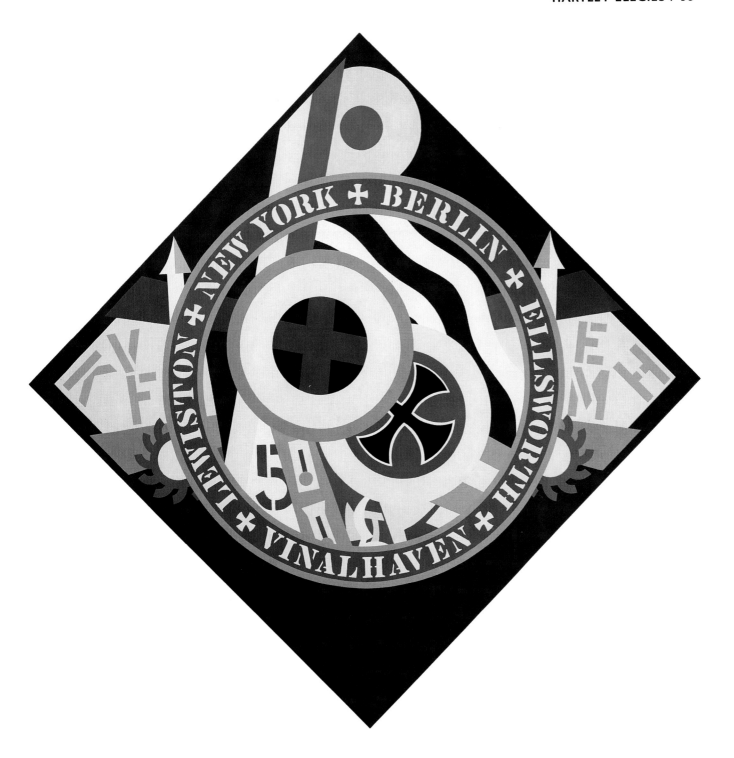

KVF XI, 1989–1994. OIL ON CANVAS, COLLECTION OF THE ARTIST.

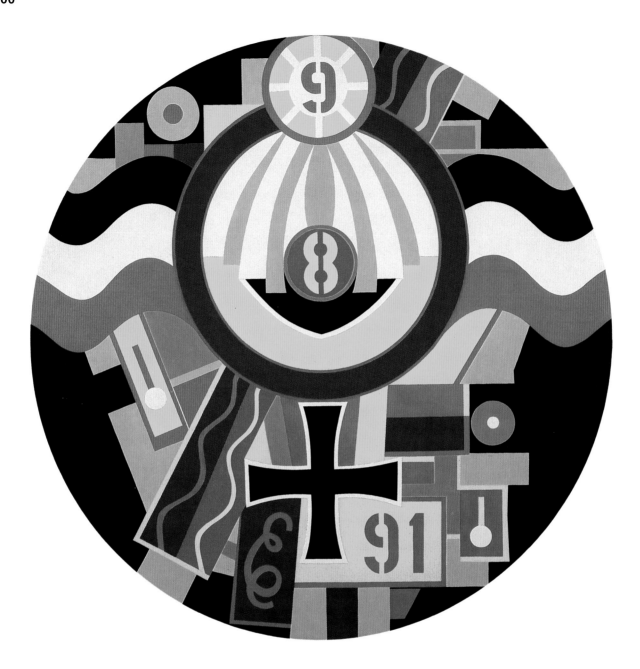

KVF XIII, 1989–1994. OIL ON CANVAS, COLLECTION OF THE ARTIST.

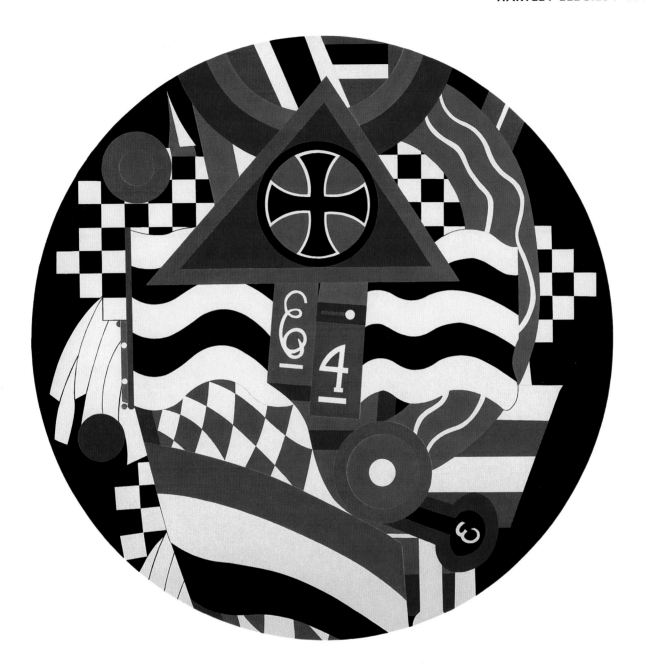

KVF XIV, 1989–1994. OIL ON CANVAS, COLLECTION OF THE ARTIST.

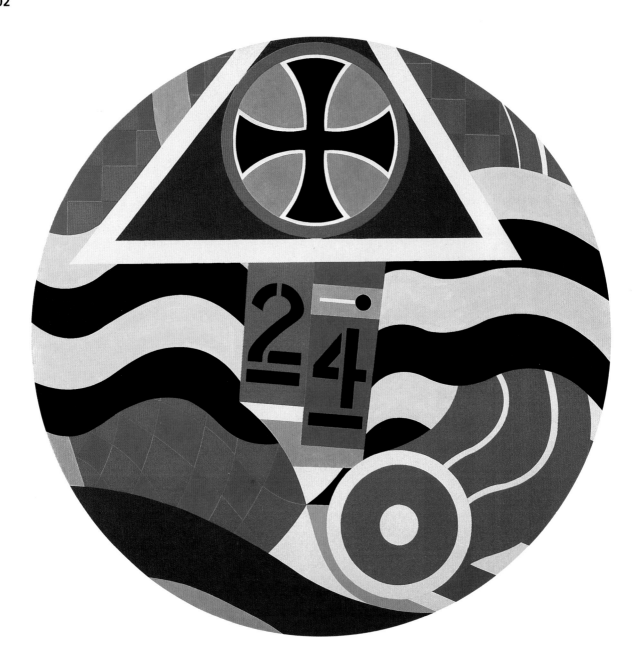

KVF XV, 1989–1994. OIL ON CANVAS, COLLECTION OF THE ARTIST.

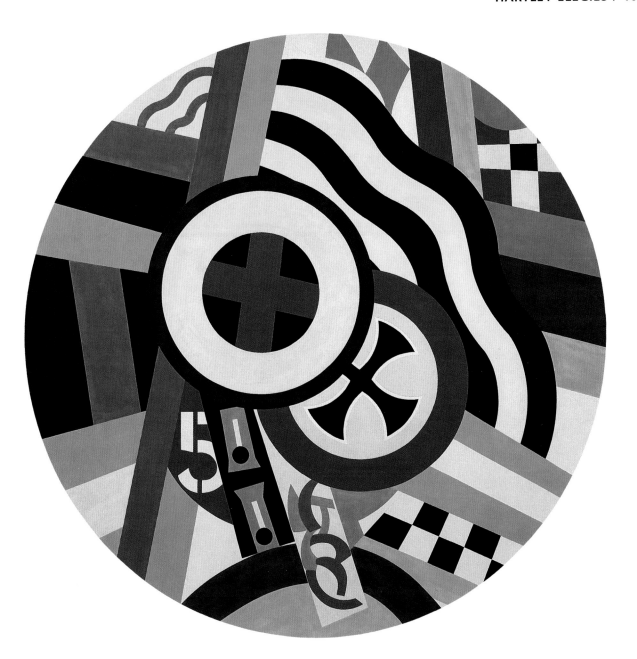

KVF XVI, 1989–1994. OIL ON CANVAS, COLLECTION OF THE ARTIST.

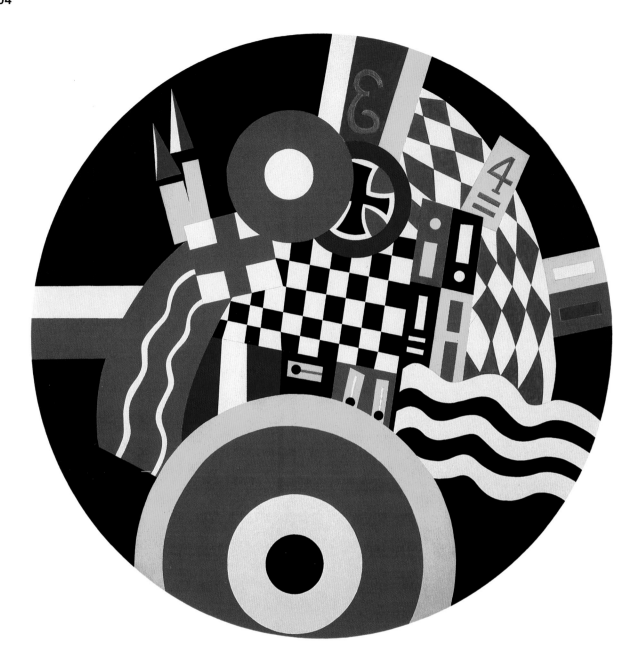

KVF XVII, 1989–1994. OIL ON CANVAS, COLLECTION OF THE ARTIST.

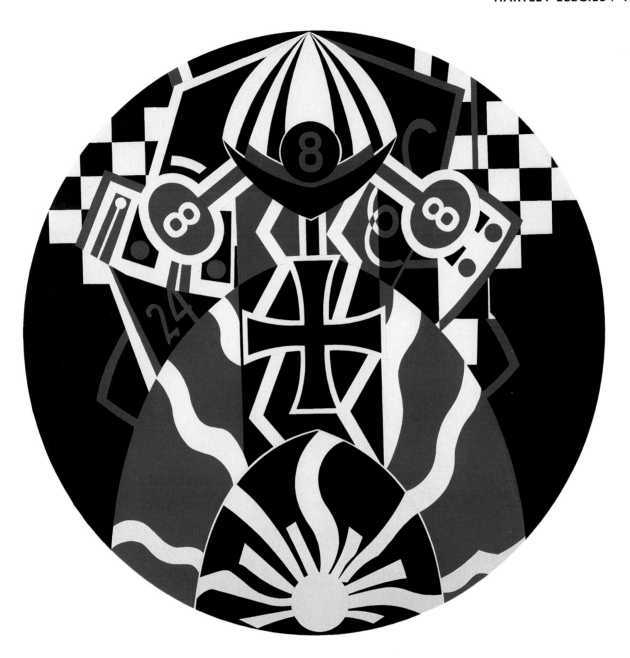

KVF XVIII, 1989–1994. OIL ON CANVAS, COLLECTION OF THE ARTIST.

[WORKS IN THE EXHIBITION]

Dimensions are in inches;
height precedes width.

WORKS BY MARSDEN HARTLEY
(American, 1877–1943)

1. *Abstraction (Military Symbols)*, 1914–1915
oil on canvas
39¼ x 32
The Toledo Museum of Art
Purchased with funds from the Libbey
Endowment
Gift of Edward Drummond Libbey

2. *The Aero*, circa 1914
canvas with painted frame
42 x 34½ (including frame)
National Gallery of Art, Washington
Andrew W. Mellon Fund
(shown in Minneapolis only)

3. *E*, 1915
oil on canvas
47⅛ x 47¼
The University of Iowa Museum of Art
Mark Ranney Memorial Fund

4. *The Iron Cross*, 1915
oil on canvas
47³⁄₁₆ x 47⅜
Collection of Washington University
Gallery of Art, St. Louis, Missouri
University Purchase, Bixby Fund, 1952
(not shown in Miami)

5. *Military*, 1914–1915
oil on canvas
23¾ x 19½
The Cleveland Museum of Art
Gift of Nelson Goodman

6. *Military Symbols 1*, circa 1913–1914
charcoal on paper
24¼ x 18¼
The Metropolitan Museum of Art
Rogers Fund, 1962
(not shown in Miami)

7. *Military Symbols 2*, circa 1913–1914
charcoal on paper
24¼ x 18¼
The Metropolitan Museum of Art
Rogers Fund, 1962
(not shown in Miami)

8. *Painting, Number 5*, 1914–1915
oil on canvas
39½ x 31¾
Collection of Whitney Museum of
American Art
Gift of an anonymous donor
(shown in Minneapolis only)

9. *Painting No. 46*, 1914–1915
oil on canvas
39 x 31¼
Albright-Knox Art Gallery, Buffalo, New
York
Philip Kirwen Fund, 1956

10. *Painting No. 47, Berlin*, 1914–1915
oil on canvas
39½ x 31⅝
Hirshhorn Museum and Sculpture Garden,
Smithsonian Institution
Gift of Joseph H. Hirshhorn, 1972

11. *Painting No. 48*, 1913
oil on canvas
47³⁄₁₆ x 47³⁄₁₆
The Brooklyn Museum
Dick S. Ramsay Fund

12. *Portrait*, circa 1914–1915
oil on canvas
32¼ x 21½
Frederick R. Weisman Art Museum
Bequest of Hudson Walker from the Ione
and Hudson Walker Collection

13. *Pre-War Pageant*, 1914
oil on canvas
40 x 32
Columbus Museum of Art
Gift of Ferdinand Howald

14. *The Warriors*, 1913
oil on canvas
47½ x 47¼
The Regis Collection, Minneapolis,
Minnesota
(not shown in Miami)

ADDITIONAL RELATED WORKS

15. Alfred Stieglitz (American, 1864–1946)
Portrait of Marsden Hartley, 1915
gelatin platinum print
9⅞ x 8
Frederick R. Weisman Art Museum
Gift of Ione and Hudson Walker

16. Marius de Zayas (Mexican, 1880–1961)
Marsden Hartley, 1911
pen-and-ink and watercolor on paper
28½ x 22⅝
The Metropolitan Museum of Art
The Alfred Stieglitz Collection, 1949
(not shown in Miami)

17. World War I German Hussar Officer's
Parade Uniform, circa 1914
West Point Museum Collections
U.S. Military Academy, West Point,
New York

18. World War I German Artillery
Sergeant's Dress Coat, 1900–1914
West Point Museum Collections
U.S. Military Academy, West Point,
New York

19. World War I Prussian Guard Infantry
Spiked Helmet, circa 1914
West Point Museum Collections
U.S. Military Academy, West Point,
New York

20. World War I German Iron Cross,
circa 1914
black-painted iron alloy
1.69 x 1.69
Minnesota Historical Society
Gift of Mrs. T. J. Chittenden

21. World War I German Iron Cross,
circa 1914
iron and ribbon
5 x 1¾
Chicago Historical Society

WORKS BY ROBERT INDIANA
(American, b. 1928)

22. *KvF I*, 1989–1994
oil on canvas
77 x 51 (rectangular)
Collection of the artist

23. *KvF II*, 1989–1994
oil on canvas
77 x 51 (rectangular)
Collection of the artist

24. *KvF III*, 1989–1994
oil on canvas
77 x 51 (rectangular)
Collection of the artist

25. *KvF IV*, 1989–1994
oil on canvas
77 x 51 (rectangular)
Collection of the artist

26. *KvF V*, 1989–1994
oil on canvas
77 x 51 (rectangular)
Collection of the artist

27. *KvF VII*, 1989–1994
oil on canvas
85 x 85 (diamond)
Collection of the artist

28. *KvF VIII*, 1989–1994
oil on canvas
85 x 85 (diamond)
Collection of the artist

29. *KvF X*, 1989–1994
oil on canvas
85 x 85 (diamond)
Collection of the artist

30. *KvF XI*, 1989–1994
oil on canvas
85 x 85 (diamond)
Collection of the artist

31. *KvF XII*, 1989–1994
oil on canvas
85 x 85 (diamond)
Collection of the artist

32. *KvF XIII* 1989–1994
oil on canvas
Diam: 60 (tondo)
Collection of the artist

33. *KvF XIV*, 1989–1994
oil on canvas
Diam: 60 (tondo)
Collection of the artist

34. *KvF XV*, 1989–1994
oil on canvas
Diam: 60 (tondo)
Collection of the artist

35. *KvF XVII*, 1989–1994
oil on canvas
Diam: 60 (tondo)
Collection of the artist

36. *KvF XVIII*, 1989–1994
oil on canvas
Diam: 60 (tondo)
Collection of the artist

[SELECTED BIBLIOGRAPHY]

Asmus, Gesine, ed. *Berlin um 1900*. Berlin: Berlinische Galerie, 1984.

Baigell, Matthew. "The Influence of Whitman on Early Twentieth-Century American Painting." *The Mickle Street Review* 12 (1990): 99–113.

Barron, Stephanie. "Giving Art History the Slip." *Art in America* 62, no. 2 (March–April 1974): 80–84.

Barry, Roxana. "The Age of Blood and Iron: Marsden Hartley in Berlin." *Arts Magazine* 54, no. 2 (October 1979): 166–171.

Boberg, Jochen, Tilman Fichter, and Eckhart Gillen, eds. *Die Metropole: Industriekultur in Berlin im 20. Jahrhundert*. Munich: C. H. Beck, 1986.

Bolle, Michael, and Rolf Bothe, eds. *Eldorado: Homosexuelle Frauen und Männer in Berlin, 1850–1950*. exh. cat. Berlin: Berlin Museum und Frölich und Kaufmann, 1984.

Blumenfeld, Warren, and Diane Raymond. *Looking at Gay and Lesbian Life*. New York: Philosophical Library, 1988.

Bronski, Michael. *Culture Clash: The Making of a Gay Sensibility*. Boston: South End Press, 1984.

Champa, Kermit. "'Charlie Was Like That.'" *Artforum* 12, no. 6 (March 1974): 54–59.

Chauncey, George, Jr. "Christian Brotherhood or Sexual Perversion? Homosexual Identities and the Construction of Sexual Boundaries in the World War One Era." *Journal of Social History* 19 (Winter 1985): 189–211.

_____. *Gay New York: Gender, Urban Culture, and the Making of the Gay Male World, 1890–1940*. New York: Basic Books, 1994.

D'Emilio, John, and Estelle B. Freedman. *Intimate Matters: A History of Sexuality in America*. New York: Harper and Row, 1988.

Davidson, Abraham. "Demuth's Poster Portraits." *Artforum* 17, no. 3 (November 1978): 54–57.

Definitive Statements: American Art, 1964–66. exh. cat. Providence, R.I.: David Winton Bell Gallery, Brown University, 1986.

Eldredge, Charles C. "Nature Symbolized: American Painting from Ryder to Hartley." *The Spiritual in Art: Abstract Painting, 1890–1985*. exh. cat. Los Angeles: Los Angeles County Museum of Art; New York: Abbeville Press, 1986.

Frank, Robin Jaffee. *Charles Demuth: Poster Portraits, 1923–1929*. exh. cat. New Haven: Yale University Art Gallery, 1994.

Fussell, Paul. *The Great War and Modern Memory*. London, Oxford, and New York: Oxford University Press, 1975.

Gaehtgens, Thomas W. "Paris-München-Berlin. Marsden Hartley und die europäische Avantgarde." *Kunst um 1800 und die Folgen*. Munich: Prestel Verlag, 1988.

Gallup, Donald. "The Weaving of a Pattern: Marsden Hartley and Gertrude Stein." *Magazine of Art* 41 (November 1948): 256–261.

Guilbaut, Serge. *How New York Stole the Idea of Modern Art*. Translated by Arthur Goldhammer. Chicago: University of Chicago Press, 1983.

Hand-Painted Pop: American Art in Transition, 1955–62. exh. cat. Edited by Russell Ferguson. New York: Rizzoli International Publications for the Museum of Contemporary Art, Los Angeles, 1992.

Haskell, Barbara. *Marsden Hartley*. exh. cat. New York: Whitney Museum of American Art and New York University Press, 1980.

_____. *Charles Demuth*. exh. cat. New York: Whitney Museum of American Art and Harry N. Abrams, 1987.

_____. *Joseph Stella*. exh. cat. New York: Whitney Museum of American Art and Harry N. Abrams, 1994.

Homer, William Innes. *Alfred Stieglitz and the American Avant-Garde*. Boston: New York Graphic Society, 1977.

James, William. *The Varieties of Religious Experience*. 1902. Reprint, Cambridge, Mass.: Harvard University Press, 1985.

Katz, Jonathan Ned. *Gay American History: Lesbians and Gay Men in the U.S.A.* 1976. Rev. ed., New York: Meridian, 1992.

Katz, William. *Robert Indiana: Early Sculpture, 1960–62*. exh. cat. London: Salama-Caro Gallery, 1991.

King, Lyndel. *Marsden Hartley, 1908–1942: The Ione and Hudson D. Walker Collection*. exh. cat. Minneapolis: University Art Museum, University of Minnesota, 1984.

Koestenbaum, Wayne. *Double-Talk: The Erotics of Male Literary Collaboration*. New York: Routledge, 1989.

Korff, Gottfried, and Reinhard Rürup, eds. *Berlin, Berlin: Die Austellung zur Geschichte der Stadt*. exh. cat. Berlin: Nicolai, 1987.

Lemos, Peter. "Indiana in Maine." *Art News* 88, no. 8 (October 1989): 166–169.

Levin, Gail. "Hidden Symbolism in Marsden Hartley's Military Pictures." *Arts Magazine* 54, no. 2 (October 1979): 154–158.

Little, Carl. "Robert Indiana at the Portland Museum of Art." *Art in America* 79, no. 10 (October 1991): 162–163.

Ludington, Townsend. *Marsden Hartley: The Biography of an American Artist*. Boston: Little, Brown, 1992.

Martin, Robert K. *The Homosexual Tradition in American Poetry*. Austin: University of Texas Press, 1979.

_____. ed. *The Continuing Presence of Walt Whitman*. Iowa City: University of Iowa Press, 1992.

Matthiessen, F. O., and Russell Cheney. *Rat and the Devil: Journal Letters of F. O. Matthiessen and Russell Cheney*. Edited by Louis Hyde. Hamden, Conn.: Archon Books, 1978.

McCoubrey, John W. *Robert Indiana*. exh. cat. Philadelphia: Institute of Contemporary Art, 1968.

McDonnell, Patricia, "American Artists in Expressionist Berlin: Ideological Crosscurrents in the Early Modernism of America and Germany, 1905–1915." Ph.D. diss.: Brown University, 1991.

_____."Indian Fantasy: Marsden Hartley's Myth of *Amerika* in Expressionist Berlin," *North Carolina Museum of Art Bulletin* 16 (1993): 50–64.

_____. "Spirituality in the Art of Marsden Hartley and Wassily Kandinsky, 1910–1915." *Archives of American Art* 29 (1989): 27–33.

Mecklenburg, Virginia. *Wood Works: Constructions by Robert Indiana*. exh. cat. Washington, D.C.: Smithsonian Institution Press for the National Museum of American Art, 1984.

Mellow, James. *Charmed Circle: Gertrude Stein and Company*. New York: Avon Books, 1982.

Moon, Michael. *Disseminating Whitman: Revision and Corporeality in Leaves of Grass*. Cambridge, Mass.: Harvard University Press, 1991.

Mosse, George L. *Nationalism and Sexuality: Respectability and Abnormal Sexuality in Modern Europe*. New York: H. Fertig, 1985.

Oosterhuis, Harry, ed. *Homosexuality and Male Bonding in Pre-Nazi Germany*. London and New York: Harrington Park Press, 1991.

Peladeau, Marius B. "'LOVE' on a Maine Island." *Historic Preservation* 38, no. 1 (February 1986): 12–16.

Petrow, Steven. "Robert Indiana's Love Story." *The Advocate* 598 (March 10, 1992): 72–76.

Plante, Michael. "The 'Second Occupation': American Expatriate Painters and the Reception of American Art in Paris, 1946–58." Ph.D. diss.: Brown University, 1992.

Reichman, Leah Carol. "Robert Indiana and the Psychological Aspects of His Art." M.A. thesis: Hunter College, 1980.

Robinson, William H. "Marsden Hartley's *Military*." *Bulletin of the Cleveland Museum of Art* 76, no. 1 (January 1989): 2–26.

Röhl, John C. G., ed. *Kaiser Wilhelm II. New Interpretations*. Cambridge, England: Cambridge University Press, 1982.

Ryan, Susan Elizabeth. "Elegy for an Exile." *Art and Antiques* 8, no. 5 (May 1991): 84–89; 106, 109.

_____. "Figures of Speech: The Art of Robert Indiana, 1958–73." Ph.D. diss.: University of Michigan, 1992.

Scott, Gail R., ed. *On Art by Marsden Hartley*. New York: Horizon Press, 1982.

_____. *Marsden Hartley*. New York: Abbeville Press, 1988.

Sedgwick, Eve Kosofsky. *Between Men: English Literature and Male Homosocial Desire*. New York: Columbia University Press, 1985.

_____. *Epistemology of the Closet*. Berkeley: University of California Press, 1990.

Sheehan, Susan. *Robert Indiana Prints: A Catalogue Raisonné, 1951–1991*. New York: Susan Sheehan Gallery, 1991.

Snitow, Ann, Christine Stansell and Sharon Thompson, eds. *Powers of Desire: The Politics of Sexuality*. New York: Monthly Review Press, 1983.

Steakley, James D. *The Homosexual Emancipation Movement in Germany*. New York: Arno Press, 1975.

_____. "Iconography of a Scandal: Political Cartoons and the Eulenburg Affair in Wilhelmine Germany." *Hidden from History: Reclaiming the Gay and Lesbian Past*. New York: New American Library, 1989.

Steiner, Wendy. *Exact Resemblance to Exact Resemblance: The Literary Portraiture of Gertrude Stein*. New Haven: Yale University Press, 1978.

Steinweiler, Andreas, and Wolfgang Theiss. *750 Warme Berliner*. Berlin: Verlag rosa Winkel, 1987.

Swenson, G. R. "The Horizons of Robert Indiana." *Art News* 65, no. 3 (May 1966): 48–49, 60–62.

Taylor, Paul. "Love Story." *Connoisseur* 221, no. 955 (August 1991): 46–51, 94–97.

Tobin, Robert, et. al. *Robert Indiana*. exh. cat. Austin: University Art Museum, University of Texas at Austin, 1977.

Van der Marck, Jan. *Richard Stankiewicz and Robert Indiana*. exh. cat. Minneapolis: Walker Art Center, 1963.

Warhol, Andy, and Pat Hackett. *POPism: The Warhol '60s*. New York: Harcourt, Brace, Jovanovich, 1980.

Weinberg, Jonathan. "'Some Unknown Thing.' The Illustrations of Charles Demuth." *Arts Magazine* 61, no. 4 (December 1986): 14–21.

_____. "Demuth and Difference." *Art in America* 76, no. 4 (April 1988): 188–195, 221, 223.

_____. *Speaking for Vice: Homosexuality in the Art of Charles Demuth, Marsden Hartley, and the First American Avant-Garde*. New Haven: Yale University Press, 1993.

Weinhardt, Carl J., Jr. *Robert Indiana*. New York: Harry N. Abrams, 1990.

Wohl, Robert. *The Generation of 1914*. Cambridge, Mass.: Harvard University Press, 1979.